INFORMATION

Z 692 .C65 I54 1998

IMAG

Information imagineering

Meeting at the Interface

Editors

Milton T. Wolf, Pat Ensor, and Mary Augusta Thomas

For the

Library and Information Technology Association
and the
Library Administration and Management Association

American Library Association
Chicago and London 1998

Parts of this work were developed from material originally presented at the conference, held October 12–16, 1996, in Pittsburgh, Pennsylvania, entitled "Transforming Libraries: A National Conference and Exhibition on Leadership and Technology in the Information Age."

Project editor: Louise D. Howe

Composition by the dotted i in Janson Text and Korinna using QuarkXpress v 3.32

Printed on 50-pound white offset, a pH-neutral stock, and bound in 10-point coated cover stock by McNaughton & Gunn.

The paper used in this publication meets the minimum requirements of American National Standard for Information Sciences—Permanence of Paper for Printed Library Materials, ANSI Z39.48-1992. ∞

Library of Congress Cataloging-in-Publication Data

Information imagineering : meeting at the interface / edited by Milton
 T. Wolf, Pat Ensor, and Mary Augusta Thomas for the Library and
 Information Technology Association and the Library Administration and
 Management Association.
 p. cm.
 Includes index.
 ISBN 0-8389-0729-6 (acid-free paper)
 1. Libraries—United States—Special collections—Electronic
information resources. 2. Digital libraries—United States.
3. Museums—United States—Data processing. 4. Museum techniques—
United States. I. Wolf, Milton T. II. Ensor, Pat. III. Thomas, Mary
Augusta. IV. Library and Information Technology Association (U.S.)
V. Library Administration and Management Association.
Z692.C65I54 1998
025'.00285—dc21 97-44296

Printed in the United States of America.

02 01 00 99 98 5 4 3 2 1

To the memory of

Paul Evan Peters
(1947–1996)

who had planned to contribute to this book,
who helped formulate its conception, and
who arrived at the Interface
long before most of us

CONTENTS

■ PART THREE ■

From Print to Pixels

■ PART FOUR ■

Redefining Our Information Institutions

■ PART FIVE ■

Visioning the New Organization

■ PART SIX ■

A Mirror Held Up to Tomorrow

FOREWORD

In the pages that follow, technology thinkers from the library field and beyond imagine what the future holds for the information world. We are seeing the library and information people embracing new technologies and envisioning great possibilities. I recently served on the National Information Infrastructure Advisory Council (NII AC), where we considered the role of government in building and developing the Information Highway. In the course of our work we heard from a panel of librarians from around the country describing activities in libraries and discussing the needs and challenges for the future. We heard teachers, librarians, and school students describe the difference access to the Internet had made in their lives. Librarians and other information professionals are indeed making a difference, and we must continue to focus on how technology can improve people's lives.

To carry these successes forward, we and our organizations must meet three challenges: (1) to think globally and act locally; (2) to manage fast-changing multimedia documents; (3) to develop Just-for-You libraries.

In our schools and in our libraries we must be more and more aware and understanding of different cultures from around the world. We need to develop better understanding and incorporate different traditions into our organizations. We also should be recruiting for diversity. We should fully involve people from all cultures in libraries because we live in a global village.

The enrichment that this diversity brings to our learning and our understanding is valuable to all of us. The other side of this is that we must act locally. It is easy for us to look to Washington for national solutions rather than working in our own backyard. Many of us who work in academic libraries do not have as strong a partnership, for example, with our local public library as we might. We can build many kinds of partnerships—between school libraries and medical libraries, for example. With the shift to managed health care more and more people are being sent home from hospitals early. Their families and caregivers need more information about self-care. The giving of true informed consent requires information about a proposed medical procedure. Cooperation among school, public, academic, and medical libraries to ensure that people that have access to information about long-term wellness can make a significant difference. How many major research libraries

are working with small communities to make sure that they too get on the information highway?

The second challenge relates to managing multimedia documents and teaching mediacy skills. We are just beginning to understand the issues surrounding multimedia documents. Just as you never step in the same river twice, a document on the Net is never the same twice. Librarians are concerned about preserving information. How will we apply our techniques to a networked, multimedia environment? How will we find what was there yesterday, much less last year? Will we have the hardware and the software to be able to read it? Will we have the documentation? We need an interdisciplinary perspective from historians, artists, and others to understand more fully how to manage these evolving multimedia documents.

We're not just providing access to these collections, we're creating new ones. Each library has unique materials that can be made available to scholars and to the wider public around the world. How do we manage these collections? How do we create them? Again, the answer is in partnerships. One of our faculty in information science at University of Pittsburgh is working with an art historian; another is working with somebody in anthropology; and another with people in the medical school. All of these projects are to create and make available multimedia publications from materials in our libraries and archives and also from what's available in our universities and in our communities. Whether the collections are photographs, electronic records, sound recordings, moving images, art works, or other types of resources, we are exploring new ways to provide access to them. The opportunities are endless, and we are learning rapidly how to fill these new roles of creator and publisher.

Our new roles demand education and training. What are the skills and the knowledge that we need to teach for the future, not just in master's and Ph.D. programs, but throughout lifelong learning? What should we be teaching in K–12? Should we require every student to have a computer or laptop? Should we have specialized labs? What is information literacy? An educated person must not only know how to use the technology and how to find information within the library or the Net, but also how to evaluate information and how to be ethical. Developing a better understanding of mediacy and how to ensure we all have the knowledge and skills needed to succeed in our information-intensive society are critical for the years ahead.

The third challenge is developing what I call "Just-for-You" libraries. For years we built libraries and collections just in case someone needed them. We would work very hard to identify the needs of our users, to sift through everything out there, and to bring into the library what was needed, organize it, and make it available, providing reference access to

it. These Just-in-Case collections must continue to exist for many reasons, including preservation and possible future use.

Over the years we have moved more to "Just-in-Time" delivery, with electronic delivery, through increased networking and sharing among libraries. We've never been able to have everything the users needed within the four walls of our building, so we have provided access through networks and cooperation with other libraries around the world. Information resources can be delivered very quickly, just in time for the individual. What we are moving toward is customized, individualized service that is "Just for You."

For example, if a person is a whole-to-part learner, and better with visual images than text information, presentation may be customized for those needs. If a person cannot see and therefore must have a voice recognition system and software that will read the material aloud, customized delivery can be tailored for that individual. This does not replace the librarian. In fact in many cases, special and medical librarians have been leaders in creating this customization.

To meet these challenges we need to educate information professionals for tomorrow's jobs and careers and to encourage research and new ideas. I invite you to draw inspiration from the visionaries contributing to this book and start now on your own journey of imagineering. I have been in this field a very, very long time, and I can't think of a more exciting time to be a part of it!

Toni Carbo, Dean
School of Information Sciences
University of Pittsburgh

PREFACE

Paul Evan Peters, to whom this book is dedicated, understood early on that the information revolution was really a people revolution. Paul knew that while there are a number of factors involved in the evolution of human societies, the one factor that dominates the process is technological innovation.

Historically, technological breakthroughs, such as the invention of the wheel, the smelting of metallic ores, the printing press, the steam engine, electrical and nuclear power, have all ultimately transformed society, dramatically affecting the manner in which society organizes and perceives itself.

Paul's vision of the information universe cut across all disciplines of thought for he, more than most, understood that sooner or later we would all meet at the Interface, that space, which is sometimes physical and sometimes virtual (cyberspace), where humans and their technical constructs meet and interact.

So, taking our cue from Paul, the editors of this book reached out across information institutions negotiating the "digital divide" to find out what the latest technologies were doing to us and for us. We started our search at a conference entitled Transforming Libraries: A National Conference and Exhibition on Leadership and Technology in the Information Age, which took place October 12 through 16, 1996, in Pittsburgh, Pennsylvania. Organized by the Library and Information Technology Association (LITA) and the Library Administration and Management Association (LAMA), both divisions of the American Library Association, the conference initiated our inquiry into our increasingly electronic information suprastructure and its impact on the welfare of the general public.

From there and beyond, we have assembled not only some of the best and brightest opinions from the mainstream library and information fields but also a few thought-experiments from various related fields. Librarians, archivists, curators, computer aficionados, and information specialists of all stripes should find not only common ground within these pages but also the necessary seeds of cross-fertilization. The Interface doesn't care about gender, race, or the source of unusual ideas, but it may well be the most powerful technological forum ever devised for sharing human information resources.

The significant effect of the Internet and the World Wide Web on organizational operations alone has challenged information resource managers to rethink the basics of an organization's infrastructure. The rapid pace of technological change has outpaced many traditional organizations' responses, sometimes antiquating cherished beliefs and institutions almost overnight. The ability of the computer not only to simulate present processes but also to model alternatives has created, especially in those institutions devoted to information transfer, new paradigms of operations and an unsettled future.

But whatever this brave new digital world brings, rest assured that "ideas" are on the social fast track, that "content" management will supersede the thoughtless accumulation of infodumps, and that we are only beginning to perceive the changes the electronic frontier will cause in such important areas as protection of intellectual property, censorship, organizational structuring, and the overall political process worldwide.

The Interface between us and our technical creations is at that stage of intimacy that we can no longer beg the question of design. In this book we will examine some of the possible directions and some of the possible solutions to a world that is accreting digitally to one of the most significant "Information Commons" ever provided to the proverbial "hairless ape."

As Paul Evan Peters knew (and the reason he was instrumental in creating the Imagineering Interest Group of LITA): Technology is morally neutral but we, on the other hand, are an uneasy mixture of good and bad. We must combine our imaginative powers and our tool-making (engineering) skills, we must "imagineer" our future. The world is meeting now at the Interface at a computer near you!

PART

I

Retooling for the Future

The More We Change, the More We Should Stay the Same

Some Common Errors Concerning Libraries, Computers, and the Information Age

■ ■ ■ ■ ■

BRUCE GILBERT

That technology has transformed, and will continue to transform, our society and our workplaces, as well as our libraries and other cultural institutions, is a truth that has reached the status of the commonplace. That technology has had this effect on humankind for many years is not as widely recognized.

Today, there is no doubt that constant change is an everyday part of life; there is even less doubt that worldwide knowledge of medicine, science, and technology continues to march forward. Much of the recent well-publicized explosion of information in these areas has been fueled by the growth of information technologies in general and the Internet in particular. Yet for all this "information about information," cogent and accurate pronouncements about this emerging world of "electronica" remain as elusive as cold fusion.

What has happened is that the mercurial nature of life in an electronic age, to paraphrase Huey Long, has made "every computer user a guru." The spread of computer network technology into households, businesses, and schools, combined with the ease and immediacy of publishing on the Internet, has created an audience for a cacophony of conflicting and competing voices. A great deal of error is heard in this din;

BRUCE GILBERT is assistant professor of librarianship and the head of library systems at Drake University in Des Moines, Iowa. He has written articles for several periodicals and is a reviewer for *Telecommunications Electronic Reviews*. Bruce can be reached via e-mail at BG7601s@acad.drake.edu. His Web page is http://www.drake.edu/lib/sys/bruce.

heard repetitively, this error can become accepted as truth, and awareness that this "accepted error" has negative consequences will quickly disappear.

This chapter will examine three commonly repeated errors about the age of "informatica electronica":

1. "Computer people" and "book people" are antagonists due to the staid nature of the latter and the revolutionary ways of the former.

2. Technology will render obsolete the need for traditional bibliographic and critical skills.

3. Technology will drastically change the nature of what librarians and information professionals do in the future.

ERROR NUMBER 1

The Computer Person vs. the Book Person—of Paradigms and Other Forms of Change

Since Thomas Kuhn's *The Structure of Scientific Revolutions* was first published in 1962, his ideas have gradually and undeniably been subsumed in the popular consciousness. Ironically, "changing paradigms" has become the accepted intellectual paradigm of the day in much of the popular, as well as academic, press. Today, the most important paradigm shift to those of us who labor in what one could refer to as the "information industry" is the battle of "print vs. electronic" as methods for conveying information to our customers.

What does our experience have to do with paradigms? Thomas Kuhn taught that, for successive levels of "progress" or scientific truth to be accepted, the previous generation of scientists must pass from the scene (and please remember that Kuhn was speaking of scientists, not librarians or administrators). Such scientists were attached to old "paradigms," or patterns of thought concerning a subject, and could not be trusted to grasp the newer, emerging truths that constant experimentation and research provide.

Yet, in the fast-moving flow of modern life, we do not possess the luxury of waiting while dinosaurs drag themselves from the field. If Kuhn is correct, there is too much at stake to wait for this evolutionary process to take its course.

But is this application of Kuhn correct? Or, more significantly for toilers in the information vineyards, is there any meaningful difference between the changing natures of the "book person" and the "computer person" paradigms?

Many people would scoff at even posing such a question. "Of course, there is a difference," the book person might say. "Look at those computer people, they are totally dependent on their technology, while I can still find and use all the information I need with print products."

What such a view fails to consider, of course, is that print is simply another form, indeed a highly advanced one, of technology. If Cleopatra and Queen Nefertiti were miraculously transported to modern times, there is little doubt that, while they might have a hard time grasping the necessity or the utility of modern electronics, they would stand in awe of our publishing and library industry. To think of a system that could put into the hands of every person, at little or no direct expense to that person, the news of the day or the thoughts of Aristotle or any lesser modern thinker, is a technological concept that would surely seem unattainable as well as subversive.

We can see that this reality has interesting ramifications. The print vs. electronic debate is one about means, not ends; those who argue we should not abandon reliance on print for reliance on "technology" are merely arguing in favor of an existing technology and against a newer form.

A disdainful computer user, on the other hand, might say, "Look at those dinosaur print people, clinging to their books! Why can't they see that the battle is over, electronic information has carried the day, and the sooner the 'print people' recognize this and recant their obsolete ways, the better!"

Such a view does not take into account, however, how quickly the ground has shifted under the "computer person's" feet in recent times. That he or she can manipulate data much more easily than in times gone by is indisputable and a cause for considerable satisfaction, but this does not by itself justify a change in mental landscape. Further, in the blink of a few short years, the service world of the computer specialist has completely changed. The change from "mainframe mentality" through the personal computer revolution, toward a world of "network devices" or "appliances" (sophisticated machines that somehow don't even require the sobriquet "computer" any longer) has further supplanted many ingrained modes of thought.

Before we leave this benighted "computer person," we must address one final paradox. The scenario above suggests that a major shift in thinking for computer users was the change of focus from "mainframe" to "network." Today we struggle to make the "network" ubiquitous and

66

What will be of interest to future "networked"
computer users is the data that travels over this
network, just as the telephone is of little interest
to the user, who is concerned only with the
voice and words of the other party.

99

dependable, but soon the network will fade into the background and become of interest only in those increasingly rare times when it does not function. What will be of interest (to a great extent it already is) to future "networked" computer users is the data that travels over this network, just as the telephone is of little interest to the user, who is concerned only with the voice and words of the other party. The computer user will be much more interested in data than in telephony. Today's obsession with the network will seem as outmoded as an earlier generation's fixation on the horseless carriage.

So, when you read that "book people" are destined for the trash heap and "computer people" are the next rulers of the universe, keep in mind that the latter have no inherently superior vision of the future by virtue of their occupation. Both, in their struggle to serve the shifting sands of user wants and needs, are ultimately doomed if they mistake allegiance to present forms of technology for the discernible outline of the future.

ERROR NUMBER 2

Technology Will Make Traditional Skills Obsolete—Why Search Tools Will Never Replace Search Skills

In our day-to-day endeavors, there can be no doubt that computer technology has already had a huge impact. In the industrialized world, armies of information workers have sprung up. Many of these come from tra-

ditional backgrounds, be they librarianship, computing professions, or data processing. However, the needs of our institutions have made it imperative that they take on hybrid roles, with computing people gaining some of the search-and-retrieval skills of library and information professionals, while librarians and other "research-based" professionals have become more technically literate. Both the microcomputer and the mainframe-based database have helped drive these changes.

We have now embarked on the second level of this technology-driven reformation. This truly revolutionary "second movement" is marked by the introduction of software that makes the resources of the Internet available to any person or any organization (who is in an area with the telecommunications infrastructure, that is) with access to a microcomputer, a modem, and either an organizational membership or the funds for a personal Internet account. The hallmark of this movement is the repositioning of the need for technical and informational expertise; whereas in the first movement, the need for this was on-site, that is, in libraries, computer centers, and data processing departments, now the need is shifting to "on-desk," wherein considerable expertise is assumed on the part of every user.

Is there a danger that "traditional" information skills, i.e., information retrieval or classification abilities, will become unneeded in this environment? No, since dealing with the quality, organization, and amount of information available electronically has quickly become a serious problem for users. The overwhelming popularity of such rudimentary tools as search engines and "subject libraries" of the Internet illustrate the nature and the depth of this current organizational chaos. Search engines invite the user to search the entire known Internet for terms that may exist in a document's title or at the bottom of the "page," where the enterprising author has appended terms that have no topical connection, but are simply designed to exploit this weakness of existing tools. "Subject libraries" vary widely in quality, ranging from focused, evaluative, critical sites to broad-based "laundry list" sites that will include almost any submitted site, as quickly as the new site can be assigned a category.

In contemplating this widely divergent quality, remember that HTTP (Hypertext Transfer Protocol), FTP (File Transfer Protocol), SMTP (Simple Mail Transfer Protocol), and the like, are protocols, not standards. In short, these acronyms refer to ways that my computer can interact with your computer if both are set up in a prearranged manner. However, it is important to remember that agreeing to handle data in a certain way does not include agreement that it will be handled well, that its existence will be discoverable, or that its transmission will involve quality or content. This critical context is clearly missing in the way most users approach the Internet.

Thus the "traditional" skills of the librarian or other information professional in this climate remain invaluable. Using our critical and bibliographic skills, we can clear coherent pathways through the maze-like world of information. There is no substitute for traditional bibliographic, organizational, and critical skills when it comes to making sense of this new realm of electronic information.

ERROR NUMBER 3

Technology Will Change What We Do

Technology will certainly change the way we do things; inarguably, this process is already in place. Yet, does this change in methods mean we will be changing at the core what we do? My reply to that question is, no, it does not have to, and it probably should not. To see how I arrived at this conclusion, we will first examine some recent history of the information age, and then consider if the lessons gleaned from this examination will provide background for some conclusions about our future.

A Personal and Societal History

While we're always looking for "the next big thing" (in libraries, museums, computer clubs, and elsewhere in the "information industry"), the undeniable truth is, there is no end of "big things." The latest technology news comes across one's desk every day, and there is no way of telling what "the next really big thing" is; when one hears of them every day, "big things" cease to excite. Eventually, they fail to titillate, until finally they barely sate. Yet another one must certainly be out there, and it must be important, because the media (both popular and informational) never cease to look for it.

From my own experience, I can easily trace the "one big thing" I have experienced in the past several years to when I first "launched" the Mosaic (Version 1.01b) Web browser in 1993 and had the first "near-paper," i.e., attractively presented and easily customizable, experience I'd ever had when using a networked computer. Subsequent developments, from initial versions of Netscape, through streaming video, to flashing and blinking images, have left me succeedingly less tremulous; some recently ballyhooed events, such as new browser releases, have actually seemed like steps sideways, if not backwards.

This initial ability to view images and text on a computer in a click-able interface that is easily "graspable" seemed to open the door to a whole new arena of providing information to anyone with access to a computer and a modem, regardless of their physical location. This rev-elation was not, however, necessarily shared by all of my colleagues and acquaintances; there were people involved in libraries, education, and com-merce who failed to see this new "big thing" that was so apparent to me.

Some of these colleagues have subsequently become converts. Others are still skeptical, while still others will remain unconvinced for as long as one can foresee. For them, no "big thing" that will impact the way they live and think is ever likely to leap forward from an advance in telecom-munications. One can hardly blame them; I feel I'm no closer to grasp-ing what kind of a "big thing" the Internet will be to our future than I was in 1993 when I experienced that fleeting Mosaic-based epiphany.

To compare this anecdotal personal history with a wider view, it might be useful to take a look at another transforming societal experi-ence. In contemplating the history of the past century, we must cer-tainly admit that this will be known as the Age of Film, the time when the moving picture industry went from flip-book oddity to the most powerful and influential force in the worlds of information and com-munication, as well as entertainment.

The role of the motion picture in asserting American dominance in the global culture can hardly be understated, any more than its role in facilitating the most deadly conflicts in human history. We are the first generation in history that is so used to being constantly accompanied by projected moving images that we are generally unable to fathom what an unusual and recent phenomenon this is.

Yet, at the end of the day, how complete is this domination? Cer-tainly the ability to view moving pictures is ubiquitous in the developed world, and has even made inroads in many less-developed areas. Yet there are widespread and widely recognized problems with this tech-nology; from concerns over preservation of deteriorating film stock to content concerns wherein one modern, expensive motion picture or tele-vision program looks and acts much like many mindless others, one can see that this juggernaut technological and cultural force, with all its bene-fits, is fraught with problems, perils, and conditional drawbacks.

Have Things Changed, or Is It Merely Us?

This brief analysis of film and hypertext shows us that technology is powerful, but not all-powerful. It is, in and of itself, value-neutral. "Technology" does not care whether you use it for good or for ill, or to

promote quality or base communications. When someone makes a film or puts up a Web page, it proves only that the author has the access and the facilities it takes to create one.

This points to one of those basic verities that we should stress to our users. The current Internet obviously contains both gold and iron pyrite, and it is entirely up to the user to determine which glittering pile (if any) he or she should accept. Experience demonstrates that the user certainly must possess certain knowledge and skills in order to choose wisely; yet these faculties, praiseworthy as they are, may not be enough.

Thus when we as service professionals consider the tremendous tools that new technologies can be, we should not stop at the new capabilities they give us. Much more important is the opportunity they present to have people think about what it means to be a critical consumer of information.

For example, when we hear the familiar argument that information on the Internet "can't be trusted" because we are unsure of its origins or authenticity, we must ask about the accuracy of the information that we routinely accept every day from newspapers, television, and other popular media. Just because words issue forth from an anchorperson's mouth or a scholar's printer, should we routinely accept this as worthwhile information? Thus, the skilled professional can take a common argument about the nature of information on the Internet and frame it as a gateway to wider consideration of the nature of all sorts of information providers.

In getting down to the basics of the ways we get information and from whom, how much, and how fast, we are talking about much more than "information"; we are touching on the very nature of the knowledge that we acquire. A salient part of this process must be the revolutionary idea that users will benefit from learning something about the information process itself.

This kind of "revolutionary" approach is, after all, one that some concerned professionals have been practicing for a long time. For example, if we examine the reference interview (the process wherein a reference librarian refines a user query), we can see that the reference librarian must be keenly aware that the user often will not understand the nature of the new sea of knowledge upon which he or she is embarked. (A classic example of this is the user who asks for a book on whales when trying to find the novel *Moby Dick*.)

The role of the professional has not changed, regardless of whether the user's query is delivered at an information desk, by telephone, or by e-mail. Changes in the format of that patron's query should not have an effect on our focus, which should be, first, meeting an immediate infor-

mation need, and second, wherever possible, inculcating skills and knowledge.

It must be at this crucial intersection where we find the librarian (or the information professional, or cybrarian, or whatever nomenclature we choose). Ultimately, although the methods and tools one uses will vary hugely (probably beyond what we can imagine), the final aims will not vary from terms that S. R. Ranganathan could accept.

Librarians will help stranded users find their way; they will endorse the values of free, unfettered discourse; they will help preserve and organize the intellectual artifacts of a culture; and they will promote the lifelong learning process that should be a component of every citizen's span. They will do this because they have the ability to do it, and because they always have done it; they will do this because they are there; and they will do it because, in the end, if they don't, no one else will.

The enduring truth is that we should not flinch from this challenge just because it places new burdens on us. People will demand more in the information age, but more importantly, this new emphasis moves the locus of the argument about the future of scholarly inquiry and community involvement much closer to the domain of the information provider or broker or purveyor. Those who calmly and clearly accept this challenge are guaranteed an interesting time in the foreseeable future, and that is one prediction that I guarantee will be true.

The Five Plus One Disciplines

*A Path Toward Discovering
Librarianship's Future Roles*

■ ■ ■ ■ ■

GARY SILVER

ACT I

And the Master Then Asked,
"But, Who Decided
Which Direction Is West?"

During the 1996 LITA/LAMA convention in Pittsburgh, Shelley Phipps of the University of Arizona–Tucson stated, "Technology is not the key to our future. People are—people who are capable of continuous learning." Modeling her commentary upon the work of Peter Senge (*The Fifth Discipline:* see http://www.fieldbook.com), Shelley Phipps described five disciplines—personal mastery, shared vision, team learning, mental models, and systems thinking—that librarians need to develop the "new awareness . . . new attitudes and beliefs" that are necessary to face the realities of technological change and generational and cultural differences in ways of seeking information. "Discovering ourselves," she concluded, "is the way we will discover our future role." (See "The Five

GARY SILVER—After twenty-two years' professional experience as director of several public library regional systems and an earlier stint as an urban secondary school administrator working with Instructional Systems Technology, Gary Silver is sole proprietor of Walden3, an Internet-client/server solutions consulting firm located in Manitowoc, Wisconsin. Walden3 (Walden3.com) specializes in building organizational intranets and public electronic communities.

Disciplines: Learning Organizations and Technological Change" in part 5 of this book.)

From community networking to intranet development that I first engaged in as a director of two regional library systems, and now in my work as a consultant, I am convinced that Phipps is correct when she states that people who are capable of continuous learning are the key to the future success of information systems. Also, I am absolutely convinced that persons such as Phipps (including, among others, Peter Senge, Art Kleiner, and Dilbert's Dogbert) are no longer making fuzzy sounds-good-for-the-conference speculative statements about THE FUTURE. I am convinced that such statements have moved from the realm of speculation into the solid realm of the theory.

Our time present is like the past time when Melvil Dewey developed solid theory that allowed a massive embarkation into the yet-to-be-calmed waters of the arrangement and classification of knowledge.

Historic though our now time might be, I do want your reading of this chapter to be fun. Fun is serious business. And, therefore, I must ask you to sign the following waiver. Please read the next paragraph, and if you agree to the terms, sign your name and continue. If you disagree with the terms or with signing your name, then you are probably a 1968 spiritual traveler with Jerry Rubin, and you are FREE to continue without my blessing. (See http://elaine.teleport.com/~danw/stew/jerry.html.)

> The following piece of writing is held harmless for any fun which might be generated by its reading. The reader vouches to being old enough to freely make this decision.
>
> I agree _____ This date _____

That done, let me clarify three potential confusion points.

Potential confusion possibility number one: Within the landscape of confusion possibility number one, you may choose to believe (a phrase taken from the fine writing of Suki Colgrave) that what I'm telling you is going to amount to one big joke. And, you might be thinking, "what the $%@$#* is this person writing about?" If so, then you truly need to read on, because you haven't yet mastered step one of the proposed five disciplines. Step one is PERSONAL MASTERY.

Potential confusion point number two: Librarians often value a background that includes literature, art, and such-like "slushy-squshy" (thank you, Mr. Kipling) stuff. I'd guess that *Nightwood* by Djuna Barnes has been read more frequently by librarians than by M.F.A. students majoring in creative writing. I suspect also that librarians dislike and/or distrust sweeping, somewhat insulting, generalizations such as I've just made. In the realm of confusion point number two, if you find yourself

becoming miffed or angry because of what I've just said, then we have a second indicator of why you need to read what I'm shortly going to write about, the proposed five disciplines.

Before continuing, I choose to play the "WebMaster who has just discovered push technology" and thrust upon you some predominantly extraneous personal information such as that one of my favorite movies is *Terminator II*, which stars Arnold Schwarzenegger and Linda Hamilton. (She's kewel; see www.geocities.com/Hollywood/4020). I also very much admire Jackie Robinson—not just because he was a great baseball player, but because he (along with Catfish Hunter [baseball]; Bobby Clark [hockey], and Bill Talbott [tennis]) is one of my fellow diabetic heroes. (See http://www.castleweb.com/diabetes.) However, concerning your personal health and your sports likes and dislikes, my advice to you is to never mention them in an interview or professional job situation. That is, unless you're a Saint Beauvian literary critic. Otherwise, no one appreciates that kind of stuff. Talking about that kind of stuff will just leave you open for being labeled "unprofessional" by the Luddites.

I have said that the statements being made by Phipps and others are theoretical in nature. In the process known as the "scientific" method, speculation precedes theory. Library science, assumedly, follows the scientific method in developing general theories about how we operate, manage, budget, build, and so forth.

Before the theoretical, there is speculation. I contend—I speculate—that the library profession is emerging from a period of widespread speculative commentary. We have all heard, and wondered about, the validity of such well publicized speculative commentary as, "the book is dead . . . librarians must now be cybrarians."

The library community has many less-publicized speculations concerning its future. Examples of these include the trend to bequeathing professional status to non-degreed library workers, outsourcing of support services, so-called flattening of the organization, and career plateauing.

When speculation happens, there is no right and no wrong. There are, however, consequences to speculation. If, for example, you speculate that a flying saucer is following in the wake of the comet Hale-Bopp (see http://www.jpl.nasa.gov/comet), you may arrive at some interesting intellectual conclusions and behavioral consequences—mass suicide, for one.

Another characteristic of purely speculative statement is that speculation generally happens when the future appears to be unclear. Speculation helps the human brain chase after, and attempt to illuminate, the

unknown—an unknown that is generally assumed to be hostile—a big mean bugaboo that is lurking in the dark. But when cast, the light of speculation is cast willy-nilly, often illuminating little but the identity of fleeting fears, the interior peculiarities of the one doing speculation. Speculation often brightens like the thousand murky lights of the normally sanguine villagers, turned mob, who are out in the dark searching for the invisible Frankenstein monster of future reality.

Scientific process, on the other hand, seeks organized, demonstrable proof of the essential truth or falsity residing within a speculative statement.

INTERMISSION

The best ideas happen and are heard outside the conference lecture room. When I was twenty-four years old, I went to a drinking party where I bumped into a guy who said, "People avoid me because they know I'm the kind of guy you could get to like." For the remainder of that night, I avoided him. Today, I have heard professionals say strikingly similar things when excusing themselves for not taking time to master Internet navigation.

ACT II

The Five Disciplines

We are moving into an age of the theoretical. How long will this age last? What are the ramifications of moving from a speculative period of time into one which is marked by solid theoretical development? And, what is theoretical development? What does it mean to be developing theory? And, dare we develop, or dare we not develop? Like Dewey, do we?

If you went to library school and learned your lessons well, earned an ALA-accredited M.L.S. degree, then I don't have to tell you what it means to develop and test theory. You have an M.L.S. degree, you are a Master of Library Science—you are a scientist, right? Library scientist? Information scientist? And, if you think about it for a moment, I really shouldn't have to tell you what it means to be engaging in the more-or-less scientific development and testing of theory. After all, the U.S. Department of Education, National Science Foundation, and all those folks have spent years investing money for science education in

"

Dare we develop, or dare we not develop?
Like Dewey, do we?

"

the American school teacher employment system. If you've graduated from that system and paid at least a minimum amount of attention while you were housed there, you should know the basics of what's called the scientific method. You observe, you develop a theory, you test the validity of the theory. . . . Then, you test again to see if the first test was kosher.

The pioneering work done by Peter Senge at MIT (*The Fifth Discipline*, Doubleday, 1990) first suggested the five disciplines that must be undertaken if an organization is to become one characterized by continuous learning. As mentioned above, these disciplines include: personal mastery, shared vision, team learning, mental models, and systems thinking. The disciplines are sequential in the order that they develop, or illuminate, as it were, in the psychobehavioral development of the learner. In this, I believe that the sequential ordering of the five disciplines is a suggestion of how consciousness illuminates itself to a new reality, in a way that is very similar to Alvin Toffler's demarcation of technology development into waves, and Carl Jung's demarcation of the development of consciousness within the archetypal arrangement of the numbers one through five.

(STOP STOP STOP) is the title of a 1966 recording by the Hollies; it is also what the reader of this article needs to do right NOW. I want you to go back up to the last paragraph and reread the sentence about Toffler and Jung. Most librarians, I suspect, understand the reference to Toffler's "demarcation of technology development," as in, the second wave was agriculture and now we're in the penultimate of the third wave with the biotechnological fourth wave already crashing in upon us as the third rushes back out to the big technological splash from whence comes all waves. But, what about the symbology of Jung's numerics?

Why *(STOP STOP STOP)*? Because I must ask you to focus on the next to last paragraph (linear presentation) and I want you to consider that if this chapter were being written for the World Wide Web, you'd

probably find the stuff about Toffler's waves and Jung's numerics to be highlighted, thus representing a hot link (nonlinear) . . . so that as you read, you can play (push the hot button) play (push the hot button) play (push the hot button) instant learner whenever you come across stuff you don't understand. Dig?

Perhaps you are feeling that I have been rough on you, for I have expected you to know what librarians profess to know? If so, permit me to apologize by giving you at least five straight paragraphs of good old fashioned nineteenth-century linear narrative that should bring all the left-brained management types back to where I started when the little voice known as your cognitive-consciousness-buddy, aka yourself, started reading this chapter—if not, I've really missed my mark in trumpeting you all this jazz, and you are best left doing the waltz.

Here come the promised paragraphs.

Personal Mastery

Gail Sheehy, in her book *New Passages,* talks about personal mastery as being one of the first requirements to successfully enter one's personal second adulthood, a period which she posits to begin somewhere between the ages of forty-five and fifty-five. In Sheehy's scheme, the age of personal mastery is followed by the age of integrity.

Sheehy's stage of personal mastery corresponds with the personal mastery discipline which Shelley Phipps suggests as being a growth component for librarians who will begin the process of discovering new roles for themselves and the library profession. In a broad sense, the final discipline elaborated by Phipps, systems thinking, corresponds with Sheehy's age of integrity.

In the personal mastery stage, we find individuals who have learned to accept comfortably their own identity and authentication as a person and who have learned to respond situationally to ideas as opposed to responding to the emotional content that lies beneath the surface of any situation—good or bad. Personal mastery is characterized by an ability to "wait for the appropriate moment" to respond. Any manager who has attained personal mastery knows that the "appropriate moment" may be placed anywhere in time relative to the occurrence of a "situation." A word may be proactively spoken prior to the occurrence of a predicted situation, or, a word may be spoken during the moment of a situation because the object or the reason for needing to speak is right there, out in the open, ready to be addressed. Or, as we undoubtedly all know, some words that must be spoken are best left until the negative

emotions of a particular situation have subsided. Persons who have attained personal mastery have transformed their own passions into compassion for the people and situations with whom they are involved.

One way to think of personal mastery is to consider the quality to be a "management of one's self." This may be especially helpful for directors or department heads who have traditionally managed in a top-down control and goal-setting environment.

Shared Vision

The new technological environment is egalitarian. In less global-Internet-world-consciousness-developing times, we used to say that if folks didn't like a particular politician, policy, or process, they could "vote with their feet." Managers (incompetent ones, albeit) said stuff like, "If you don't like it, leave."

In twenty-first-century technologically oriented organizations, leaving isn't quite what it used to be. In twenty-first-century organizations, employers and/or management are actually encouraging employees to "leave, get out, shoo." I'm not talking about downsizing. I'm talking about companies that have recognized company-specific benefits in having certain sets, groups, or evolving work communities of employees do their jobs off location by telecommuting. Any library director who has worked with building construction knows that each public-service location added, each departmental workstation or office added means dollars. And, in a building project, these dollars add up to either cutting back elsewhere within the construction budget, making the project "cheaper" by foregoing the projection of future expenses such as furnishing improvements, or doing the marketing work of an innocent Oliver Twist by going back to the funding agency, or voters, and expending the political-trust capital required to ask for more.

What if your tech servicers workers were located at home, instead of in that expensive workroom (e.g., $125 per square foot)? Or, what if your "electronic services reference librarian" were not present in the library except via linked dedicated teleconference line between the library's "electronic reference desk" and the librarian's home office?

Here, experienced managers and/or directors of libraries may say, "Well, that's a cool idea, that's nice speculation, but in the first place, if I let staff go home and work, I'd have no control over what they do; my board, my voters, my whomever would never permit such a thing; and anyhow, this all sounds like a lot of work, and where can anyone show me that this is being done in libraries?"

As I contend, we, the library profession, are moving from a time period of about ten to fifteen years of rampant speculation concerning how new technology will affect our workplace, our service patterns, our future as a profession. Here, in this chapter, my purpose is to begin to suggest the formation of theoretical statements gathered from the flotsam of past speculative storms.

To have a worker go home and work, telecommute, however one wishes to describe this new space-time-person relationship among employer and employee, will require a tremendous amount of developed shared vision to be successful. As in traditional library service, the shared vision begins with a good ALA-accredited library school education. Like old-time radio transmission and reception, all components in the channel will need to be on the same wavelength, and because "transmitted communication just doesn't naturally happen all on the same wavelength," the process of working at home will require built-in transformers, conductors, amplifiers. Shared vision doesn't mean mindless "1984" groupthink—shared vision is the necessary ingredient required to have all residents of a new telecommunting work community be able to "see" the job and to "allow" the job to pass through their portion of the system (transformer, amplifier, encoder) without interference—or, as the old telecommunications gurus used to say, "Without noise in the channel."

Shared vision is a very important, very difficult step. The reason for its importance is summed up in the following comment from a hypothetical manager faced with having to let "Jack the cataloger" work at home via telecommute: "Why should this person get to stay at home and work when he wants to, when my home garden is going to weeds because I must be here working during the day?"

This brief made-up example shows us why personal mastery is the first step in the five disciplines Shelley Phipps urges upon librarians, and shared vision is the second.

Team Learning

Once personal mastery and shared vision have developed, team learning becomes one of the easier disciplines to master individually, but one of the more difficult disciplines to integrate into the evolving electronic workplace, or systemic thinking organization.

Early examples of team learning via Internet are illustrated by the early formation of newsgroups, discussion forums that are primarily e-mail based. Here, we have an individual learner signing on to a list

66

What is now most challenging is to create a deliberately formed learning community within the workplace so that team learning can happen and be used as a catalyst to increased productivity.

99

service, reading a newsgroup about a topic that, presumably, is of prior interest to the learner. How many reference librarians have signed on to "Stumpers-L" primarily because they are reference librarians?

This concept of an individual using the Internet for gaining information or electronically participating in an interest area should be easily understood. Folks who like NASCAR racing talk to other NASCAR racing fans, and so forth.

What is now most challenging is to create a deliberately formed learning community within the workplace so that team learning can happen and be used as a catalyst to increased productivity. And this too is a great challenge, because here, the only prior interest brought to the process by a participant team learner may be concern for keeping his or her job, or keeping the boss happy by "playing along" with this new-fangled electronic toy. I mean, isn't the boss just resume building with all this Internet stuff, anyway?

In a minute, I will give brief consideration to the disciplines of modeling and systems thinking. First, let me mention that if you've ever had the hankering to try your hand at writing a library management book or article, the concept of deliberately formed learning communities in the workplace is a gold mine of writing topic possibilities. Such topics include: the evolving definition of team; the evolving definition of a manager as being one who is a continuous learner and who thus is by necessity a simultaneous leader and follower of managed employees; the evolving definition of what combination of time when, space where, process how, product what, constitutes a unit of work. And, for my own particular interest and for the purpose of making sense of the title of this chapter, the evolving definition of "what it means to be able to read."

INTERMISSION

See the magazine *American Prospect*, March/April 1997, "Seeing Through Computers: Education in a culture of simulation," by Sherry Turkle. One brief excerpted sentence should whet your appetite for reading the entire article (pages 76–82): "I think of this new criticism as the basis for a new class of skills: readership skills for the culture of simulation." (*Elongated intermission:* After reading the Turkle article, take time to listen closely to Peter Gabriel's recording, *Games without Frontiers*.)

Before providing a brief illustration of how team learning is evolving as a result of the Internet and developmental intranet communication capabilities, I want to reemphasize that the phenomenon of team learning as we currently see its evolution has predominantly resulted from the random confluence of similarly interested persons who are Internet connected and who, having found a common locus of connectivity, have congregated with one another, thus building the twenty-first-century community grouping.

Schematically, this early random evolution of nascent learning communities can be likened to the formation of planets in a solar system—floating (surfing) dust, rock, and gas become attracted to a point of dense gravity, and planet (electronic community) building begins.

Randomness, unfortunately, except in a phenomenological sense of "constant recurrence," does not lend itself to "cookie-cutter" replication and is thus not particularly useful in the workplace. That is why, to restate myself, "What is now most challenging is to create a deliberately formed learning community within the workplace so that team learning and increased productivity can happen."

What is the breadth of team learning? Let me give you an example of team learning in which one of my business partners, Ken Bell, participates. Ken is a marketing guy; he's also a network engineer and a programmer. Ken regularly visits several commercial server sites which are frequented by users, programmers, sales reps, company service techs, and plain old kibitzers and buffs. The ancient (a year or two ago) origin of such sites is generally nothing more than an e-mail address for the service and/or comments department of company X.

In any event, while it may be that the "learning group" to which Ken belongs evolved from a random "happening," or conglomeration of net surfers looking for similar product information, the purposeful learning which presently happens because of the group's coalescence is multifold.

Certainly, relative to traditional classroom or seminar learning experiences, the evolved learning community is no longer composed of a homogeneous group of individuals who are acquiring previously agreed-upon and similar knowledge, skills, and appreciations. Each participant comes to the table (or forum or classroom or chat room) with a different set and level of knowledge and expectations. The resulting exchange of information embodies the ground level of a team learning process that Shelley Phipps has envisioned for library practitioners who are seeking to discover a new professional role.

Mental Models

Mental modeling, or visualization, is not a new management activity. Nor is the practice of mental modeling a new psychological insight technique. Historically, though, mental modeling has been a planning and visualization technique of the individual thinker. Applied by the individual thinker, mental modeling allows the planner to engage in playful permutations of an idea, accepting or discarding ideas with a fluidity not possible in "reality."

Today, using interactive virtual reality applications, mental modeling can be accomplished as a group-held vision with the result that stakeholder groups such as staff, board, and a variety of both traditional and nontraditional partners can be brought into the development process with immediacy. Groups that have accomplished a shared vision and are engaging in shared mental modeling can beneficially practice a new planning technique known as "fast failure."

Although not specifically identified as such, the use of fast failure as a success technique is conceptually implicit in Andrew S. Grove's book *Only the Paranoid Survive* (Doubleday, 1996). Grove, who is president and CEO of Intel Corporation, also provides wonderful real-life examples of personal mastery and team learning during periods of great challenge and change.

In many respects, mental modeling is a way of making the dream come true.

Systems Thinking

Systems thinking benefits an organization by increasing the vision and scope of possible choice.

Successfully applied systems thinking has a traditional management result: The organization grows, resources increase, and services are either enhanced or added to meet the identified needs of clientele.

The failure to apply systems thinking successfully means that the organization is spending what business economists call "opportunity cost." Simply stated, opportunity cost says that "if I spend my five dollars on a bag of toffee, I no longer have the opportunity to spend my five dollars on chocolate-covered peanuts." In any purchase or choice, opportunity cost is spent. The question for library managers, of course, is how to most effectively spend this "ability to choose."

───────────────── **INTERMISSION** ─────────────────

A circle inside a circle is a square. We are standing in front of Arthur C. Clarke's great black monolith while assuring ourselves that stone-age builders must have had the help of von Daniken's space folk to construct the great trilithon circle on Salisbury plain. I believe that there is a sixth discipline, that which is represented by the words "Plus One" in this chapter's title. The sixth discipline is a developed ability to read and think in terms of interactive virtual reality web publishing which is just now beginning to take place. Or, as Sherry Turkle might put it, "Reading skills for the simulation culture."

ACT III

The Future

Usually, the final act is when the curtain is drawn down. I've chosen the theatrical motif as a way of presenting information in this chapter because I want you to conclude your reading experience in a way similar to that wished for his audience by Bertrolt Brecht. I want you to think as you leave the theater . . . and perhaps, I want to fool you into thinking that it's actually raining, when it isn't. I want you to leave the theater and wonder if that woman hailing a cab on the street corner is really just a woman, or is she an actress, and in actuality, a continuation of the play.

The ability to successfully read "Plus One" pages, script, or whatever we'll end up calling the newest of the new electronic publishing, will necessitate the development of an ability to engage in "organized nonlinear" thought.

I personally believe that this development will occur only after a critical mass of persons have gone through the first three steps of the

five disciplines. This is why the information I have provided in the chapter relative to mental models and systems thinking is scanty. We aren't there yet—"we've only just begun." That is the irony.

And so, here, at the end of the play, does the curtain come down, or does the curtain rise? The same Master once said to "Catch the steaming teapot . . . catch it in the delicate web of your fine imagination." I believe that the curtain is rising.

Technology
Serves

The Lessons of Client/Server Automation in a Climate of Organizational Change

■ ■ ■ ■ ■

JOSEPH LUCIA

The move toward "client/server" systems that has characterized the last several years in the library automation marketplace reflects a common perception that this relatively new computing architecture brings with it benefits of increased productivity, flexibility, cost effectiveness, and greater user autonomy. This significant change in library automation technology is occurring at a time of substantial organizational upheaval in many libraries. The pressures resulting in these upheavals are at once economic (typified by reduced budgets and contracting staff sizes) and strategic (typified by a changing understanding of the nature and scope of libraries' organizational missions).

This environment of technological and organizational "co-evolution" is epitomized by a number of recent events at Lehigh University. Lehigh was an early implementor of the client/server version of the SIRSI Unicorn system. In addition, within several months of that SIRSI implementation, Lehigh's library and computing center underwent a strategic planning and restructuring process that resulted in merged services and redesigned work flows and work processes in all areas of our operations. A complete account of this process may be found at http://www.lehigh .edu/~inluir/irdocs/reorgtxt.htm.

JOSEPH LUCIA is the group leader for information management services in the Information Resources organization (comprising libraries, computing services, network support, and telecommunications) at Lehigh University in Bethlehem, Pennsylvania.

Lehigh: The Source

Lehigh University is a medium-sized "national" university (~4,200 undergraduates, ~2,000 graduate students) with historical strengths in engineering and business education but with a prominent and growing College of Arts and Sciences. The institution has a solid history of technological innovation within pragmatic constraints, meaning that major projects on the campus are typically designed to reach the largest possible constituency rather than to pilot or test cutting-edge applications and developments. The university's current strategic plan embraces computing and information technologies as a means to facilitate the development of "learning-centered" programs at the undergraduate and graduate levels. In this context, the Lehigh library has been a consistent but judicious early adopter of automated (and networked) information systems and services for well over a decade. Also in this context, the recent integration of all computing and library operations within a new Information Resources organization is intended, first, to strengthen the connections between the university's technology and information infrastructures and, second, to make possible better management and more innovative uses of the university's information and educational technology assets.

How We Chose Our Systems

In early 1994, as we prepared to go to market to replace our soon-to-be obsolescent Geac 8000 library system, we had a number of guiding principles. We wanted to find a system that would be more than an "updated" version of our existing applications; that would, in other words, provide us with a more flexible and open automation environment by such means as a scalable hardware architecture, a "standard" operating system (UNIX), and support for a variety of emerging standards and protocols (for example, Z39.50). We wanted to use the increasing power of the PC to enhance functionality and ease of use in the new system. We wanted to integrate the library systems environment with the overall desktop computing environment at our institution. We wanted configurability both at the system level and at the level of the individual workstation. We wanted to achieve something resembling device- and location-independent access to our new system by utilizing the expanding network infrastructure on our campus. And, finally, we envisioned our new system as a means for integrating access to the emerging realm of Internet-based resources and services. These factors,

taken together, pointed us in the direction of a client/server architecture, though at that moment in time there were few systems of this sort on the market. There was, in fact, a significant level of skepticism among automation experts regarding the applicability of the client/server model to library systems. Richard Boss, for example, remarked that "Very few libraries have a compelling need for client/server other than requiring Z39.50 for linking with other systems" in his study "Client/Server Technology for Libraries with a Survey of Current Vendor Offerings" (*Library Technology Reports* 30 no. 6 [November/December 1994], 703).

Following a complex and delay-ridden RFP and product review process, we elected in early spring of 1995 to implement the SIRSI Unicorn library system.

Infrastructure

The first hurdle in bringing up a client/server system is assuring that you have adequate computing power at the workstation level to comfortably run the client software and also that you have a flexible network environment with the capacity to exceed throughput demands at periods of peak use. Getting the desktop and network resources in place and keeping them operational requires a significant long-term commitment of technical staff. The gains made in system functionality and flexibility are often offset to a great degree by the management burden of a significant increase in the complexity of the overall system architecture. (For a brief analysis of technical support and cost issues, see the Boss article cited above.)

Because of some difficulties in our system selection process, our initial system implementation timetable slipped by a full calendar year. We were able in the intervening period to achieve pervasive network upgrades (increased capacity, increased connection points) of all public and staff areas in our library facilities, to develop significant expertise in network administration and LAN management, to establish a baseline for desktop PC configuration and to upgrade public and staff machines incrementally to that level, and to encourage our more retrograde staff members to begin working in a graphical computing environment—this was 1994–95, and we still had some folks resisting the move from DOS to Windows 3.1.

One of the ironies of the client/server environment is that, in the name of technological flexibility and "staff empowerment," it's often necessary, initially at least, to enforce a certain level of uniformity in the way your staff accesses computing resources and in the way their

individual PCs are configured. When you introduce network configuration and LAN account administration into a computing environment, uniformity is critical to efficient system management. At Lehigh we achieved this end by consolidating all critical office automation applications (word processing, spreadsheets, databases, etc.) on a new LAN server that was accessed by all staff from a uniform Windows-based menu.

As we prepared to implement SIRSI, we had in place a reliable network, adequate power at staff and public workstations, and a staff with a recently developed familiarity with Windows and graphical PC applications.

New Skills

Rather than review here our conversion and implementation procedures, I will focus first on preparing staff for such a change and then on some of the initial benefits of that change.

While less an issue in 1997 than it was in 1994, it remains critical, as suggested above, that as broad a cross section of your staff as possible develop substantial experience with the PC system operating environment in which your client software will run. For us, this meant a year-long process (going back to 1994) of in-house training sessions in MS Windows and a variety of Windows-based applications, which we were able to couple to the implementation of a new LAN server and, concurrently, to the upgrading of the PCs on most staff members' desks. It's certainly worth noting that such wide-scale equipment upgrades go a long way toward bolstering staff eagerness to embrace the move to a new library system. In addition, an upgraded PC on someone's desktop often encourages a self-directed discovery of features and functions that represents important informal "skill building" for the new system. This brings up a related point, which is that in any organization you will find individuals with widely varying computing skills and widely varying abilities to acquire such skills on demand. Furthermore, computing abilities, skills, and willingness to learn are rarely congruent with staff "levels." It is, in fact, often the case that curious and motivated "support staff" members become the computing experts or resource people in their departments or work groups. Bringing these folks into the process in some official manner, by designating them as "local experts," or the first point of contact for Windows or applications problems, helps greatly in the development of a flexible support structure for a new library system. It is, after all, likely to be the case that

❝

It is often the case that curious and motivated "support staff" members become the computing experts or resource people in their departments or workgroups.

❞

these same individuals will be leaders in learning the ins and outs of the new library system.

As is implied above, one of our primary goals for client/server was the integration of the system interface with the desktop (Windows) computing environment, thus enabling staff to take advantage of some of the productivity and ease-of-use features inherent in graphical applications. We also expected that these same features would facilitate the streamlining and convergence of processes in a number of areas. Though these are distinct effects of the new system, they are directly intertwined with some of the concurrent goals of the organizational restructuring at Lehigh. Though we did not envision this coupling of new technology with organizational change at the time we selected the SIRSI system, the functional gains realized by the new system served as catalysts to our redesign of some key work processes.

Basic Gains

In our experience, the immediate benefits of client/server at the staff desktop fall into three categories: functionality gains, customization, and skill "cross-fertilization."

Functionality Gains

As distinct from terminal- or terminal-emulation-based systems, graphical client/server environments typically support multiple ways of doing particular tasks, which in our case include pull-down menus, programmable function keys, and user-configurable icon panels and control bars. Increased efficiency here is the direct result of staff being able to select the approach to their tasks that they find most intuitive and easy

to manage. Graphical client software also supports "cut and paste" operations within and between applications (making it easy, for instance, to grab a piece of data from an OCLC session and drop it into a local system cataloging record), rapid task switching between related activities (acquisitions, cataloging, and serials functions, for instance) or related applications (a local cataloging session and an OCLC or Z39.50 session). And though it's not an effect of the client software itself, the upgraded hardware infrastructure results in concurrency (and redundancy) of key functions across all staff desktops (e.g., you no longer have specific machines or terminals dedicated to a single activity such as label printing or OCLC searching) and you typically are also able to perform multiple functions (library technical processing, spreadsheets, word processing, Web surfing, e-mail, etc.) at any individual workstation. There are, of course, some negatives in this new environment, most notably that some functions and procedures in graphical applications may be slower to execute than in a terminal-based interface. I suspect, however, that such inefficiencies will be remedied as graphical client software matures over the next couple of years.

Customization

There are two dimensions to customization at the desktop. The first and perhaps most operationally significant is the ability for staff members to control the features and functions of the client software itself: which menus or icons are used, how various services are accessed, which functions and commands they default to in various places in the system. Though perhaps not of major significance, this flexibility at the very least enables users to feel that there's some "give" in the system, that it is capable of supporting their individual work patterns and preferences. In a related manner, the graphical computing environment invites a certain amount of workstation personalization by such means as "wallpapers" and backgrounds, color and sound customization, screen savers, and unique icons. Allowing such freedom to the individual staff member provides some sense of control over the work environment. Doing so, however, is not without its risks: letting people bring in software from home or pull it down off the Net carries with it many security risks.

Skill "Cross-Fertilization"

In this area, it's actually the integration of the client software into the staff desktop environment that has the greatest impact. Because of customization capabilities, staff members develop a greater sense of ownership of their PC environment. Beyond this, increased local control of computing resources accompanied by increased complexities and capa-

bilities in graphical operating systems and applications mean that staff often interact to answer functional questions and to solve basic problems. One result is an increase in staff alliances and staff friendships structured around the development and sharing of new skills. As implied above, it's frequently support staff who take leadership in learning and thus who also initiate such cooperative activities, either because they see opportunities for job growth and skill development or because they find that tinkering with new technology alleviates some of the tedium of more routine sorts of work. In our case, this task and knowledge sharing also paved the way for the breakdown of boundaries between previously distinct areas of activity, such as cataloging and acquisitions, as staff in these areas worked together in bringing up the new system while simultaneously merging some processes and procedures.

Distractions

Embedding library systems functions within a broader graphical computing environment is not an unalloyed blessing. The networked Windows PC is a box full of snazzy toys: Web browsers, games, multimedia packages. It presents the user with a self-contained "hyperworld" and with an experience of feature overload. In this light, the line between "work" and amusement can get rather blurry, even in terms of the "look and feel" of tools versus toys. The line between home computing and work computing can itself become indistinct, especially in the era of telecommuting. Work and play happen in the same virtual space.

Decentralize, and Make It Better

In the context of work task redesign at Lehigh and in light also of a long-term shrinkage of library staff, one hope we had for our new library system was that it facilitate the decentralization of many of the operations and functions that were performed in the past by the Library Systems department. Client/server architecture provides a means to this end in many cases: first, because it's typically built around standard networking protocols that enable high-speed data transfers and output (for record loading, database updates, and report printing) at a multiplicity of locations and, second, because sophisticated graphical interfaces can help library staff do basic system policy configuration and report generation without the intervention of a trained operator. Transferring operational tasks to the departments with direct needs was the only way we could stretch our limited support staff to handle the new demands of our environment, such as network configuration, UNIX

system management, World Wide Web service design and development, and desktop support.

In this regard, again, the system put us ahead of the curve in relation to the imperatives of our reorganization. All database loading activities now occur at the desktops where acquisitions and cataloging take place; in most cases, new bibliographic data is moved into our system daily by support staff as a standard part of the ordering or copy cataloging process, using utilities invoked directly through the client software. Using similar utilities, it is now also possible for staff to make global database changes, to review and adjust indexing and authority control parameters, to view and change other system parameters when necessary, and to generate any required system or database statistics. We do, of course, provide consultation and support for such activities, and we allow access to these utilities only by staff who have the technical knowledge to use them appropriately. But such tasks no longer intrinsically require a dedicated operator or systems consultant. Staff are now also able to configure, schedule, and print or download any bibliographic or analytical reports to which they have authorized access. Equally as significant, all regularly scheduled system output—book orders, overdue notices, claims—is monitored and printed within the functional unit where that service resides. In effect, we no longer require a computer operations function, because database backups, too, have been simplified and automated.

One of the critical changes in the "library" side of our organization brought about by the recent restructuring was the merger of a number of previously distinct technical processing units (acquisitions, cataloging, government documents, and serials) into a single "cross-functional" Information Organization team consisting of a very small number of professional staff and a large cadre of support staff. Support staff are being cross-trained within this new team to perform basic tasks in all of the functional areas. Moreover, the previously existing distinctions between acquisitions and cataloging activities are eroding rather rapidly.

It is primarily the functional flexibility of our new client/server system that has enabled us to retool and merge operations so quickly. Our redefined work flows are built around preselection of catalog copy from OCLC by support staff and subsequent copy cataloging refinement without resort to paper prints (achieving a single point of work). As a result, we've achieved a fairly complete convergence of acquisitions and cataloging functions, with the benefit of immediate access to high quality bibliographic data by all staff. There are some burdens of this approach. It requires new skill development for many staff members to assure a high quality of input to our database. It is also the case that some of the capabilities we've been promised by our vendor have not

yet been delivered, thus, in effect, impeding some proposed organizational changes that depend on those capabilities.

But Some Things Are Harder

It would be foolish to claim that client/server library systems have no major deficiencies. Some of these have been hinted at above, but it is worth reviewing them explicitly. They present a number of problems, specifically with respect to staff impacts, system support demands, client software distribution, and infrastructure dependencies.

Staff Impacts

Client/server systems make a number of real demands on staff. First of all, they require that everyone function in a much more complex desktop computing environment. Though productivity gains can definitely be realized with such technology, the skill set of the basic system user must be a broader and deeper one than that required in the context of host-based "dedicated terminal" systems. It is necessary to invest time and money in training staff in a wider range of computing skills if one hopes to maximize the advantage of client/server over earlier system technology. Additionally, staff activities are tied more directly than ever before to the power and reliability of the desktop PC. Failure to support and upgrade this basic resource will reduce the amount and quality of the work people can do.

Beyond technology, there are other impacts, most significantly a large (and possibly ongoing) series of procedural changes that can result in reconfigured work groups, redefined jobs, and reduced staff numbers in certain areas. Such changes can greatly enrich the work lives of eager and flexible staff members who are comfortable in a dynamic environment, but they can also traumatize and alienate steady producers who want to work in a stable, predictable setting. Managing this dimension of the technology/organizational "co-evolution" process requires a great deal of sensitivity and supportiveness on behalf of line supervisors and operational managers. There are no manuals that come with the system to explain how to do this.

System Support Demands

My earlier remarks on the move away from centralized operation support to a more distributed mode of system operation belie the intractable reality that client/server computing environments are often monumentally complex, in spite of the fact that it's easier to accomplish certain

basic tasks than in host-based environments. The need for systems support doesn't go away; instead, it gets reoriented toward configuring and optimizing the required networking infrastructure (which is typically a higher-level skill than that required of a system operator), configuring and supporting a proliferating and complex desktop environment, and dealing with many software and operating system complexities on both the server and the client sides of the system. Much of a system's flexibility and configurability result from a detailed "applications programming interface" that allows users to tailor applications to local needs. Complicating this picture further is the reality that "open" client/server systems are usually built around protocols (such as Z39.50 and HTTP) that demand a very high level of technical competence if they are going to be exploited in unique ways in a particular institutional environment. There are no simple solutions to meeting these new demands. Staff reallocations are one possibility. Developing staff expertise at the functional unit level to provide a strong "bottom layer" of the support system can also be a creative way to meet the need. But don't expect to reduce system support activities. They can be restructured, distributed, and/or merged with other functions (network support, desktop support, Web support, etc.), but that's about the most you can hope for.

Client Software Distribution

One of the impediments to implementing client/server systems that is difficult to anticipate beforehand is the need to distribute and maintain the currency of client software on a large number of machines at a variety of locations within an organization. This requirement is typically compounded by frequent software version changes at various times in the software life cycle, by the reality of heterogeneous desktop computing and LAN environments in various corners of an organization, and the reality of multiple loci of responsibility for the support of the aforementioned diversity of desktop and LAN environments. And though there's been a lot of talk about client/server systems in the trade press, they are not, in fact, widely deployed on an interdepartmental basis in many university settings, which means that the people who typically support network end-user PC environments have little experience with or understanding of the actual demands such systems make for configuration uniformity and for ease of software updating. In effect, secure, tightly controlled LAN environments are often not very client/server friendly. Technical support staff outside of the library itself may not be immediately sympathetic to the suggestion that they adjust their LAN management and desktop configuration procedures to support your new system. They may just ignore you and hope you'll go away, unless you can invoke some higher authority. And that gets at

another organizational issue, which is the need for coordination between various computing support units to make client/server implementation proceed smoothly. This is one of the activities that has been greatly facilitated by our merger of library and computing functions at Lehigh.

Another issue that can emerge with respect to the support of client software is its suitability for LAN installation (which is in most cases the best approach in terms of efficiency). Not all vendors will support such configurations, typically because it's far more difficult to provide easy approaches to end-user client customization in a LAN environment. So it's important to understand in detail how your client package needs to be configured—what pieces of it can be shared from a server and which pieces have to be unique to a particular user's setup.

Other areas in which client software problems can arise include off-campus access requirements—users who want to use the client from home will require some support in getting it installed and appropriately configured to connect via PPP, for instance. Sad to say, this is not something you want to spring on that anthropology professor who's all thumbs with his PC but who loves the new catalog and is eager to be able to use it from home.

Because distributing and supporting client software can be such an onerous task, you may find yourself dealing with multiple interfaces, such as a text-based terminal interface for dial-in users and users with underpowered workstations on campus. Rest assured, this will not make your public services staff very happy.

Infrastructure Dependencies

Implicit in my remarks about support demands is the fact that there are more pieces to client/server and therefore more points of potential difficulty. You need strong coordination between technically competent people to get a client/server system running in any sort of large-scale implementation. Just to be explicit, let me enumerate the components: in a host-based system you've got a central machine, some interconnection mechanism (typically, dedicated cable or phone lines), and a simple terminal on the user end; in a client/server environment you've got a central server (or server cluster), a network (which involves routers, concentrators, wires, and transport protocols), a desktop workstation (a complex computer in its own right, with lots of applications and local devices), and client software (which interacts with both the server and the desktop machine). Now it is the case that contemporary computing hardware is many orders of magnitude more robust and reliable than the technology of host-based systems. But such complexity requires careful, systematic management. That is an unavoidable necessity.

Technology "Drift"

In a computing environment where the configuration of the desktop machines that run your client software is likely to evolve through several generations of technology during the life of your client/server system, you will invariably have to deal with a moment when what's running on the desktop presents problems for your system. For us at Lehigh this happened within six months of our initial system implementation. Windows 95 was implemented on a wide scale on our campus late in the 1995–96 academic year. This change introduced new bugs in our client software and subsequently, because of major configuration difficulties, completely stalled our efforts to distribute the software to LAN servers and offices around campus. This hampered user access to our system and resulted in an ad hoc decision to substitute what was at the time a functionally inferior Web interface to the catalog as the only manageable alternative, much to the chagrin of public services staff. This particular fiasco occurred just as we were beginning our merger of library and computing operations and pointed up a crucial need for coordination in relation to new software and infrastructure deployment.

What We Learned in Public Service

Our public services staff learned some important lessons. First, from a public-service standpoint, system selection and implementation planning had been based on features and characteristics of the graphical client software, but because of unanticipated distribution difficulties, that interface was not in place for all users. Second, the graphical interface presents a functionally rich environment that libraries are able to exploit easily, but rich system capabilities embedded in such interfaces are often difficult for users to access. Third, and perhaps most disconcerting, public services staff confronted a need to support multiple interfaces (the graphical client, a Web interface, and the text interface), which presented documentation difficulties and which also quite clearly confused users, who wondered if they were looking at the same system. Public services staff themselves were often confounded by rapid version changes in the client software (for about three months after initial implementation, there was a major version change every couple of weeks). They became increasingly aware of a trade-off between functionality (lots of bells and whistles) and usability (straightforward access to powerful basic search options) and found that, in this light, new, highly desirable "features" (as seen by library staff) can in fact be substantial

66

The graphical interface presents a functionally rich environment that libraries are able to exploit easily, but rich system capabilities embedded in such interfaces are often difficult for users to access.

99

impediments to users, who typically prefer simplicity to a confusing array of choices (one has only to look at the current wave of Web search engines to verify this insight).

Managing Client/Server

Though client/server systems are widely touted in the computing industry, their implementation in complex, heterogeneous university environments is proceeding rather slowly. Here are some points to remember:

- There's not a large pool of experience to draw on for supporting client/server systems.
- There are organizational impediments to overcome, such as getting the various parties who support networking and desktop computing at your institution to understand your needs and to commit to your project.
- There are substantial infrastructure roadblocks, not the least of which are significant differences between LAN and desktop configurations across departments, sometimes even within a single computing services organization.
- There are competing and more easily managed technologies, such as Web-based interfaces, that will be seen by many people (often including those managing the technology) as acceptable substitutes for dedicated client software that remains, at the present time at least, more powerful and functionally robust.
- Quick solutions (text and Web interface alternatives) become the default choice, because there are simply too many difficulties

involved in wide-scale deployment and support of dedicated client software.

- ▪ The potential for local customization and control of the system is far more difficult to realize in actual practice than the system architecture in the abstract leads you to believe.

I don't make these points to undermine the value of this technology. It is very powerful, and it can effect significant changes in the way we do our work, as I hope I've demonstrated, with some of the examples I've presented above, in relation to its role in supporting work reorganization at Lehigh. But the difficulties need to be understood.

In light of some of the difficulties we've experienced at Lehigh in implementing and supporting a client/server system, I want to suggest a number of things that can make the support of client/server a far easier undertaking.

- ▪ The adoption of a "network-aware" approach to client software that enables intelligent installation of shared components on a central server and the copying of key configuration files to a writeable "local" drive or file space.

- ▪ The development of automatic "server-side" version control so that whenever a user initiates a session with outdated client software, an automatic transfer and reinstallation takes place, preserving or regenerating in the process the user's personal configuration options.

- ▪ The establishment within computing management organizations of systematic and consistent desktop configuration and support services. (This is something we are currently attempting to achieve with Information Resources at Lehigh.)

- ▪ Following from the above, the adoption within computing management organizations of common LAN models that allow for uniformity of software installation even in large-scale situations. (Again, this is something we are hoping to achieve in Information Resources at Lehigh.)

- ▪ The gradual shift away from "installed," platform-bound client software and toward the integration of "client" functions within more generic interface environments (such as Web browsers) via the use of Java and other emerging software tools.

Moore's Law and
Future Library Technology

■ ■ ■ ■ ■

ANDREW WOHRLEY

The cover of *Wired* magazine for January 1997 displays the baleful neurotic red eye of HAL, singing "Daisy" and announcing his birthday as January 12, 1997. The film *2001: A Space Odyssey* came out in 1969, and comparing the world of 1997 with the world that *2001* anticipated illustrates the hazards of forecasting the development of high technology. In *2001*, one computer could reason and go mad, act alone to accomplish a mission, and program itself. Today, computers operate together, do what they are programmed to do (not to say that they always do what programmers want!), and occasionally drive humans crazy. While Clarke and Kubrick created great art in *2001*, they were off base on their science and technology prognostications.

In forecasting, caution is in order. The only reasonable way to extrapolate the advance of technology for libraries is to identify fundamental principles and base predictions on these principles. The most appropriate bases for this discussion are Moore's Law, the continuing increases in bandwidth, and the decrease in the cost of memory per byte. The principles that have guided the development of the Internet include flat-rate pricing and the fusion of all forms of telecommunication to the Internet. The final trend that will be discussed is the democratization of information. It is an axiom that technology cannot be better than the people who operate it. Therefore, all the technology trends discussed assume a librarian at the helm who maximizes the value of the technology.

ANDREW WOHRLEY, a contributor to the *Cybrarian's Manual* (ALA, 1997), is a librarian at Auburn University. He may be reached at wohrlaj@lib.auburn.edu.

It All Starts with Moore's Law

Moore's law is the most important law in discussing the advance of computer technology. Gordon Moore, a founder of Intel, stated that the number of circuits per unit of area doubles every eighteen months.[1] However, Moore's Law is less a physical law than a rule of thumb, and some observers (including Gordon Moore himself) contend that its validity will soon end.[2] However, since Moore's Law has lasted this long, expecting that it will continue to be true seems reasonable. Using Moore's law, the number of circuits per area should be more than four million times greater in 2020 than today!

The possibilities provided by such an advance in technology are endless, with faster catalog and database searches and more powerful automatic indexing tools being just a few of the more pedestrian possibilities. More exotic possibilities include automatic translation of all transmissions, whether text or audio. When these possibilities happen, librarians will shift more to being managers of media than organizers of information. The computer will slowly take over more of the functions that librarians have traditionally held, freeing librarians to concentrate on providing better service to their customers. The day when a computer can analyze text and catalog it accurately no longer sounds as remote as it used to. An artificial intelligence or expert system that conducts a reference interview and then calls up resources that answer the patron's problem is also more than just a possibility.

To keep up in such an environment, the need for continuing education is obvious. Librarians will begin their careers using one type of technology and will end their careers using another one entirely. Look at the recent past, where MARC (Machine-Readable Cataloging) records started in the sixties, OCLC began admitting libraries outside Ohio in the seventies, the personal computer rolled out in the eighties, and as the nineties close, the browser wars are in full swing. Library schools are now instituting Master of Information Science degrees to give their students the skills that they need to use information technology. However, such a degree must be recognized for what it is—a degree that will be obsolete in a few years. The librarian must be prepared to go through his or her career as in some sense a part-time student forever. Libraries must invest in the education of their employees so that they can remain the masters of technology.

Changes in technologies and services require new skills, and no one is willing to bet against more change in the future. The advance of technology provides more information to the user, provides it more quickly, and provides it more conveniently. Occasionally one hears cries for

bringing back the card catalog, but the death of the card catalog is as real as the death of penmanship classes in library schools.

More Bandwidth!

The amount of bandwidth available for Internetworking has increased at incredible rates. In 1987, 56K was considered a roaring start to the NSFNet backbone, while in 1997, thoughtful observers question if 288M is adequate for demand and some universities are looking at an "Internet2" with 622M/sec bandwidth.[3] In 1987, FTP (File Transfer Protocol), Telnet and e-mail, along with certain high-performance computing applications, made up the bulk of network traffic. Today, along with those three applications, there are now IPhone, CUSeeMe and Java, among other network applications, demanding more bandwidth. The increase of more than 5,071 times in a decade does not measure the redundancy of the high bandwidth lines, nor does it measure the growth of the Internet to areas that did not have it previously. If anything, these measures undercount the growth of bandwidth. While demand shows no sign of slackening anywhere anytime soon, bandwidth supply should be able to keep up with the demand.

The amount of bandwidth available to the consumer is going to take a quantum leap when the "last mile" between the network server and the home is finally bridged with megabaud network bandwidth. Phone companies and cable television companies are looking for any competitive advantage that they can find, in order to be the ones installing that final mile and reaping the profits. The last mile is probably the major technology revolution on the horizon. Even with a 33,000 baud modem, text is about all the technology can handle, but with megabaud access to the Internet, moving graphics become possible. The possibility of greater Web activity will require greater bandwidth on the backbone lines that carry the packets around the world.

Already, software like Java applets and devices like the new NetPC count on the availability of large amounts of bandwidth. The NetPC as currently described is a keyboard, chips, and a network interface designed to act as an inexpensive client station. Up till now, libraries have been willing to pay for a complete microcomputer and then just use it as a dumb terminal. A NetPC is a dumb terminal by design and priced accordingly. While it remains to be seen whether the NetPC will gain broad market acceptance, it appears to make a good fit with what libraries need in an online catalog/Web browser.

Memory!

While cheap memory is almost taken for granted, it is critical for electronic libraries. Without cheap, dense, quickly readable data, Internet searches will bog down quickly and render the Internet unusable. Librarians often fail to consider memory because it serves our purposes quickly and reliably; the only problem most people can identify about their computer's memory is that it doesn't have enough. The decrease in the cost of memory is particularly impressive considering that a decade ago 20 megabytes of memory was good for a home computer, while in 1997, 1,600 megabytes of memory is considered to be just keeping up.

Memory can be stored on a variety of media, from drives to chips to laser discs. Memory chips, like CPU (Central Processing Unit) chips, follow Moore's Law and the chips of today have 256M memory, compared to the 1M chips of 1990.[4] Networked sources, tape memory and laser-read memory storage (laser discs and CD-ROMs—Compact Disc–Read-Only Memory) should be adequate in the future for the demands of users. Future developments in optical disc technology should include layered and multispectral disc storage. All of these advances in memory, and other advances almost unimaginable today, will not only allow more memory, but will provide faster access to the information online.

The problem with all memory technology is the threat of obsolescence as new hardware replaces old hardware, and the data that the old hardware used to read becomes unreadable and is forgotten. Libraries must counter this problem either by insisting on backwards compatibility between new hardware and old data formats, or by planning for the cost and time involved in converting old data formats when planning new hardware purchases. Technology that was dearly bought and on the cutting edge of technology yesterday, has become today's obsolete bargain. Under such circumstances, it becomes even more important that care be taken when making hardware replacements; otherwise, the data will be lost.

What Is IT Worth?

Related to the growth of bandwidth is its cost. Flat-rate pricing is very controversial because it seems to subsidize waste while providing little incentive for increasing bandwidth. Despite this criticism, flat-rate pricing remains popular with most categories of users because it allows them to predict accurately how much they will be billed for usage; anticipating that flat-rate pricing will remain the standard into the

future seems reasonable. While customers have a variety of Internet service providers (ISPs) vying for their attention and money and the environment remains competitive, users will probably have the option of flat rates. ISPs have become skilled both at predicting future demand and at setting flat rates that allow them to recoup their operating expenses and to invest in improvements to bandwidth. Recently, America Online has had trouble meeting demand, but this does not appear to be a permanent condition inherent in the technology that AOL uses; rather, it seems to stem from an error in anticipating demand. In contrast, other services, including those that offer flat-rate pricing, are meeting their customers' demands for service without outages.

Charging for use has some attractions, but in application, it is hard to see how the Internet would be much different from what it is today. Users, though, would be monitored under a much more intrusive system than currently exists. On the other hand, some technologies, such as videoconferencing, might benefit from charge-for-use rates because of the major bandwidth requirements inherent in transmitting audio and video in real time. If one considers the Internet a utility used to find information, charge-for-use makes sense. If, however, the Internet is a space in which one exists, flat rates are better.

Data Fusion

The fusion of all telecommunications is potentially the most powerful change that the Internet will bring to libraries. Up till now, telecommunications technology has had a box associated with each major means of communication. Television is a box with a cathode ray tube (CRT). Radio is a box with a speaker. The telephone is a box with a handset connected by a cord. All these boxes have had their own associated analog technology that has divided them and prevented them from being considered together. The Internet is beginning to smash the old way of thinking about telecommunications by making it possible to send visual data, audio data, and person-to-person audio communications over the same channel.

New packet-switching technology moves bits from place to place in ways that are different from the old analog channels, yet with better signal quality. Nicholas Negroponte, the founder and head of MIT's Media Lab, calls this "Bits Are Bits" and teaches a class by the same name.[5] The Internet is a technological change so fundamental that it makes absolutely no sense to consider the Internet to be a passing fad, or "CB radio but with more typing," as Dave Barry so memorably put it.

Instead, the Internet must be viewed as a transformation of information technology. Since the fundamental basis of information is changing, the work of the information professional must change with it.

Libraries and librarians have had text as their focus since Sumer. However, just as clay tablets eventually gave way to papyrus, so text on paper will at least partially give way to electrons on a CRT, and librarians will adjust accordingly. Audio and video will unite with text, and it will be the challenge of librarians to provide access to that information. When the bandwidth of cable TV is married to the selections available from a video store, there is no reason to doubt that demand on the Internet will skyrocket. More serious uses, such as the online archiving of the public record of government in video format, are another possibility. Much is made of the lack of public participation in government in America. The public record of government at all levels may be a natural addition to the Internet.

Freedom Wants Information

The democratization of information is leading to a world where everyone becomes a publisher. The newspaperman A. J. Liebling once said, "Freedom of the press belongs to the man who owns one," and for decades no one could dispute him. Today, people can, and do, publish on the Web covering every conceivable topic, from the personal to the global. Much of that information matters to no one but themselves, yet it makes the Internet a more interesting place. The library can best serve the democratic environment by demonstrating that access is a critical part of publishing, and the online library can become the new public square where voices are heard on topics of the day.

Observers point to indexing and searching as the single toughest problem for digital libraries.[6] Most companies and other private sponsors of information on the Internet are primarily concerned with providing information exclusively about themselves. Libraries, with their traditional commitment to information organization and access for everyone, are ideally poised to organize information in a situation where everyone is publishing to everyone else.

Even when companies are organizing all the information they can find on the Web, there is still a role for the librarian building a customized online bibliography for a limited audience. In fact, with the wildly varying numbers of sources and media coming online, it appears that librarians will be especially necessary for the most "wired" users, to save them from drowning in the flood of information.

What Does This Mean for Us?

These trends mean that librarians should be prepared for a fundamental transformation of the nature of their stock. Typeset books have served humanity well for five hundred years in disseminating information. Libraries in the future will be repositories of electrons, if they have any stock at all. These electrons must be as accessible as the current book collection, but they must be more mobile for the users than books are. In a library of electrons, nothing need be real. In a library of networks, nothing need be local. When one realizes that collections are no longer real or local, why then are librarians needed?

Librarians are needed because even in the coming age of indexing machines, nothing will index itself. Librarians will ensure that information technology is put into the service of humanity. The environment that we live in today is probably the best that humanity has ever known by every quantifiable measure. Our health, safety, and jobs depend largely on an interlocking chain of information systems that require the smooth flow of information from the people who produce it to the people who need it.

"

In a library of electrons, nothing need be real. In a library of networks, nothing need be local.

"

These links individually may not count for much, but taken together they are important, and finding them and the information they contain is exactly the sort of job at which librarians excel. Even today, people who are sophisticated Internet users are surprised when their librarian goes to the Web and finds a source of which they were unaware that answers their question exactly. For this reason, and for others, the role of the librarian will be one of a mediator between the public and cyberspace.

The current library makes no allowance for online cross-references for users to the full text of the collection. The library user of the future will expect to be able to do everything in the library that he can do on the

Web. If he cannot, his opinion of the library as a great anachronism will be confirmed. Currently, when libraries go electronic, they start with their catalog, add a journal index or two, and, depending on the library, proceed to stand-alone CD-ROM stations. In almost every case, each system has its own interface. Libraries must begin to unite and use their buying power to insist that publishers and standards-making organizations keep their interfaces consistent with each other. The Z39.50 standard is a step in the right direction, but future steps must keep in mind the convenience of the user and allow for a simple way to cross-reference all of the electronic information that the library possesses.[7]

The next twenty years should be a golden age for libraries. Information will become an active, not a static, thing. The stereotype of the librarian being the quiet warehouser of books will disappear forever to be replaced by the librarian as the master of research, technology, and information. While such a transformation will not be easy, and will require funds and planning for new machines and networks and training in new technology, such a change will occur. An information overload will be inevitable for people who will be swamped with their own jobs and not have the time to wade through cyberspace to find what they need. Indeed, reference interviews will become more faceless as the questions come in electronically and the responses go out the same way.

The reference resources that librarians previously bought as books, and paid to catalog, store, and track in circulation, will be increasingly available over the Internet. Currently, most Internet resources cost only the time it takes to find these items and to make hyperlinks to them. On the best pages, the information will be more timely than anything from previous media. For example, the National Center for Biotechnology Information (NCBI) is posting complete genome sequences from plants, animals, cultures, and humans on the Web to facilitate research (see http://www.ncbi.nlm.nih.gov/). The private sector is doing the same kind of thing to a lesser extent, especially with directory information.

Librarians in the future will have career paths available to them that are unimaginable now, careers in which the organization of information at the source will be at a premium. These changes are not threatening the librarian, but are offering an opportunity to transform the profession.

Notes

1. Robert F. Service, "Can Chip Devices Keep Shrinking?" *Science*, 274 (1996): 1834.

2. Robert Lenzner, "Whither Moore's Law?" *Forbes*, September 11, 1995, 167.

3. See http://www.internet2.edu for an overview of Internet2.

4. See note 1 above.

5. Nicholas Negroponte, *Being Digital* (New York: Knopf, 1995), 202.

6. Bruce R. Schatz, "Information Retrieval in Digital Libraries: Bringing Search to the Net," *Science*, 274 (1997): 322.

7. ANSI/NISO Z39.50-1995: *Information Retrieval Application Service Definition and Protocol Specification for Open Systems Interconnection* (Bethesda, Md.: NISO Press, 1995).

The Clash of the Titans

*Information Retrieval vs.
Data Retrieval*

■ ■ ■ ■ ■

SUE MYBURGH

We are constantly warned that the Information Age is upon us. So are the Electronic Revolution, the National Information Infrastructure and the Information Superhighway. The nomenclature hardly matters—what concerns us is the impact that current developments in telecommunications and information processing will have on us, the information workers. Have matters already been taken out of our hands by a variety of other players? Are we already, or are we soon to become, peripheral to the processes of dissemination of information? What are the organizational and social consequences if information generation, control, and retrieval are placed in the hands of those motivated only by greed, or worse?

The development of one communications mechanism, even one as seemingly ubiquitous and powerful as the Internet, is not going to be enough to change everything overnight—or even most things over a century. But it will force some changes. We need to discover to what extent information work will change.

Easy Information Is New

With the widespread availability of the Internet, many are experiencing the vast dimensions of the information available to them for the first time. People are becoming aware of the possibilities that information

SUE MYBURGH is a senior lecturer at the University of South Australia. Her e-mail address is sue.myburgh@unisa.edu.au.

offers for solving individual problems and changing lives. They are encountering new problems—information overload and information angst. For many, information seems to have been "invented" with the appearance of the Internet. Perhaps their previous encounters with published information took place primarily in the school or public library. Using the Internet is quite different from using the public library, the previous bastion of publicly available free information. Suddenly, all this information is in people's homes, at their places of work, and in public cafes (as well as in libraries). It is deceptively easy to use; it is mesmerizing and fun.

As Koenemann succinctly explains: "We are experiencing in our work and home environments a dramatic explosion of information sources that have become available to an exponentially growing number of users. This has resulted in a shift in the profiles of users of online information systems: more users with no or minimal training in information retrieval (IR) have gained access to tools that were once the almost exclusive domain of librarians who served as intermediaries between end-users with their particular information needs and the information retrieval tools."[1]

Because the technology of the Internet (specifically the graphical browsers such as Netscape and Internet Explorer) is so deceptively easy to use, nobody needs to go to graduate school to learn the necessary skills. Anybody can put in any search term—and because of the infinite and mutating documents available, success is assured. It is seldom that no relevant documents will be retrieved.

The End of the Information Professional?

If the Net is so easy to use, and is so widely available (at least to affluent, English-speaking people, predominantly in the "Western" world—which must include Australasia), then everybody will be able to get their own information, quickly, cheaply, and easily. Does this mean that libraries, as physical entities or organizations, will become museum-like and cease to have meaning (and budgets)? Do we still need information professionals acting as intermediaries? Does this mean the end of the information professions, with only computer scientists and Web page designers surviving? Of course not. In all of this, we will see a changing and even more central role for librarians.

This point of view can be best understood if we take a few steps back in time and examine the debate which raged for over a decade in the 1970s and 1980s concerning the supremacy of searches performed

by end users over those performed by intermediaries. It is important to examine this conflict for two reasons. The first reason is that on the Internet, everybody is an end user. Anybody can assume the mantle of the "subject expert" in whatever area they happen to be interested at the time. Second, everybody is now a publisher. This means that anything can and does get published, in a random and uncontrolled fashion.

End User vs. Intermediary =
Scientist vs. Humanist

For those who have forgotten this debate, a few notes may be necessary. The end users of the 1970s were usually research scientists in the so-called "hard" sciences of engineering, medicine, chemistry, and the like. That which could be observed, measured, sensed, quantified, and labeled (in discrete, unambiguous terms) was important to them. In fact, it was the knowledge of the concrete and finite terms that are characteristic of these disciplines which purportedly gave them the edge in online searching. These end users understood the terminology of their fields much better than an English Literature Honors person could. All they needed to do (apparently) was to enter these terms into the system and the documents in which the specified terms appeared most frequently were identified; this constituted a successful search! Of course, it was a separate process to get hold of the documents themselves.

The intermediaries were librarians. By far the majority of librarians (certainly up until the 1980s) had a worldview shaped by the humanities and social sciences. In a word (dare one say it) they were erudite. They were intrigued by language and literature, and the discovery of knowledge; they were motivated by the high ideals of enlightening and supporting the communities in which they worked. It was these people who understood why thesauri were important and how they operated. Their job was to translate information needs as expressed by the end users into terminology and statements understood by the computer, and in this way they retrieved useful documents.

Is Relevance Quantifiable?

A related, parallel discussion concerned assessing information retrieval systems. An effective information system, which facilitates successful searches, is usually determined in at least two ways: by the total num-

ber of items identified (recall), as against the identification of those items that are useful and satisfy an information need (precision). Only two conditions must be met: the recall rate needs to be numerically high, and most of the documents recalled must be able to satisfy the information need. There is a strong quantifiable element, in that the more "relevant" hits there are, the more successful the search is deemed to be.

This "counting" approach is seriously flawed in at least two ways. In controlled experiments, there is a struggle to arrive at what can be viewed as "conclusive conclusions," based on the counting approach. Even with such (very small) finite universes of documents, it is virtually impossible to determine whether all relevant documents have been identified.

The second flaw in the argument, to my mind, is the word "relevance." How relevant is the result to the actual information need? From one point of view, this is quickly reduced to a quantifiable amount. The more "search terms" the document contains (either in its text or in its metadata) the more relevant—i.e., the more answering and responsive to the quest. Users, however, are probably the most appropriate people to consult concerning relevance. They should be able to determine whether certain documents contain the information that satisfies their information need. This assessment does not necessarily correlate with the number of search terms that appear in the document.

The objective of an information search frequently is not the identification of every single document that contains a particular word or phrase. Often the objective is to find the most important one, the most suitable one, or the most relevant one. All concepts are subjective and open to wide ranges of individual interpretation. As Ellis has noted, users assess the results of searches in various ways—"by substantive topic; by approach or perspective; and by level, quality or type of treatment."[2] He further notes, correctly, that "Conventional computer-based searches usually produce undifferentiated sets of references; no attempt is made to discriminate between material in terms of approach, perspective, level, quality, or type of treatment." However, it is precisely these elements that are important to the users of the information.

The Clash of the Titans

This conflict represents to me a clash of two cultures, two universes, two philosophies of life—a clash of the Titans. This dichotomy is situated in the encounter that takes place between the information retrievalists,

on the one hand, and the data retrievalists, on the other; those who labor with qualitative research methods, as against those to whom quantitative research is all.

Henninger and Belkin explain it another way: "The field of information retrieval can be divided along the lines of its system-based and user-based concerns. While the system-based view is concerned with efficient search techniques to match query and document representations, the user-based view must account for the cognitive state of the searcher and the problem solving context."[3]

How to evaluate the success of an information retrieval system remains an unresolved issue today because, among other things, the distinction between information retrieval systems and data retrieval systems is blurred. A data retrieval system is actually a simple thing, relatively speaking. A datum is a discrete fact, which usually contains a concept that is measurable in some way. A mountain has a certain height, water

66

Everything is data—but data is not everything.

99

freezes at a certain temperature, the exchange rate between Canadian and Singapore dollars is set on a certain day. Even metadata systems are not complex. Metadata simply provides information about information—a book is written by a certain author, an article appeared in a certain journal in a certain year. Because data are discrete and unambiguous, they can be entered into the system in a clearly defined way, and can be retrieved in the same way. They are generally quantifiable and can also easily be assessed for accuracy and correctness.

Information is more complex. Information is at the very least a combination of various data. Sometimes data are abstract only and have meaning only in a relative sense—and are therefore hardly recognizable as data. Furthermore, information is more frequently expressed in language than numbers (although I recognize the argument that everything is information. More properly, everything is data—but data is not everything). Because information uses language, the problems of the communication process, linguistics, and vocabulary all play a role in

increasing the complexity of a system that seeks to retrieve information. This is clearly distinguished from so-called "information retrieval systems" that merely provide data as references to other information (metadata). In fact, a "proper" information retrieval system should contain the actual information required—in other words, it should be full text or perhaps multimedia.

So far as identifying the subject matter of documents is concerned, there are two distinct schools of thought—roughly analogous to the two worlds here in collision. One point of view determines an indexing language as an intellectual construct, a crafted language: semiotics, semantics, linguistics, syntactics are analyzed, connected, linked, explained. The resulting thesaurus should contain every item in a particular vocabulary, and its relationship with every other item should be dissected, displayed, routed. The other school of thought (embraced by the data retrievalists) maintains that the words used in the text are perfectly adequate, as they are the terms most likely to be used by the searcher anyway. Neither of these schools of thought has provided much evidence of its particular superiority, in particular in terms of recall and precision and matching the search result with the user's need.

Information Retrievalist vs. Data Retrievalist

At one end of the continuum is the data retrievalist, intent on retrieving quantifiable, consistent, discrete facts. Data—and metadata—are entered into a system. The data retrieval system drops all words that are "insignificant," and counts the recurrence of the important words (keywords) in the metadata that describe the document or that are actually present in the document (irrespective of possible variations of meaning, even within the same text). The higher the frequency, the better the chance of retrieval, the better the chance that the information need has been met. Search statements, exactly matching the terminology originally used to construct the system, are entered, and the system then identifies the documents, or document surrogates, that match. The more documents retrieved in this way, in relation to the universe of documents, the more successful. Data retrievalists find it hard to understand the problems with information retrieval systems.

Online bibliographic databases are frequently assessed by the standards of the data retrievalists, rather than the information retrievalists. Here, creative works or intellectual efforts or information communications are reduced to a series of metadata tags that are easily identifiable.

None of the search terms, or metadata, tell us anything in particular about the communication or subject content or "aboutness" of the putative document, except for the subject headings, or indexing language.

At the other end of the continuum are the information retrievalists. This group is of the opinion that it is only the indexing language that expresses the "aboutness" of the document which is ultimately the source of the answer to the need. Other metadata is of secondary importance; the system should contain the actual information, and not only references to it. The "aboutness" of a document is expressed in the system in greater or lesser detail. It can be expressed in a stylized, abstract, remote language called the indexing language, or by a selection of terms from the text, or even every word in the text.

What Is a Successful Internet Search?

The problem of how to define a successful search on the Internet is even more problematic than in standard bibliographic, or even fulltext, databases. One difficulty in this area, of course, is defining exactly how to test search results. Recall and precision measures lose their importance in Internet search engine systems and are increasingly unrealistic and irrelevant. The link between traditional measures of effectiveness and optimal retrieval is not clear and has to be reconsidered and reformulated.

There are several reasons for this. It is not uncommon to have over 10,000 hits in response to a search statement. The total number of documents available through the Internet is unknown and can never be known, as it changes constantly. Another reason is the clash of the Titans. In the Internet we essentially have an information retrieval system (in the true sense of the word—total information content at the fingertips). But this information retrieval system was built by data retrievalists, empirical scientists, for whom things needed to be weighed and measured. Ironically, they not only constructed a system that deconstructed and fragmented communication modes, making communication processes little more than random, but also developed the system of hypertext, which is anathema to the cultural idea of a structured, hierarchal indexing language that information retrievalists had viewed as the only way to properly "control" information (as opposed to data).

To further confound the issue, this information retrieval system is not used by intermediaries, as noted; it is used by end users—those who require the information. These end users do belong to an entirely different population than the original end users, who could be considered

to belong to the data retrievalist side of things. The new end users are information retrievalists.

The New End User

While there are millions of people with access to the Internet, little is known of how people use the Web to find information. It is known, however, that there are several methods for locating information. These include going directly to a given address, using search engines (spiders, knowbots, wanderers, etc.), browsing or "surfing," or going to organized indexes such as Yahoo!, CyberStacks, and InfoMine. Often a combination of search strategies and techniques—browsing and search engines—is employed. Each of these methods requires sophisticated knowledge of how the universe of information, and information retrieval, operates in order to have a truly successful outcome.

Previously, to locate information on the Web, you had to know the address of the site you wished to visit, or you relied on a system of links, connecting you from document to document, until you finally arrived at the information you required. Browsing or surfing is still often employed by the neophyte Internet user. In this mode, the searcher moves from one link to another, pursuing links that look interesting. While this can be fascinating and often provides the desired information, it can also be time-consuming, frustrating, and even disorienting. It is difficult to control a search such as this, as there is no clear-cut mechanism to locate similarly useful sites or to broaden or narrow searches as one goes. One may also encounter dead ends, or link rot, and this all wastes time.

Hypertext vs. the Search Engine

Hypertext is essentially a multimedia database in which the links or connections between documents are made clear, and these links are enabled by nodes in the documents. The interconnection between related thoughts, concepts, and documents is not a new one; there has long been an understanding that documents do not exist in isolation, but are referential, usually retrospectively. There is an interconnectivity of thought and function between documents—poems refer to other poems, articles cite other articles, receipts relate to invoices. What is new is the mechanism that facilitates this referential process, providing immediate connection to cited or related documents.

Both Vannevar Bush, with whom the idea originated, and Dimitroff, writing much later, emphasize that this mode of searching—following trails that associate ideas—is a replica of the information-seeking processes of the brain. Dimitroff has stated: "As an alternative to Boolean-based information retrieval systems, hypertext-based systems offer nonlinear or associative links between discrete units of information. Theoretically these links more closely mimic human thought processes."[4] This is a moot point, as theoretically this allows for the processes of serendipity, or the fortuitous and incidental juxtaposition of ideas (possibly with creative outcomes), but in reality one can only follow the routes that are to a greater or lesser extent preordained (albeit seemingly infinite).

Almost at the other end of the continuum, we now have search engines. These are pieces of software, designed by data retrievalists, that travel the Web and count the numbers of key terms occurring in certain documents, sometimes only in their title or address. These terms are then included in an inverted index, which points to the Uniform Resource Locator (URL) at which these terms may be found. There are several insurmountable problems with this system, not least of which is uncontrolled vocabulary. There are also problems with the number of Web sites (out of the entire universe) that are in fact indexed. Another weakness is that a term may appear several times in a site that does not contain information relevant to an information need.

Using search engines demands that the end user has some understanding of how to construct a search statement. Boolean logic is not well understood outside the world of the information worker (and sometimes not that well inside it, either). It is not widely understood that the Boolean operator AND is exclusionary, rather than inclusive. There is typically no consideration that other people may use different terminology while addressing the same subject matter. Other aspects of searching are not understood in principle either, such as proximity matching, truncation, stemming, fuzzy logic, concept searching, and the like. What further complicates this is the total lack of standardization in the engines: use of asterisks, dollar signs, parentheses, and inverted commas is not the same across systems. Also, when errors occur, the messages displayed are frequently nearly meaningless to the untrained searcher. However, perhaps the biggest handicap to untrained searchers is that they have not carefully considered the nature and scale of their information need, and lack the skills to refine it into a search problem. They do not really know what they are looking for.

Fortunately or unfortunately, such ignorance is sometimes bliss. Even without this knowledge or skill, it is hard not to have a return rate of over 1,000 documents. The problem then becomes identifying those which are in fact useful. This is a time-consuming activity.

Lager makes the claim that "new computing techniques—artificial intelligence, natural language processing, relevancy feedback, query-by-example, and concept-based searching—have added a new sophistication to information retrieval. Robots, computers that search the Web using these new techniques (aka Boolean searcher, spiders, or wanderers) offer the Net searcher a higher degree of precision in retrieval."[5] I dispute this. A higher degree of precision can only be achieved once there is a more sophisticated grasp both of the processes of information retrieval and of the way in which the Web and the search engines are constructed.

Interestingly, Wildemuth cites several studies that reveal little difference between searchers using Boolean logic and searches using browsing techniques.[6] This may be because there is simply so much information available out there that users depart feeling satiated, in spite of the fact that they may either have digressed or entirely missed seminal documents. In this context, information is only as good as the methods available to search for it.

Pity the Poor End User

At this juncture, it is useful to return to the starting point, which is really to ask, "Why do people want information?" As Wilson claims, whether an information need is created because of one's work or to solve a personal problem, such needs are usually crisis-driven and spasmodic.[7] As a result, end users' knowledge of information sources and how to use them will always be deficient, as they are generally intermittent.

The Centre for Human Computer Information Design, in the School of Informatics at the City University, London, is undertaking a research project that addresses three main problems:

- *The requirements problem:* User's information needs may be ambiguous, embedded in a task context, and evolve within the information seeking process.

- *The articulation problem:* Even if needs are partially known, describing those needs in terms that correspond to the indexing or contents of resources is often difficult.

- *The visibility problem:* Query formulation is critically determined by the user's knowledge of the domain and available resource space. This problem is increasingly important with the growth of highly networked resources (e.g., the World Wide Web).[8]

These problems indicate that a level of sophistication is required by the end user; otherwise, there needs to be a major redesign of today's search engines. Even this may not necessarily overcome all the obstacles.

As Schneiderman, Byrd, and Croft point out: "Poor user-interface designs can be improved. But even then, as users move from one search service to another, inconsistencies can cause slower performance, uncertainty, mistaken assumptions, and failures to find relevant documents."[9] They go on to suggest eight guidelines that should assist with this problem. The systems' interface should:

- "Strive for consistency [of terminology] . . . ;
- Provide shortcuts for skilled users . . . ;
- Offer informative feedback . . . ;
- Design for closure . . . ;
- Offer simple error handling . . . ;
- Permit easy reversal of actions . . . ;
- Support user control . . . ;
- Reduce short-term memory load."

The Net as Home to the Information Retrievalist

Neither the data retrievalist nor the neophyte untrained Net searcher can operate effectively (not to mention efficiently) in the present Web environment. The data retrievalist and neophyte alike will identify thousands of documents—not one of which may answer the information need. This is supported by Quintana, who indicates that studies done up until the date of his article show that, in general, a knowledge of, and training in, search mechanisms improves searching and search results.[10] Effective search and exploration requires the use of sophisticated tactics, many of which also require appropriate domain knowledge. These tactics are unknown to many searchers, and their effective application is sufficiently complex to challenge even expert searchers. The librarian will still need to be intermediary to digital libraries.

While it is deceptively easy to gain access to the Net, it is nonetheless intriguingly difficult to access precisely the information one wants, in the quantity one wants, and in a reasonable amount of time. Thus, for serious research in both academia and business (as well as searches for flippant and entertaining materials, and nearly everything in between), skilled Net navigators will be more and more in demand. And these Net navigators will be drawn from the ranks of the traditional information professions.

66

The information worker understands what an information need is, and the ways in which information can be used in the holistic view. This requires nothing short of an understanding of the human spirit, its foibles, and its strengths.

99

Librarians (how increasingly archaic this term sounds, even while their profession becomes more important) are professionally skilled in searching, as they understand not only how to perform searches, but also how the universe of knowledge is constructed, created, and made available. They are sensitized to the problems of linguistics, semiotics, semantics, and syntactics that need to be wrestled with when a thesaurus is created—and they understand the strengths and weakness of indexing languages. Librarians are familiar with the concept of dealing with information retrieval as a problem-solving exercise. Old concepts in new guises (such as Selective Dissemination of Information, which is now known as a form of information filtering) are well understood. Information professionals are also superbly placed to repackage and present information in ways that make it even more accessible to those who require it.

Most importantly, information workers can place an information need in context and interpret it. They have an almost intuitive understanding of the world of information because of their long experience of handling both its artifacts, its descriptions, and the people who use it.

It is only the trained information worker who is able to work within the vagaries and discrepancies of such systems. Only an information worker will understand the philosophical differences of varying worldviews between authors and searchers. Only an information worker will contract and expand a search, crystallize, shear off, add pieces, take a step up to a broader view, move sideways into synonyms in order to achieve the objective and locate the needed information. Only the information worker has the motivation and determination. The information worker understands what an information need is, and the ways in which information can be used in the holistic view. This requires nothing short of an understanding of the human spirit, its foibles, and its strengths.

The long professional tradition of information work has demonstrated its ability to apply tested solutions to new problems. Searching

the Internet will not prove an exception to this. The battle between the end user and the intermediary placed the responsibility for the success of a search firmly at the feet of the searcher, and it is the skilled searcher who will prove the most effective.

Notes

1. Jurgen Koenemann and Nicholas J. Belkin, "A Case for Interaction: A Study of Interactive Information Retrieval Behaviour and Effectiveness" [online], (1996). Available at http://www.acm.org/sigchi/chi96/proceedings/papers/Koenemann/jk1_txt.htm

2. David Ellis, *New Horizons in Information Retrieval* (London: Library Association, 1990).

3. Scott Henninger and Nicholas J. Belkin, "Interface Issues and Interaction Strategies for Information Retrieval Systems" [online], (1996?). Available from http://www.acm.org/sigchi/chi96/proceedings/tutorial/Henninger/njb_txt.htm

4. Alexandra Dimitroff and Dietmar Wolfram, "The Effect of Linkage Structure on Retrieval Performance and User Response in a Hypertext-Based Bibliographic Retrieval System" [online], (1996?). Available from http://www.oclc.org/oclc/research/publications/review95/part3/dimitrof.htm

5. Mark Lager, "Spinning a Web Search" [online], (1996?). Available from http://www.library.ucsb.edu/untangle/lager.html

6. Barbara M. Wildemuth, "Defining Search Success: Evaluation of Searcher Performance in Digital Libraries" [online], (1995). Available from http://edfu.lis.uiuc.edu/allerton/95/s1/wildemuth.html

7. Tom Wilson, "Information-Seeking Behaviour: Designing Information Systems to Meet Our Clients' Needs," in *ACURIL: Association of Caribbean University, Research and Institutional Libraries Conference* (San Juan, Puerto Rico: the Association, 1995).

8. Centre for HCI Design, School of Informatics, City University (London), "Modelling Information Seeking Strategies and Resources ESRC Cognitive Engineering Programme" [online], (1996). Available from http://soi.city.ac.uk/research/hcid/cogeng.html

9. Ben Schneiderman, Don Byrd, and W. Bruce Croft, "Clarifying Searching: A User-Interface Framework for Text Searches," *D-Lib Magazine* [journal online], (January 1997). Available from http://www.dlib.org/dlib/january97/retrieval/01schneiderman.html

10. Yuri Quintana, Mohamed Kamel, and Rob McGeachy, "Formal Methods for Evaluating Information Retrieval in Hypertext Systems" [online], (1996). Available from http://itrc.uwaterloo.ca/~engl210e/BookShelf/Supplemental/ResearchPapers/quintana/quintana.htm

Generations

After Document Delivery, What?

■ ■ ■ ■ ■

T. D. WEBB

Technological change tends to be self-directing. Every advance springs from its antecedents, and every technology seeks to deliver greater power for less effort. For information technology (IT), the tendency of change has been to extract the greatest possible amount of information from the latest sources and put it into the hands of end users. But computer-aided library technology is different from IT. Although libraries handle and deliver information, they also perform the functions of knowledge preservation and comprehensive knowledge collecting.

A review of the last thirty years shows that library technology has not followed the IT tendency of extracting extremely current information. Instead, libraries invested most of their efforts and resources in technological feats more related to comprehensive collection building and knowledge preservation. In so doing, they almost lost any presence in the course of IT development. And now others are in control of the Internet and World Wide Web (WWW), the most current, fastest growing, and most promising and enthralling information technologies ever seen. Document delivery has now become the focus of both technologies. It is a natural sequitur to IT antecedents. For libraries, on the other hand, it has become a service that library users expect as a result of the comprehensive bibliographic access traditionally provided to them.

T. D. WEBB is the director of the library at the University of Hawaii, Kapiolani College in Honolulu, Hawaii. His e-mail address is twebb@hawaii.edu.

Yet because of their experience in various technologies, libraries are now positioned either to take a leading role in information delivery by creating a new type of service, or once again to limit their use of advancing technology to customary processes of preservation and collection building and to pass up another chance to exploit technology for the betterment of librarianship.

LIBRARY AUTOMATION

The First Generation

Library automation began over three decades ago when libraries started to share cataloging records electronically to reduce the need for original cataloging. This led to the creation of huge bibliographic databases. Yet although the MARC (Machine-Readable Cataloging) format and the bibliographic utility are among the most notable achievements of library automation, the multiplication of such databases in competition with each other entailed considerable duplication of effort and expenditure within libraries that might have been directed toward equally admirable advances in other areas.

In the first generation, libraries also began automating their acquisitions and circulation functions. Then they created searchable databases of their collections. This was followed by retrospective conversion (retrocon) projects to transform card catalogs into automated ones and to put records for entire collections online, from the very newest to the very oldest. These comprehensive retrocon projects were excessively expensive, however, in terms of money, time, and progress toward other potential goals. And what was really gained? Knowledge doubles every few years now. Libraries cannot hope to keep up with new knowledge if they are fixated on the old. Libraries would be in a more advanced automation environment now if they had favored gradual retrocon, closed card catalogs, and moved forward on other fronts, such as computerized access to periodical literature, which soon fell to IT vendors.

Library computerization of separate components was followed by their linking into integrated systems that saved computer space and processing time. First developed at large, affluent academic libraries, these systems were purchased by private companies to sell to libraries that lacked the resources to develop and maintain their own systems. These companies literally created the library automation market. Then other firms developed their own systems for direct marketing to libraries.

These turnkey systems required relatively little computer expertise to operate, and library automation surged as marketing strategies and advanced computer technology entered the library marketplace.

Throughout the first generation, however, especially when the market was forming, libraries had too little input into systems design. Input could have been mustered and coordinated through tighter cooperation among libraries to specify desirable systems output, establish better communication with vendors, and maintain consultation with technology developers.

The Second Generation

During the next generation, libraries began creating supercatalogs capable of searching other online catalogs in distant libraries. Catalogs then became "platforms" to access remotely or to load magnetic tapes of periodical indexes, directories, and other resources to supplement book access. These developments began to give shape to the notion of retrieving any and all knowledge from a single workstation, no matter where that knowledge was stored. Some proponents even proclaimed the imminence of the virtual library. Many librarians heard the call and adopted that vision as the sole future of libraries.

CD-ROM (Compact Disc–Read-Only Memory) technology began to have a major impact on libraries about this time, but as a stand-alone technology outside the integrated systems approach that had become the backbone of library automation. Nevertheless, CD-ROM indexes gave users the computerized access to periodical literature they had yearned for. This breakthrough provided an invaluable user service that library automation plans had chosen not to tackle because of the pursuit of comprehensive retrocon and online book catalogs.

Because CD-ROM was designed for stand-alone workstations and individual users, mainly in businesses, it was a major setback for library automation. An entire industry grew up to invent an expensive array of servers, jukeboxes, and networks to adapt CD-ROM technology for libraries, and library automation was split into two equally important but disparate technological domains.

In this generation, librarians were still preoccupied with automated access to books and with knowledge accumulation. Libraries paid too little attention to users' increasing thirst for immediate information, and so played no significant role in the development of an important, but maverick, technology.

The Current Generation

Supercatalogs and CD-ROM indexes instilled in users the erroneous expectation that they could readily obtain from their own libraries the documents these powerful and tantalizing machines revealed to them. But libraries were ill-prepared to satisfy that demand. Other than inter-library loan, they had no provision for obtaining books held in distant libraries or articles in periodicals to which they didn't subscribe. Consequently, document delivery has now become a primary pursuit of libraries.

Vendors in this present generation, however, have been more perceptive. They responded to the information market with document delivery utilities, such as CARL UnCover and its competitors, and full-text online databases. Also, the very popular CD-ROM periodical indexes quickly became full-text CD-ROM periodical collections, and even online full-text databases, compounding the split from the integrated system approach and increasing the complexity of managing library information systems.

Libraries have responded to the demand for document delivery in two ways. First, they have subscribed to more online databases, document services, and full-text CD-ROM products, and have uploaded full-text files onto their platforms. The second response has been to pour funds into prototypes of the virtual library—an electronic repository/gateway to all knowledge, information, and data. It has not seemed to matter that only a fraction of all knowledge is in electronic format, or that such a comprehensive online resource is not even desired by most users.

The Virtu-ish Library

The consensus now, however, is that the virtual library will be delayed a generation or two due to issues of user unreadiness, publishers' objections, and the lack of system interoperability. Yet vendors like America Online and others are already providing many virtual services that libraries cannot, given their noble but impractical vision of complete virtuality. The vendors are more realistic in their offerings, more targeted to the minimal needs of their clientele, and in a better position to strike deals with publishers. Moreover, they are more practiced at exploiting technology. As IT vendors gradually enlarge their virtual collections, libraries run the risk of becoming relegated to the knowledge collection function and being shut out of the IT decision-making loop.

If libraries assume that users want electronic access to everything, and wait for the complete virtualization of knowledge before moving forward

with plans to exploit the current technology, they are doomed to play catch-up with IT vendors and publishers. It will be a costly, losing contest that will net no more than was gained from comprehensive retrocon.

The Next Generation

As the fading vision of the completely virtual library is replaced by the selective virtuality of online services, one course of action for libraries is simply to dig in where they are and continue to provide information in a variety of formats. Some say the major task before the profession of librarianship is to acquire information in the format most appropriate to its content and the way it will be used. While format management is an efficient and necessary future, it is not a very exciting one because it again uses new technology just to perform traditional library functions.

66

Library patrons never really wanted universal bibliographic access or even document delivery. They want the information that's in the documents—online, current, and affordable.

99

Nor will this function alone propel libraries into the forefront of information technology. And if the Internet, Web, and other looming technologies threaten the publishing industry, are the customary practices of librarianship any safer?

Some libraries are taking a different approach and creating more modest virtual collections, as the vendors have, by offering their own selected online resources through electronic reserves collections, virtual reference desks, and special collections via the library's platform, the Internet, or the Web. These small virtual collections do not duplicate or compete with the vendors' popular collections, but supplement them with more specialized publications targeted at a library's users.

In any case, document delivery, electronic or otherwise, will remain a major activity for libraries. But again, users are far ahead of where librarians thought they could catch up with them. Library patrons never really wanted universal bibliographic access or even document delivery. They want the information that's in the documents—online, current, and affordable. That much is obvious. But it implies an important concept: Users will go wherever good information is located.

An Alternate Future

Librarians know the locations of vast amounts of information that few users ever discover because, although very valuable to the right users, the information never finds its way into conventional publications. This information resides in research institutions, community organizations, business associations, historical societies, and other similar bodies. With current technology, librarians can bring this hidden information into use through local databases.

A premier example of a library-maintained online database is the Human Genome Data Base (GDB) at Johns Hopkins University (http://gdbwww.gdb.org/gdb/gdbtop.html). Librarians played a leading role in creating this database with scientists and researchers, and now guide its management. The GDB draws its contents from many sources, including original studies of genetics researchers. And although most libraries cannot afford to create a resource as sophisticated and costly as the GDB, it represents a type of service that current technology makes affordable on a smaller scale. In Web-based projects modeled after the GDB, librarians can become suppliers and managers of electronic, subject-specific database resources.

This new model of librarianship is well suited to academic libraries because of the nearness of faculty, specialists, and research centers. For example, the Kapiolani College Library and the East-West Center in Honolulu jointly created a full-text WWW database of curricular materials collected by the center during its annual Asian studies institutes (http://library.kcc.hawaii.edu/asdp/). As part of their activities, institute participants develop syllabi, bibliographies, and other curricular materials that are added to the center's collection. They are then shared with participants at subsequent institutes.

Now on the Web, the Asian studies database is accessible to many more users, and attracts contributions from Asianists who cannot attend the center's institutes. The database is more dynamic than any print compilation could ever be, if it could ever be published at all, and the information is of great value to Asian studies faculty and students in

Hawaii, across the United States, and worldwide. East-West center staff perform the editorial functions of soliciting, selecting, and editing submissions to the collection. Kapiolani librarians maintain the database and equipment, and upload new materials forwarded by the center.

The Kapiolani Library has constructed other WWW collections of emergency medical resources, historical documents relating to the Hawaiian monarchy, syllabi for Pacific islands studies, and others (http://library.kcc.hawaii.edu). The Kapiolani Library chose to create these online resources because they are pertinent to the mission of the college, because there are stores of information to support the projects, and because there is a pressing local and international demand for the information.

At the University of Ulster, the Conflict Archive on the Internet (CAIN) is another example of a Web-based, library-managed subject resource (http://cain.ulst.ac.uk). When completed, CAIN will provide a multimedia collection to support research, teaching, and learning about the conflict in Northern Ireland, with emphasis on conflict resolution. The collection will include full-text documents not easily accessible elsewhere, such as grey literature and source materials from political and paramilitary groups, statistical data, and items from political collections in Northern Ireland. Even materials from "prohibited" or outlawed organizations are being collected.

CAIN's management structure is elaborate. A steering group has overall responsibility for the project; an executive group oversees day-to-day project operation; a project team is charged with the design and creation of the CAIN online resource itself; and three project assurance teams advise on content, technical development, and service. Other reviewers evaluate the Web site's content, layout, and ease of use as the site develops and whenever new materials are added. A group of researchers supervise the selection of new materials for the collection.

Along with its content objectives, the CAIN Project also serves as a model for other academic and research institutions intent on developing networked information resources and demonstrates "the role of higher education institutions as publishers of their own information and that of other information providers" (from Annual Report on the site).

The Cornell University Law Library is another example of a library-cum-publisher of a highly specialized collection. The International Court of Justice Web site provides the full text of the Court's recent decisions (http://www.law.cornell.edu/icj/). Also known as the World Court, the International Court of Justice is the highest judicial body of the United Nations. Before the Cornell site was launched in 1996, fifty years after the court's formation, its decisions were only available in print.

One of the court's judges asked the Cornell Law Library to undertake the project, and the library readily agreed. The court provides the

library with a machine-readable copy of decisions as they are rendered, in both English and French, which are the court's dual official languages. This service will make the decisions available to a worldwide audience on a very timely basis. At present, only the decisions from 1996 to the present are online, but they are supplemented with the full text of accompanying declarations of the judges, as well as individual, separate, and dissenting opinions that issued from each case. The site also provides background information about the court and the United Nations, links to other international law Web sites, and acts as a research guide. Plans for developing the collection also include adding all retrospective cases when the resources for conversion become available. Other plans call for a search engine, a page of resources for students, a gallery of images, and other features.

Because no special funding was provided, the library is carrying the project on its existing budget. The technical work is handled by a law-school student who was formerly a computing professional but is now a student employee of the library. The library staff added their site-related tasks to their regular duties. The work is made easier because the documents are received from the court in electronic format.

In addition to opening a new domain for librarianship, these projects promote cooperation between the libraries involved and various other organizations and agencies that supply, select, edit, or otherwise affect the content of online resources. The result is that the projects have allowed the libraries to become more deeply integrated into the scholarly, professional, and research communities, and within their respective parent organizations as well.

In most libraries everywhere, librarians know of hidden information that begs for wider distribution, but that will never reach print. The technology to achieve that distribution is now at hand and affordable. Libraries can convert the information into usable databases, and in so doing will initiate a service to complement document delivery and format management, and will create a new place for themselves in the information community.

Because libraries spent so much time and money on OCLC clones, retrocon, supercatalogs, and CD-ROM patchworking, the field of library automation became separated from the IT industry. We can now merge back into the flow by exploiting the prevailing technology to create a type of full-text resource no other segment of the industry is positioned to supply. Document delivery is not the ultimate end of automated library service. When combined with our online catalogs, document delivery services, and format management, library-published online resources will carve a large new domain for libraries in the information industry.

Intellectual Freedom
on the Net

■ ■ ■ ■ ■

CAROL L. RITZENTHALER

Over the last twenty years, automation and new technologies have been growing more prevalent in libraries and are exerting a significant force upon information flow and library services. These changes are largely due to the computer revolution in which personal computers (PCs) became more affordable and more portable, and software to run them became more efficient and user friendly. More and more could be done on the desktop computer instead of running applications on large mainframes. Individuals began to make use of computer technology and find new uses for it. We have moved from the Industrial Era into an Information Age as new computer technology and the Internet allow libraries to connect to other information sources beyond those they can readily provide.

As libraries have been the traditional cornerstone for research, they can continue in this role throughout the new Information Age by continuing to provide access to information available electronically in addition to the traditional book medium. However, in doing so, fundamental issues need to be resolved. The American Library Association Council's "Access to Electronic Information, Services, and Networks: Interpreta-

CAROL L. RITZENTHALER is an OCLC services coordinator and Internet trainer for OHIONET. She was responsible for the planning, promotion, and implementation of Internet services for OHIONET staff and its member libraries, and designed the menu interface for the OHIONET Connection™.

tion of the Library Bill of Rights" serves to support access to information through any medium available, including the Internet.

Next to e-mail, the most popular Internet tool is the World Wide Web (WWW). This is the most powerful Internet tool because it can display sound, video, and images in addition to text. It allows one to communicate and share information in a multimedia environment.

While most of the information on the Internet and the World Wide Web is probably commercial in nature, there is much that concerns ordinary, everyday topics and information such as politics, sports, educational resources, health news, and consumer information. Like most things, however, the Internet has a dark side. Some of the information contains obscene or pornographic material that many find offensive. Issues revolving around child pornography, invasion of privacy, obscenity, infringement of copyrighted works, spreading of false and libelous information, and reading and answering another person's mail are recognized problems that have come to the forefront (Whittle 1996). The Internet community is aware that information which many would find immoral is easily accessible through the Internet, and that illegal acts do go on. The problem is that no one really knows how controls can be enacted.

Restricting access to information that many find obscene or inappropriate is seen as a violation of the First Amendment, which states that:

> Congress shall make no law respecting an establishment of religion, or prohibiting the free exercise thereof; or abridging the freedom of speech, or of the press; or the right of the people peaceably to assemble, and to petition the government for a redress of grievances (U.S. Constitution, Amendment 1).

As regulations are enacted in an effort to control access to information available through the Internet, rights protected under the First Amendment are being challenged. There are other legal issues and ethical ramifications as well that need to be addressed.

The Bill of Rights in Cyberspace

The Bill of Rights to the United States Constitution provided certain fundamental freedoms to all citizens. Among these is the freedom of expression and the right to publish diverse opinions, as well as the right to access those opinions. In support of the First Amendment's principle of freedom of expression and access to information available through

the Internet and other electronic resources, the American Library Association has offered its interpretation in "Access to Electronic Information, Services, and Networks: An Interpretation of the Library Bill of Rights" (ALA Council 1996), which may be found at http://www.ala.org/oitp/ebillrits.html. A question-and-answer document about the interpretation is available at http://www.ala.org/alaorg/oif/oif_q&a.html.

The rights of free speech and freedom of expression are guaranteed under the First Amendment. They apply to children as well as adults. Intellectual freedom implies the provision of free access to all ideas and all sides of an issue, regardless of the form of communication. According to the ALA Council's interpretation, "librarians and libraries exist to facilitate these rights by selecting, producing, providing access to, identifying, retrieving, organizing, and providing instruction in the use of, and preserving recorded expression regardless of the format or technology."

"

In principle, the ALA makes very high-minded statements almost to the point of being idealistic, but practice challenges many of them.

"

Librarians cannot deny access to information because of its controversial content or personal bias. "Libraries must support access to information on all subjects that serve the needs or interests of each user, regardless of the user's age or the content of the material" (ALA Council 1996). In principle, the ALA makes very high-minded statements almost to the point of being idealistic, but practice challenges many of them. Ideally, there should be unlimited access to diverse materials. However, in practice, libraries have selection policies that prohibit the purchase of obscene materials and other materials that members of a community might find offensive. This constraint is included in and supported by their materials selection policy.

Access to electronic information should be "equally, readily, and equitably accessible to all library users," according to the ALA Council (1996). The rights of children have equal weight to those of adults with regard to access to information. The ALA Council's "Interpretation"

also notes that "contracts, agreements, and licenses entered into by libraries on behalf of their users should not violate this right." An interview with Deborah Liebow, ALA Office of Intellectual Freedom, acknowledged that some members of ALA disagreed with the assertions made in the initial "Interpretation" because it did not represent actual practices. She noted, however, that the "Interpretation" was written as a statement of principle, and was not a reflection of actual practice. According to her, ALA is in the process of writing an actual working document that will address the issues that libraries face on a daily basis and a revised Interpretation should be available soon.

Even though the American Library Association recognizes that some information accessible electronically may not be in accordance with a library's selection or collection development policy, it is left to each user to determine what is appropriate. The ALA also maintains that parents, not libraries, should provide appropriate guidance for their children regarding restrictions on use of certain materials (ALA Council 1996).

At present, questions from staff in many libraries focus on *when* their library will get a connection to the Internet, rather than trying to understand what the Internet is or *why* it is important. This is especially true in Ohio as the process of implementing Ohio's Public Information Network (OPLIN) in all public libraries in the state has begun. OPLIN is the first comprehensive network of its kind in the nation because it is an effort to provide Internet access to the public at large through all public libraries in the state of Ohio.

While implementation is under way, many are asking questions and expressing concerns about the kind of information available through the Internet that is there for anyone to access. Jean Armour Polly expressed this concern by stating:

> Even if the infrastructure and resource problems are resolved . . . a lot of folks don't think Internet is a safe place for unaccompanied minors. In fact, some people think it should be reserved for scientists working on grand challenges, not ordinary ones. . . . Who will decide what constitutes acceptable use? Does the family have any electronic rights? Electronic responsibilities (Polly 1993, 38–39)?

While the Internet as a communication medium has much in common with print materials and electronic communications such as books, radio, and TV, the World Wide Web (WWW) offers a multimedia experience by incorporating the use of sound, print, and video. The unique nature of the Internet does not lend itself to the regulations that have been placed on other methods of communication. It is an entirely different communication medium that enables point-to-point commu-

nication between any computers connected to the Internet and that enables private, public, and group communication (Whittle 1996). Each method of communication has its own set of laws to govern it, and regulations have been established for each. Legal decisions are made based on the court's interpretation of the First Amendment, and these may vary from one communication method to another according to the regulations that have been established for each (Smolla 1992).

The CDA, ALA, Access, and Responsibility

The Communications Decency Act of 1996 imposed penalties on the obscene, indecent, or harassing use of telecommunications devices and interactive computer services used to send or display indecent material to minors. The Internet community and organizations such as the American Library Association, the Freedom to Read Foundation, the Center for Democracy and Technology, and the American Civil Liberties Union, to name a few, were outraged at the passage of this legislation. Free speech, freedom of information, and the information infrastructure were threatened. It also meant that Internet service providers, schools, libraries, and any other organization that provided Internet access could be held liable for content accessed or transmitted through the Internet.

The ALA and several other organizations acted quickly and joined in a suit against the federal government declaring that this act was a direct violation of human rights guaranteed under the First Amendment. The literature review that follows provides arguments both "for" and "against" the Communications Decency Act of 1996, enacted as Title V of the Telecommunications Act of 1996.

Information for analysis of the CDA and its implications for libraries and information services was found by searching the ERIC, Library Literature, Library and Information Science Abstracts (LISA), the Internet, and Information Science Abstracts online, as well as magazine indexes and local library holdings. Information has been analyzed from online and print source from the following organizations:

- American Library Association;
- Electronic Frontier Foundation;
- Computer Professionals for Social Responsibility;
- Electronic Privacy Information Center;

- Christian Coalition;
- Family Friendly Libraries;
- Family Research Council; and
- American Family Association.

The positions of these major players, as well as others including the American Civil Liberties Union (ACLU), will be reviewed with regard to their views and reactions to issues surrounding intellectual freedom and the First Amendment.

Civil libertarians see the Internet as the medium of communication through which they can gain access to information that might not have been available otherwise. They see it as a way to bring people together worldwide across boundaries of space, time, and physical location. This group of Internet advocates see government as interfering with the free flow of information on the Internet. They perceive government intervention as a threat to the very foundation upon which democracy was built.

Those who support the Communications Decency Act see the Internet as a vehicle for obtaining access to pornographic material that may have been previously difficult to access as a result of age or place restrictions. This group would prefer the government oversee the Internet for purposes of order and the social good (Ubois 1995). These opposing views have been the subject of great debate that has captured the attention of librarians and information providers following the signing of the Telecommunications Act of 1996 by President Clinton on February 8, 1996.

A three-judge panel of the U.S. District Court for the Eastern District of Pennsylvania was appointed to conduct an expedited review of the suit. The judges included Dolores K. Sloviter, Chief Judge of the U.S. Third Circuit Court of Appeals, and U.S. District Judges Ronald L. Buckwalter and Stewart Dalzell. On June 12, 1996, this panel of judges granted a preliminary injunction on the grounds that the Communications Decency Act was unconstitutional and a violation of the First Amendment and detailed findings on how the Internet works and how it is used. Until this time, different rules for different media had been the norm to justify any governmental regulation in a medium under review (Snyder 1996, 7:112).

The judges' opinions have helped to enlighten the community at large on the special characteristics of the Internet and its value to a democracy. This landmark ruling by the Philadelphia panel was obviously one that was well researched and studied. In order to assist with their review process, an Internet connection was brought into the courtroom and the judges searched the Internet for online porn and tested software that allows parents to screen out offensive material. They

could find "no evidence that sexually oriented material is the primary type of content on this new medium. Communications over the Internet do not invade an individual's home or simply appear on one's computer" (Quittner 1996, 57).

The judges did their homework in researching this case, whereas it was evident that Congress had not. There was little chance for Congressional debate and no opportunity for review by the American public before its passage in the Senate. Ramifications of the new legislation were revealed to the general public upon its signing in February. Congress had passed the Telecommunications Act of 1996 without really understanding the Internet, the role of the Internet in a democracy, or its potential as a communication and educational tool in society. The three-judge panel appointed in Philadelphia to review the constitution-

66

The judges did their homework in researching this case, whereas it was evident that Congress had not.

99

ality of the new legislation had to learn about the Internet as a new medium in order to do so. Their decisions were based on a complete and thorough understanding of the Internet and these decisions were in total support of the unconstitutionality of the Communications Decency Act under the First Amendment and resulted in an injunction until the highest court could review their decision.

Under the First Amendment, everyone has the right to read, view, listen to, and disseminate information that is protected by the Constitution. The Supreme Court has defined certain categories of speech that are not protected by the First Amendment and these are: obscenity, child pornography, defamation, and fighting words that incite immediate attacks. While it is recognized that censorship is the suppression of ideas and information, the government may impose censorship in the interest of national security (Smolla 1992).

Freedom of speech is a way in which individuals can debate issues and participate in the decision-making process to some degree. Through

free speech and the marketplace theory, ideas have the opportunity of becoming accepted, which usually leads to the consensus that the majority rules. Free speech provides an opportunity to filter out tyranny and corruption among the masses or within certain groups. Free speech also serves as a safety valve by providing an opportunity to discuss issues openly and peacefully.

The Communications Decency Act was a wake-up call to libraries and the American public regarding the issues of censorship and freedom of speech in the age of electronic communication. It clearly points out the need to identify the role of government in the regulation of free speech and the First Amendment, as it is clear that the growth of new technologies is outpacing our existing legislation.

What Happens in the Library

In many libraries, concern is expressed about children or adults seeing something inappropriate over the shoulder of another library user. These libraries may choose to provide a physical environment, such as workstations positioned at an angle, or shields for screens, so as to offer user privacy in accessing information. Regarding the privacy of Internet users in the library, Burt wrote that "viewing screens have to be readily viewable to the public services staff" in order to provide assistance in the use of Internet and other online services (1996). Lear took issue with this position by stating that patrons don't "correlate the willingness of reference personnel to provide service with proximity to the reference desk" (Lear 1996). Others suggest using a workstation that has a flat monitor instead of one that is vertical, which may present ergonomic benefits as well (Caywood 1996). The problem with this design, however, is that the equipment is difficult to get to for maintenance purposes (Sullivan 1996).

Others may choose to implement blocking software programs. Blocking software is another avenue open to libraries as well as parents to use to filter out offensive Internet sites. However, some libraries are uncomfortable with blocking software and the censorship that it seems to imply. They argue that blocking only works up to a point (Junion-Metz 4 October 1996).

Some libraries as well as school systems may be reluctant to use blocking software in light of the legal precedent to challenge blocking software recently exhibited in a case against Prodigy, an Internet service provider. A New York State judge ruled that Prodigy, which routinely screens postings for obscene or potentially libelous content, does use a

form of editorial control over content on its system and could be sued as a publisher (Diamond and Bates 1995). It follows that any organization that uses blocking software could be sued if the software fails to block out all offensive sites (Junion-Metz 4 October 1996).

Several companies have developed blocking software, also known as filtering software, that blocks access to certain Internet sites that are considered obscene or objectionable. Children who attempt to connect to one of the sites that has been blocked are informed that access to that site is denied. An effective filtering program would allow individuals to protect themselves or others from objectionable material. There are several vendors who offer these products, but each takes a different approach to restricting access to Internet resources (Junion-Metz 3 October 1996).

A study of seven programs that filter Internet access to objectionable topics, conducted at Internet World Labs, looked at the ability to block the topics of pornography, illicit drugs, violence, and bigotry. Each program was also tested for the ability to prevent children from sending out personal information in newsgroups and chat rooms. The tests revealed that only three of the programs were able to do this with reasonable certainty: Cyber Patrol, InterGo, and Specs for Kids. The top-rated product was Cyber Patrol because of its flexibility and varying levels of control for different users (Venditto 1996).

A database of banned sites that are determined undesirable by the publishers of the software is usually installed in the program. Those who purchase the blocking software need to purchase updates as well, and most are updated monthly. The drawback of this type of program is that it cannot stop a person from gaining access to a site that is not yet in the database. It also assumes that publishers know which subjects to restrict. In spite of these efforts, publishers are often overly restrictive and children can get around the safeguards to gain access to inappropriate material. With so many new sites added each day, the selection of databases to be blocked is out of date as soon as the software is distributed.

Rather than depend on software publishers to evaluate Web sites, the Recreational Software Advisory Council (RSAC) was formed for the purpose of rating software in an effort to help parents identify violent games. The Council adopted its rating system to the Web and released a version of RSACi in February. Through the use of this system, Web administrators can rate their own pages by answering a questionnaire at the RSAC site (http://www.rsac.org), which generates a PICS-compatible HTML tag that administrators can insert into the pages at their site. RSAC then records the entry in its database. The SafeSurf rating system is another option for Web administrators to use to rate their sites. SafeSurf's Web page (http://www.safesurf.com) generates the HTML tag that the Web administrator would use to rate their site

according to SafeSurf's criteria (Venditto 1996). Software programs that run either of these rating systems will block sites according to the HTML code assigned. The drawback to the self-rating system is that Web administrators have been slow to respond, so limiting access only to rated sites at this time unfortunately screens out others that would be very useful and acceptable.

While some libraries may choose to use blocking software, others resist this method and see it as a form of censorship. If a library does choose to use blocking software, it is advisable to check with legal counsel regarding liability if an individual is able to gain access to a site that is offensive through a link from another Web site. However, it does provide parents and schools with a mechanism through which they can feel more comfortable about what children can access via the Internet given the rationale that it is not practical to expect that a child's activities be monitored each minute he or she is connected to the Internet.

Blocking software should be an available option for parents who wish to restrict their child's access to undesirable sites. In order to make an informed decision about which of the blocking software packages to use, parents and librarians need to be informed about the similarities and differences between them. Parents need to know something about the agency or company that produces the blocking software, as they sometimes have a political agenda or bias that enters into their choice of sites to be blocked. Another point worth noting is that some blocking software may actually block sites that are not sexual in nature to the extent of being considered pornographic, but instead may discuss medical issues such as pregnancy, contraception, and AIDS.

Libraries are drawn into the debate over public access to the Internet as issues concerning content and accuracy of information on the Internet, restricted access, use policies, and collection development policies need to be addressed. These are issues that staff need to be familiar with also. There is also a concern about online privacy as people worry about the collection and use of personal information generated online. If an online service asks potential subscribers to provide personal information in order to open an account, some people may become apprehensive and provide an incorrect name, address, or age. If the service had no way of verifying accounts, they would not know whether the information provided were accurate. There is also concern about the extent to which personal information can be revealed online, how it might be used, and how it might be disseminated (Center for Democracy and Technology 1997).

Due to the way Internet communication is set up, information passes through dozens of computers and networks from sender to

receiver, often crossing geographic boundaries of different governments with different jurisdictions. Also, as all forms of communication are converging throughout the multimedia environment of the World Wide Web, free speech policies are becoming blurred. It is increasingly difficult to separate print media, broadcast media, and common carriers. They all seem to meld together through the technologies and tools of the Internet.

In the Name of the Children

More and more children are using the Internet every day, taking advantage of the educational resources, talking to others in chat rooms, and learning about other cultures. Protecting children from adult information is key, according to civil libertarians and those in the computer industry. The public perception that there is only sex and smut online has been blown out of proportion, largely by the news media, almost to the point of creating a panic situation. Especially troubling to parents are reports that their children are being stalked online by pedophiles who use the computer to reach beyond the playground. According to Mike Godwin of the Electronic Frontier Foundation, "groups that track abuse toward children can document only a dozen or so recent incidents in which the computer was used" (O'Connor 1997).

Can children be prevented from accessing controversial information? Is preventing access a viable alternative? What alternatives are there? Who decides what is acceptable? How and by whom are community standards set? How will the CDA affect communication in other countries? Will information coming from other countries be subjected to the same scrutiny as that which originates in this country? All of these questions and more are the subject of debate in local communities, organizations, businesses, and other agencies, including the federal government. At this point in time, no one is really sure what the best answer is, yet at the same time, most everyone knows that something must be done to ensure the safety of children.

Software companies continue to work on developing software that will block access to sites that contain sexual or other offensive content. It may be possible to provide parents with more flexibility in regulating access to Web sites by building in more options for parents to use in programming the access for their child. There is a variety of content on the Internet that, while not sexually explicit, may nonetheless be undesirable for children, such as hate crime, gang violence, guns, and

others. While blocking access to these sites through software may be the answer, Langan states that:

> Protecting children from adult information on the Internet requires parents to monitor their activities and online destinations, just as responsible parents do not let their children wander the streets unattended. And, just as in the real world, it is up to parents to teach their children how to enjoy the positive influences and avoid the negative ones. The paramount responsibility of deciding what material a child is ready to experience lies in the hands of a legal guardian; in other words, a child's censor should be his parent, not his government (1997).

While blocking software and online services currently offer an alternative to parents for restricting access, these are in the stages of early development and need more refinement to be more comprehensive, more foolproof, and easier to customize. In the interim, "a better strategy," according to the National Center for Missing and Exploited Children, "would be for children to learn how to be 'street smart' in order to better safeguard themselves in any potentially dangerous situation" (Magid 1994). The Center provides the following guidelines for children in "My Rules for Online Safety" as follows:

- I will not give out personal information such as my address, telephone numbers, parents' work address/telephone numbers, or the name and location of my school without my parents' permission.
- I will tell my parents right away if I come across any information that makes me feel uncomfortable.
- I will never agree to get together with someone I "meet" online without first checking with my parents. If my parents agree to the meeting, I will be sure that it is in a public place and bring my mother or father along.
- I will never send a person my picture or anything else without first checking with my parents.
- I will not respond to any messages that are mean or in any way make me feel uncomfortable. It is not my fault if I get a message like that. If I do I will tell my parents right away so that they can contact the online service.
- I will talk with my parents so that we can set up rules for going online. We will decide upon the time of day that I can be online, the length of time I can be online, and the appropriate areas for me to visit. I will not access other areas or break these rules without permission (Magid 1994).

The National Center for Missing and Exploited Children also offers guidelines for parents, encouraging them to take responsibility

for their children's online computer use and to stay in touch with what they are doing to ensure positive online experiences. The Center recommends that it should be a family rule to:

- Never give out identifying or personal information.
- Get to know the Web sites your child uses to find out the type of information it offers.
- Never allow a child to arrange a face-to-face meeting with another computer user without parental permission.
- Never respond to messages or bulletin board items that are 'suggestive, obscene, belligerent, threatening, or make them feel uncomfortable' (Magid 1994).

While many questions still need to be answered, the literature review found that most people and organizations recognize that there is a need to have provisions in place to protect children, free speech, and freedom of access to information. This would help ensure that individuals would be empowered to think and evaluate critically so as to make informed decisions. The information infrastructure is extremely critical in a democracy and global economy. Further research is needed in light of the international nature of the Internet so that a worldwide system could be established that would set principles and standards that all could accept with regard to all issues addressed in this chapter.

References

ALA Council. 1996. "Access to Electronic Information, Services, and Networks: An Interpretation of the *Library Bill of Rights.*" Chicago: American Library Association, January 24, 1996.

Burt, David. 1996. "Privacy of Internet Users." [Online] Available from publib@ nysernet.org; 23 October 1996 (accessed 23 October 1996).

Caywood, Carolyn. 1996. "Privacy of Internet Users." [Online] Available from publib@nysernet.org; 28 October 1996 (accessed 29 October 1996).

Center for Democracy & Technology. 1997. "Privacy Issues Wrap Up." [Online] Available from http://www.cdt.org/publications/pp_2.37.html (accessed 23 January 1997).

Columbus Metropolitan Library. 1995. "Internet, Technology & the Library." In *Metroscene*, the Magazine of the Main Library. (May/June) : 1–2. Columbus, Ohio: Columbus Metropolitan Library.

Congressional Quarterly Almanac. 1993. "House Bill Supports Information Highway." 1993 edition: 245–46. Washington, D.C.: Congressional Quarterly, Inc.

Crawford, Walt. 1987. *Patron Access: Issues for Online Catalogs.* Boston, Mass.: G. K. Hall.

Diamond, Edwin and Stephen Bates. 1996. "Law and Order Comes to Cyberspace." [Online] Available from http://www.mit.edu/aft/athena/org/t/techreview/www.articles/oct95/Diamond.htm (accessed 5 September 1996).

[Godwin, Mike] 1996. "EFF: Representing the Interests of 'Netizens.'" Electronic Frontier Foundation. [Online] Available from http://www.eff.org/EFFdocs/about_eff.html#netizens (accessed 31 May 1996).

Godwin, Mike. 1996. "Law of the Net: An Ill-Defined Act." [Online] Available from http://www.internetworld.com/1996/06/law.html (accessed 07 October 1996).

_____. 1996. "Sinking the CDA." *Internet World* 8 (October): 108-12.

_____. 1996. "Witness To History." *Internet World* 7 (September): 96-100.

_____. 1996. "Your Constitutional Rights Have Been Sacrificed for Political Expediency; EFF Statement on 1996 Telecommunications Regulation Bill." February 1, 1996. [Online] Available at http://www.eff.org/pub/Alerts/cda_020296_eff.statement (accessed 28 May 1996).

Junion-Metz, Gail. 1996. "Child Safety on the Net: A CyberSchool Workshop" (presented by the Worthington Public Library, Worthington, Ohio, 3 October).

_____. 1996. "Libraries & Controversial Net Resources." (Presented at the Ohio Library Council Conference, Columbus, Ohio, 4 October).

Langan, Claudine. 1997. "Cyberporn: A New Legal Bog." [Online] Available from http://www.public.asu.edu/~langcl/solution2.html (accessed 06 February 1997).

Lear, Brett. 1996. "Privacy of Internet Users." [Online] Available from publib@nysernet.org; 23 October 1996 (accessed 24 October 1996).

Magid, Lawrence J. 1994. "Child Safety on the Information Highway." National Center For Missing and Exploited Children.

McClure, Charles, John Carlo Bertot, and Douglas L. Zweizig. 1994. *Public Libraries and the Internet: Study Results, Policy Issues, and Recommendations.* Final report. Washington, D.C.: National Commission on Libraries and Information Science.

O'Connor, Rory J. 1997. "Debate Continues to Heat Up over Sex on the Net" [Online] http://www.sjmercury.com/netmyth.htm (accessed 23 January 1997).

Peters, Thomas A. 1991. *The Online Catalog: A Critical Examination of Public Use.* Jefferson, N.C.: McFarland.

Polly, Jean Armour. 1993. "NREN for ALL: Insurmountable Opportunity." *Library Journal* 118 (February 1): 38-41.

Quittner, Joshua. 1996. "Free Speech for the Net; a Panel of Federal Judges Overtunes the Communications Decency Act." *Time* (June): 56–57.

Smolla, Rodney A. 1992. *Free Speech in an Open Society.* New York: Random House.

Snyder, Joe. 1996. "Too Little, Too Late." *Internet World* 7 (May): 110–12.

Sullivan, Bob. 1996. "Privacy In Using Library PC's." [Online] Available from publib@nysernet.org; 28 October 1996 (accessed 14 December 1996).

Ubois, Jeff. 1995. "The Right Role for Government on the Net." *Digital Media* 5 (July) Computer Select Full Text Database [CD-ROM]

Venditto, Gus. 1996. "Safe Computing; Seven Programs That Filter Internet Access." *Internet World* 7 (September): 48–58.

Whittle. 1996. "The Good, the Bad and the Internet." [Online] Available from http://www.theta.com/goodman/goodbad.htm (accessed 28 October 1996).

From Print to Pixels

Bricks, Bytes, or Both?

The Probable Impact of Scholarly Electronic Publishing on Library Space Needs

■ ■ ■ ■ ■

CHARLES W. BAILEY, JR.

There is legitimate enthusiasm for scholarly electronic publishing and its potentials. However, the key question for libraries is not whether electronic publishing will continue to grow in importance, but rather how quickly it will displace printed books and journals in the specialized scholarly publishing marketplace. An increasing number of academic libraries face severe space problems, and supplementing print publications with electronic versions will not save library space—it will increase space needs in the near term as a growing number of workstations are added to provide access to electronic information. It is only when the library replaces print with electronic sources that the *potential* to save space emerges as a result of electronic publishing.

If Nostradamus were alive, he might be able to predict when scholarly electronic publishing will reach such a critical mass. This essay will not try to do so; however, it will briefly outline some critical factors that may slow the evolution of scholarly electronic publishing, extend the

CHARLES W. BAILEY, JR. is the Assistant Dean for Systems at the University of Houston Libraries. Since 1989, he has participated in a variety of electronic publishing projects on the Internet. He has served as the moderator of the PACS-L discussion list <URL:http://info.lib.uh.edu/pacsl.html>, editor-in-chief of the *Public-Access Computer Systems Review* <URL:http://info.lib.uh.edu/pacsrev.html>, and co-editor of *Public-Access Computer Systems News* <URL:http://info.lib.uh.edu/pacsnews.html>. He is the author of the *Scholarly Electronic Publishing Bibliography* <URL:http://info.lib.uh.edu/sepb/sepb.html>.

life of the printed word, and necessitate the continued existence of physical library facilities.

The Infancy of Electronic Publishing

Commercial publishers, professional associations, and university presses publish the majority of scholarly information in print form. Professional associations typically use profits from publishing activities to help subsidize other organizational activities. In recent years, university presses have been encouraged to operate as profit centers, rather than relying on university subsidies. Consequently, all three types of publishers are concerned with generating profit.

Although a growing number of scholars are starting electronic journals and engaging in other electronic publishing projects, it seems likely that traditional publishers will continue to provide most scholarly information in the future. Current electronic publishing projects by scholars are largely small-scale experimental efforts with short histories. It is unclear how long they will be sustained, especially as the Internet becomes more heavily regulated and legal issues become increasingly important. It is also unlikely that these projects can be scaled up to production levels similar to those of conventional publishers without significant expansion of their resource bases.

Scholarly publishers have mature business models for print publications. Electronic publications differ significantly from their print counterparts, and new business models must be developed to deal with the novel issues that these products raise.

One issue is the ease of copying electronic information. A printed book or journal is typically used by one person at a time in one location. While photocopying a complete book or journal is not impossible, it is time consuming and relatively expensive. These use restraints are not present in electronic documents distributed via computer networks. An electronic document can be used by many simultaneous users in many locations. Copying is easy, instant, and virtually free.

Publishers feel that there is already too much uncompensated use of print materials through photocopying and interlibrary loan. Consequently, when faced with the prospect of shifting to an electronic medium that could make this problem significantly worse, they become very concerned with access control issues.

Academic libraries want their users to have free access to electronic information anywhere, twenty-four hours a day. Publishers want to

66

Electronic commerce systems may give publishers a far higher degree of control over electronic information than they currently exercise over print information.

99

ensure that libraries provide electronic information to only faculty, students, or staff. They do not want academic libraries to undercut sales by distributing electronic information to other potential customers, such as local businesses. Technological methods for effectively restricting access to electronic information are immature, creating problems for both publishers and libraries. However, in the future, electronic commerce systems may be employed that encrypt information and allow varying fees for different types of access (e.g., view; view and print; or view, print, and store). These systems may give publishers a far higher degree of control over electronic information than they currently exercise over print information.

Electronic Information— Licensed for Ill?

As a result of current technological factors, electronic information is typically licensed, not purchased outright. Reflecting the early state of the electronic information marketplace, the terms and conditions of licenses can vary a great deal from publisher to publisher. Use restrictions are determined by the license, which is a contract. Unlike printed materials, the library does not own electronic materials, and typically it cannot lend them via interlibrary loan as it can print materials. Publishers can place limits on whether users can print, store, or redistribute electronic information. It is unclear whether libraries will be able to permanently archive electronic information that they do not own in order to preserve it. Instead of libraries, bibliographic utilities or other third parties may provide archives of commercial scholarly electronic information.

Publishers are also attempting to develop pricing models that will allow them to make a healthy profit from electronic publishing without prematurely undercutting the market for print products, which continue to be their primary income source. Electronic publishing requires publishers to build new technological and personnel infrastructures and to engage in research and development efforts. Consequently, the cost of electronic materials is often higher than their print equivalents, and costs can have considerable variability from publisher to publisher.

In recent years, many publishers have agreed to flat-rate annual fees that allow libraries to budget for electronic information use. (By contrast, unpredictable use-based costs mean that libraries must stop access when funds run out.) However, flat-rate fees could be threatened by emerging electronic commerce systems.

Lack of stable electronic publishing business models leaves publishers uncertain about whether to develop products and unclear as to how to price, market, control, and deliver them. Libraries must deal with a highly inconsistent, fragmented marketplace that requires product-by-product financial, legal, and technical evaluation; negotiation with vendors; and unique implementation considerations.

Print to Pixels

The vast majority of scholarly information in academic libraries is in printed form. For the physical library as a *public* facility to cease to exist, all new materials would need to be published in digital form, and all older printed materials would need to be converted to digital form (unless some print materials were deemed useless and discarded). Even then, users would need appropriate computer workstations and peripherals in their dorm rooms, offices, and homes that were linked to the digital library by high-speed network connections. Remote users would also need interactive digital video links to library staff so that they could get research assistance.

How feasible is it to convert the printed materials held by academic libraries to electronic form? Lesk reports that Cornell University's scanning of nineteenth-century books cost $30 to $40 a volume; however, the Andrew W. Mellon Foundation's JSTOR project found that, when OCR and correction services are added to basic scanning costs so that texts could be searched, conversion costs were 39 cents a page (or $120 for 300 pages).[1] The Library of Congress's National Digital Library Program estimates that its per-page conversion cost is between $2 and $6.[2]

In 1994–95, the 108 academic libraries that were members of the Association of Research Libraries collectively held 356,411,095 volumes.[3] The eleven nonacademic member libraries held an additional 58,486,602 volumes, for a total of 414,897,697 volumes. These collections overlap to some unknown degree, but they can be assumed to contain unusually high percentages of unique material. The cost of converting the collective collection of these largest North American research libraries would be staggering even if copyright were not an issue, which it will be for most twentieth-century material. For copyrighted materials, the copyright holder must be located and permission secured before digitization can take place. It cannot be assumed that copyright holders will be easy to locate or willing to permit conversion if located. It is likely that granting conversion permission will be contingent on fee payment and the successful negotiation of license agreements.

Another conversion issue is that scholars value and want to study the printed work as an object. A digital copy is not an acceptable substitute for the original work. Rare works also have economic value and are unlikely to be discarded even if they are converted.

Given the expense, complexity, and legal difficulties associated with digitization, academic libraries are likely to convert only a small subset of their print collections to digital form.

Since publishers have been using computers to support their operations for some time, it might be assumed that this would speed the conversion of materials published in the latter part of this century. However, it is only in recent years that major publishers have started permanently storing information—both text and graphics—used in the print publication process in standard, reusable electronic formats. Consequently, publishers face a similar conversion problem to that of libraries.

Copyright and Control

In recent years, rapidly increasing serials costs have strained academic libraries' collection budgets. This has resulted in increased scrutiny of the scholarly journal publishing system, causing many critics to note that universities pay scholars to write articles, scholars sign over their copyright to publishers, and, with these copyrights in hand, publishers sell the articles back to universities at high cost in the form of journals and article reprint rights. Calls for reform, including the possibility of universities assuming the role of electronic publishers, have grown more frequent, but, so far, universities are taking little concrete action.

Nonetheless, publishers are concerned, and this trend heightens uncertainty about how scholarly electronic publishing will evolve.

The issue of who should control scholarly publishing is likely to be aggravated by an upsurge of copyright reform activity at the national and international levels. This activity has been driven by publisher concerns over the protection of copyrighted works in the Internet and other network environments. Typically, proposed reforms significantly expand copyright holders' rights to control electronic information, while weakening libraries' and scholars' rights to utilize and redistribute it. Should such legislation be enacted, a scholarly information system could evolve where printed materials can be more freely used than electronic ones.

When producing computerized multimedia or other composite works, both publishers and scholars have discovered that the process of securing copyright permissions for the inclusion of images, video, and other types of information is complex, time consuming, and potentially expensive. This has hampered the development of these products.

Copyright is the foundation of the existing publishing system. Without difficult-to-reach consensus about how the rights of readers and publishers can be fairly balanced in the electronic environment, scholarly electronic publishing will not be an adequate substitute for print publishing.

The CDA Ruling

In addition to copyright issues, national, state, and international governments are increasingly attempting to regulate other aspects of electronic communication on the Internet and other networks. Although the range of issues seems to grow daily, censorship of electronic information is a key concern of academic libraries. An important example of this trend is the Communications Decency Act (CDA), struck down twice by lower courts and then by the Supreme Court, which would have imposed severe legal penalties for allowing minors to access "indecent" electronic materials. Since many materials needed for education and scholarly research may be viewed as indecent (e.g., artistic representations of nudity), this law would have had a chilling effect on library electronic information services. Legislative attempts to censor electronic information are likely to continue, potentially resulting in a scholarly information system where printed works have more legal protections than electronic ones.

Scholarship and instruction cannot be effectively conducted via electronic means if they must be restricted to dealing with works that are acceptable to the most conservative members of society.

Cyberscholarship and Its Rewards

Without question, electronic publishing has been a great boon for many researchers. Electronic indexes and other electronic research tools have speeded up the research process and permitted more location-independent research. As consumers, users seem to have few complaints.

As electronic publishing matures, more source materials, such as journals, are being published solely in electronic form. When faculty assume the role of authors, the question arises as to whether publication of a work in electronic form is fully equivalent to publication in print form for the purposes of promotion and tenure. This is an issue for refereed electronic journals because they are new journals published in a new medium. In the print world, authors prefer to publish in well-established, widely read, prestigious journals. Electronic journals are not yet perceived as first-tier publications, and it is unclear how long it will take for this to occur. There are also issues related to the permanence of electronic journals and their accessibility via finding tools such as indexes (some older electronic journals are now indexed, but many others are not).

Another key aspect of user acceptance is that different disciplines rely on different types of information. For example, a physical scientist may believe that current preprints and articles are the most important source of scholarly information, but a humanist may feel that books published between the fifteenth century and the present perform this function. Since journals are likely to migrate to electronic form before books, and many older books may never be in digital form, the scientist in this example may feel that electronic information is far more valuable than does the humanist, and this could affect their respective attitudes about the acceptability and validity of electronic publishing. There may be challenges associated with the acceptance of electronic journals, but at least they represent a transformation of an existing form of scholarly communication. As electronic publishing matures and its true potential is realized, scholars will produce new types of electronic documents that do not derive from older print-based models. These new documents will be even harder to judge by conventional standards.

For scholarly electronic publishing to flourish, scholars must feel that it is equivalent to print publication, and they must be rewarded for publishing in this medium.

The New Infrastructure and Its Needs

Books and other printed works are high-resolution, portable information storage devices with a familiar user interface and no expensive, complex technical support requirements. Electronic information has unique capabilities not found in print, but poses many challenges that print does not.

Unlike print information, electronic information relies on a complex and expensive technological infrastructure for its dissemination. Rapid technological obsolescence aggravates this problem. Given the relentless pace of change in the computer industry, the definition of an "adequate computer platform" for producing, delivering, and utilizing electronic information is a moving target, and hardware and software must be replaced on a regular basis to continue to provide needed functionality. The useful life of computer hardware and software is shortening as the pace of change quickens.

66

For scholarly electronic publishing to flourish, scholars must feel that it is equivalent to print publication, and they must be rewarded for publishing in this medium.

99

As noted earlier, publishers must invest in sophisticated publishing systems and deal with a variety of technological issues in order to engage in electronic publishing. Another infrastructure issue that affects them is that the scholarly publishing market is global; however, customers in developing countries may not have access to the computer

and network technologies needed to take advantage of electronic information products. Even in many developed countries, Internet access can be more difficult and expensive to obtain than it is in North America. Consequently, publishers cannot abandon print until the majority of their customers can effectively utilize electronic information, and, until this occurs, they must bear the added costs of electronic publishing on top of existing print publication costs.

Academic libraries must struggle to absorb growing software, hardware, network, and data costs in their budgets while continuing to perform their traditional print-oriented missions. While some commercial electronic publishers are supporting standard-based access to information (e.g., Web access and Z39.50), many require that proprietary software be used to access their products (this is especially true of CD-ROM vendors). This, combined with the need to restrict access to conform to license agreements and to count accesses for record-keeping purposes, results in academic libraries having to act as system integrators for a growing number of vendor products. To provide users with an easy-to-use, menu-driven environment, libraries must construct and maintain technically complex network software and hardware environments. It is unclear when (if ever) this will become unnecessary given the unpredictable nature of information technology development, where "straight-line" future projections often fail.

Of course, academic libraries do not provide the campus-wide infrastructure that is needed to fully support electronic information services. They rely on academic information technology units to provide centralized services, such as a reliable high-speed campus network, Internet access, dial-access modem pools, and general purpose computer clusters. Information technology units face significant challenges to build, maintain, and support needed campus-wide services.

With a robust campus-wide infrastructure in place, users can access electronic information resources from their offices, dorm rooms, and homes as long as these locations are equipped with an appropriate computer workstation that has a network connection or modem. For students and other users who cannot afford to purchase, upgrade, and periodically replace this equipment, remote access will be impossible or ineffective.

As any World Wide Web user knows, there is a significant difference in transmission speed between on-campus network access and dial access. While technologies for significantly improving home access speed, such as cable television modems, are emerging, improvements in campus networks and Internet connectivity may result in a continuing performance gap between on-campus and home access.

Given the display capabilities of current computer monitors, few users are eager to read long documents sitting at their computer, espe-

cially if they are using portable computers. Consequently, many electronic documents are printed for reading purposes, and the ability to print documents quickly on high-resolution printers is an important factor in electronic document use. Users may not have access to printers with these capabilities in their offices, dorm rooms, and homes. When academic libraries provide such printers, the issues of growing printing costs and paper storage requirements must be dealt with.

While printing permits document portability, some capabilities of electronic documents can be lost in the process. For example, a long electronic document may have numerous hypertext links to remote Internet sites. Hypertext navigation is lost when the document is printed.

Until all remote users have high-speed access to electronic information resources using networked workstations and fast printers, a large number of workstations are needed in the library. The fewer users who have this access, the more workstations the library must supply.

To provide needed capabilities, electronic information is often encoded in special formats. For example, word processors use proprietary file formats. Unfortunately, these formats can become obsolete, and, if data is to survive, it must be regularly converted to new formats. Standard data representation formats, such as SGML, will help address this issue; however, they are often complex and they, too, evolve over time.

A Slippery Slope: Information Authentication and Integrity

When a scholar reads a printed book or journal, there is a reasonable degree of certainty that it is not a fake and that it has not been tampered with. Such assurances are not yet common in the electronic information arena. Given the ease with which electronic information can be copied and edited, it can be altered and republished on the Internet and other networks in ways that make detection difficult. Technological strategies to deal with these electronic information authentication and integrity problems, such as public key encryption, are emerging, but are not now in common use in scholarly publishing.

A related problem is that a self-publishing author of an electronic document may change it without notification. If different versions of a document are not clearly identified and preserved, scholars cannot accurately quote from them or cite them.

Print-based scholarship has relied on the existence of an official, unchanging body of literature. For electronic scholarly publishing to

flourish, existing information authentication and integrity problems must be solved.

Electronic publishing will become increasingly important, and it has the potential to transform scholarly communication, opening up exciting new possibilities that were impossible in a print-based publishing system.[4] However, rapid technological progress does not necessarily translate into the swift and acceptable resolution of a host of fiscal, legal, logistical, social, and other issues that this technological progress raises.

For the foreseeable future, print is likely to continue to play an important, but gradually diminishing, role in scholarly communication. To support research and teaching, academic libraries will need to develop "digital libraries" that greatly enhance expedited access to print materials at the same time that they provide effective access to a growing array of electronic materials. To achieve this goal, physical facilities will need to be expanded or constructed as required to provide adequate space for print and electronic collections, computer and network servers, user workstations, study seating, service desks, and staff offices.

Acknowledgments

The author wishes to thank Pat Bozeman, Pat Ensor, Judy Myers, Martha Steele, and Linda Thompson (all of the University of Houston Libraries) for their comments on an earlier version of this paper.

Notes

1. Michael Lesk, "Going Digital," *Scientific American* 276 (March 1997): 58.

2. Guy Lamolinara, "Metamorphosis of a National Treasure," *American Libraries* 27 (March 1996): 31–33.

3. Martha Kyrillidou, Kimberly A. Maxwell, and Kendon Stubbs, comps., *ARL Statistics 1994–95: A Compilation of Statistics from the One Hundred and Nineteen Members of the Association of Research Libraries* (Washington, D.C.: Association of Research Libraries, 1996), 28.

4. To further investigate electronic publishing issues, see: Charles W. Bailey, Jr., *Scholarly Electronic Publishing Bibliography* (Houston: University of Houston Libraries, 1996–97). Available at http://info.lib.uh.edu/sepb/sepb.html.

Electronic Journals

Revolution or Evolution?

■ ■ ■ ■ ■

VIRGINIA M. SCHESCHY

The changing nature of scholarly communication in the electronic environment has been a topic of considerable interest in the professional literature, as have issues confronting libraries in dealing with electronic journals. Much less has been written about the role that commercial publishers have to play in this scenario. The majority of serial literature is published by the commercial sector—not by university presses, and not by professional organizations. Until they become major players in the electronic publishing arena, the revolution that is anticipated may not occur. An even more distressing possibility for commerical publishers is that their failure to enter the market now could ultimately reduce the influence they have—and the profits they make—from their role in facilitating scholarly communication.

Early E-journals

Electronic journals and newsletters first appeared as modest efforts by individuals or organizations to communicate more efficiently with a select audience. The first edition of the *Directory of Electronic Journals*,

VIRGINIA M. SCHESCHY is the director of technical services at Getchell Library, University of Nevada, Reno. Her e-mail address is scheschy@unr.edu.

Newsletters and Academic Discussion Lists[1] published in 1991 included just twenty-seven electronic journals and sixty-seven electronic newsletters. Only six of the journals were peer reviewed, and distribution was free for all but two of them. Comparatively few titles had a print equivalent.

In July 1992 OCLC (Online Computer Library Center) introduced the *Online Journal of Current Clinical Trials.* This was one of the earlier efforts to publish and actively market a scholarly journal in electronic form. Guidon, a proprietary graphical user interface, was developed to permit the display of equations, tables, and both color and black-and-white images. It provided timely publication of scholarly information, with comprehensive searching and browsing, and distributed access. The publication existed only in electronic form and did not have a print counterpart. Perhaps for that reason it did not attract the number of submissions that the publisher had hoped for. Even today electronic journals are not widely regarded as an acceptable medium for publication for promotion and tenure.

By 1994 the number of electronic journals had expanded sufficiently to warrant increasing attention in the professional literature of librarianship. However, *Electronic Journals in ARL Libraries: Issues and Trends*, published in that year, indicated that a somewhat narrow view still existed regarding the definition and role of an e-journal in academic libraries.

> Electronic journals are typically issued in electronic format only and are made available over the Internet. . . . Scholarly electronic journals generally originate in academic institutions, are usually free of charge to subscribers, and attempt to imitate the basic features of print serials.[2]

This definition may have been appropriate at a time when commercial publishers and vendors had not yet established their presence in the field. However, this is no longer the case, as publishers and distributors experiment with different cost models and attempt to both anticipate and react to demands from the scholarly and library communities. The field of electronic publishing is evolving so quickly that it's difficult to define what an electronic journal is and will become. For now a reworking of the definition of "serial," found in the *Anglo-American Cataloguing Rules*, will suffice:.

> An electronic journal is a publication in digital form that is issued in successive parts, usually bearing numeric or chronological designations, and intended to be continued indefinitely.

Insurmountable Opportunities?

While association and university presses may be satisfied if their publishing ventures at least cover costs, commercial publishers must make a profit for their owners or shareholders. They must carefully weigh the risks and opportunities presented by electronic journals. Obviously editorial work will remain, but publishers find the prospect of being able to dispense with printing and distribution by mail a very appealing one. However, there are many issues to be considered as publishers evaluate how best to take advantage of a potentially lucrative business opportunity while minimizing the risks. The Internet is transforming the way business is being done, and publishers do not want to be marginalized while others gain prestige and reap profits by capitalizing on new opportunities.

66

Scholars for the most part remain reluctant to contribute the results of their research to journals that exist only in electronic form.

99

Despite increasing coverage in the media of the growth of Internet resources and services, higher education has not been quick to embrace all forms of electronic information. The reaction has been one of cautious optimism, as libraries subscribe to electronic databases and journals but, at least initially, also continue subscribing to their print counterparts. Scholars for the most part remain reluctant to contribute the results of their research to journals that exist only in electronic form. Some technical and legal obstacles may actually be easier to overcome than the bias of the academy in favor of print publications for important scholarly research. Copyright in the electronic environment continues to be a vexing issue. Even when electronic journals are considered the equivalent of print for promotion and tenure, the authenticity of works published in the new medium may be in question. There must be a way to guarantee the integrity of electronic scholarly information.

Libraries are the primary subscribers of most scholarly journals, so publishers would be wise to listen to librarians' concerns. A major complaint of both scholars and librarians is that indexing for electronic journals is almost nonexistent. This means lack of accessibility to scholars, who are not going to browse or do keyword searching of multiple small data sets to retrieve the information now available through periodical indexes. Librarians continue to be frustrated by the variety of cost models being offered by the publishers of electronic journals. This is in marked contrast to the print standard of one copy for one annual subscription price, which is simple and straightforward. Also confusing are the various restrictions in publisher licensing agreements. In some cases, library staff must identify ranges of campus IP addresses to authenticate potential users of an electronic resource. In other cases, systems staff work on CGI scripts to create password access that is hidden from library users.

While publishers are grappling with the obstacles to publishing and distributing electronic journals, they're also hearing from scholars who are eager to take advantage of the unique benefits that this medium can offer. This includes the power of full-text searching along with the timeliness of electronic publishing. In addition, there are options to incorporate video images and audio with full text, the ability to link to other online resources, and opportunities for interactive discussion among subscribers. Not to be overlooked by publishers is the enthusiasm with which the next generation is embracing all things digital. At some point the problem of user acceptance may very simply cease to exist.

In the meantime librarians are hoping to reduce the not inconsiderable costs associated with purchasing and storing journal literature. Even if electronic subscription prices are not substantially lower than for print, there will be savings in not having to bind and shelve print volumes.

A Toe in the Ocean: Before the Plunge

Publishers are now starting to take the plunge, or perhaps a better analogy would be that they are dipping their toes in the water. Some logical steps are being taken to enter the market without incurring substantial financial risk. The trends listed below will certainly facilitate the transition from print to electronic journals.

1. Begin by offering existing print titles in electronic form.

In the early 1990s scholars and librarians alike were heaping accolades on e-journals such as *Post Modern Culture* and *Bryn Mawr Classical Review,*

both available at no cost. However, it appears that OCLC was ahead of its time in offering the *Online Journal of Current Clinical Trials* in electronic form only. This was a publication that required the payment of real dollars, that used a proprietary search interface, and that was not (in its early years) indexed by any of the standard indexing tools. Publishers seem to have learned from OCLC's experience, and rather than introducing new electronic journals, are now offering existing print journals in electronic form. This eliminates two significant problems that OCLC encountered with its pioneering effort: (1) the titles are familiar to scholars so they will not be reluctant to submit manuscripts to publishers, and (2) the print counterpart of these e-journals is indexed.

IDEAL, which has been developed by Academic Press, is a good example of the new services being offered. It is a three-year pilot project to expand and improve access to existing scientific journals. Included in this program are all 178 journal titles published by Academic Press. While there is no charge to search tables of contents, institutions must have a site license to authorize users to view, print, and download complete articles. The American Institute of Physics (AIP) has recently launched its Online Journal Service and offers libraries free access for 1997 to searchable, full-text versions of the AIP journals to which they subscribe. The Society for Industrial and Applied Mathematics (SIAM) is also offering a special promotion in 1997 for free online access to subscribers of its print journals. It is not clear whether a fee will be charged by either publisher beginning in 1998.

Two strategies are common to many of these efforts. One is the provision for users to view tables of contents or even abstracts without charge. This often generates interest in the full text of the articles offered. Payment, either by subscription or per use, is then required to view, print, or download the full text. Another strategy is to offer free access to a resource for a limited period of time and then to initiate a charge. An online edition of the *Wall Street Journal* was available for several months until September 1996, when the publisher began charging for access.

A number of libraries have been purchasing access to collections of e-journals for some time, not from publishers but through companies such as University Microfilms International (UMI) and Information Access Company (IAC). For years these companies have provided access to databases that index and in some cases provide abstracts to articles in journals, newspapers, and other publications. An increasing amount of full text is now being offered by these and other third-party providers. Through its ProQuest service, UMI provides full-image

databases by scanning a number of journals. IAC's full-text service is available in either ASCII form or with graphics to libraries that invest in a proprietary print server from the company.

Adding the option of electronic access to familiar and respected print journals is an important transitional step and will allow everyone associated with scholarly journals (publishers, scholars, and librarians) to become comfortable in dealing with the demands of this new medium. Changes in the present system of scholarly communication evolve slowly, so this transitional period will buy time for the promotion and tenure process to catch up with the technology.

2. Take advantage of the ubiquity of the World Wide Web.

The World Wide Web is indisputably the "killer app" of the Internet. The ease of use and colorful graphics have captured the imagination of countless new users. For many people in higher education Netscape is as essential to their work as word-processing software. Thanks to Bill Gates and Microsoft, copies of Internet Explorer are now available to virtually anyone who purchases a new microcomputer. People from grade-school students to senior citizens are creating their own home pages and are quite comfortable with a variety of Web browsers. This means that publishers no longer have to create their own search and display interface, as OCLC did with Guidon.

Today the World Wide Web and HTML (hypertext markup language) are leading the way. It is not uncommon for publishers to offer Web access to tables of contents and even abstracts of journals, with full text available as PDF (Portable Document Format) files using Adobe Acrobat. This provides a good replication of the printed page. However, readers want more than just to see a print copy of scholarly journals online. While this does distribute access and offers the power of online searching, it does not take advantage of the multimedia capabilities of e-journals or the option to link to other electronic resources. Digital design and electronic page layout present a new challenge to publishers. Michael Jensen asks, "Why present flat non-interactive pictures of pages when you can present hypertextually rich, multidimensional material directly via HTML or SGML?"[3]

Another technical consideration involves use of the Internet for commerce by for-profit companies. Network traffic continues to increase exponentially while graphics intensive Web applications gobble up bandwidth and are sometimes painfully slow to download. Also, subscribers to electronic journals are at the mercy of their Internet service providers. Problems with a router in Stockton, California, can (and have)

left scholars and librarians in Reno, Nevada, without access to important resources. Dependence upon a network over which they have no control is a risk, but one that publishers must be willing to take.

3. Forge alliances with other business partners.

Just as publishers don't want to be left on the sidelines watching the electronic journal revolution, neither do other businesses whose primary clientele are libraries. OCLC has been serving the needs of libraries for over twenty-five years. From its original focus on providing cataloging copy to Ohio libraries, it has branched to other services including interlibrary loan and reference databases. In the early 1990s it experimented with electronic publishing and, more recently, has launched an ambitious venture to provide access and to archive journals in electronic form. At regular intervals OCLC has been issuing press releases announcing yet more strategic partners in its new service, Electronic Collections Online. Web access is provided to tables of contents and abstracts, with full-text articles available in Adobe's PDF. One of the more powerful features of this service is the ability to do cross-journal searching. OCLC also offers comprehensive statistics to institutions using its service, thus making it possible for libraries to gather reliable statistical evidence on patterns of electronic journal usage.

Blackwell has developed the Electronic Journal Navigator to provide access to electronic journals. The contents of over 250 electronic journals will be available, and some of the participating publishers include Wiley, Chapman and Hall, and Kluwer. EBSCO now has EBSCO Online Subscriptions and has formed a partnership for this purpose with Academic Press. Both EBSCO and Faxon have cooperative agreements with OCLC to offer subscription services to electronic journals that are available via Electronic Collections Online. Companies that have been competitors are now working together to distribute and lessen the risk of these new business ventures and to strengthen their position in the marketplace. They are sharing technology and content, as well as the good will and reputation they have built in serving the needs of scholars and librarians.

4. Leave the archiving of electronic journals to others.

Publishers need not be overly concerned about establishing digital archives for their electronic journals—any more than they have served this function for print journals. Libraries have accepted the responsibility for preserving serial literature, whether in print or microform. Through in-house collections with extensive journal backruns and cooperative interlibrary loan arrangements, the nation's libraries have

successfully served their users' needs for periodical literature. The online environment, however, provides different opportunities to serve this need. Libraries will depend on remote sites to provide Internet access to electronic journals. They will also look to these and other sites for access to electronic backfiles. As mentioned earlier, OCLC is prepared to offer this service. The more strategic alliances it can forge, the more attractive it will be for libraries that can link to a single site for access to a multitude of titles.

A promising new venture is JSTOR, a not-for-profit organization with the ambitious goal of converting the backfile archives of over one hundred scholarly journals from print to digital form. Journal issues are taken apart, scanned, then processed with optical character recognition (OCR) software. For optimum access three files are created—the initial

"

By the beginning of the new millennium electronic journals will be as familiar to library users as CD-ROM products are today.

"

image file, the OCR text file, and a table-of-contents file. They are uploaded to JSTOR file servers, which can be accessed by academic institutions that have purchased site licenses. This will simultaneously address library preservation issues, improve journal access, and reduce journal storage costs for libraries. And yes, OCLC has now formed a strategic alliance with JSTOR.

Will electronic journals be accepted by scholars and librarians? Eventually, by most of them. Will they replace print journals? Possibly in the distant future, but certainly not in the near term. Gradually—but inevitably—the issues that currently provide barriers to the acceptance of and widespread access to electronic journals will be resolved. By the beginning of the new millennium electronic journals will be as familiar to library users as CD-ROM products are today. Print journals will not be completely replaced, but will exist side-by-side with their electronic counterpart. Each format will find a market that capitalizes on its

unique features and strengths. As Carol Tenopir stated in her column in
Library Journal:

> Rarely do new options supplant the old; they merely add new options.
> And while the web may make electronic publishing work best, it is not
> likely to replace other options, especially print.[4]

The *American Heritage Dictionary* defines evolution as "a gradual
process in which something changes into a significantly different, espe-
cially more complex or more sophisticated, form." This offers a good
description of the current transformation of journal literature. While
"dead-tree editions" of journals will continue to have their supporters,
even as the card catalog still does, the future of journals is electronic—
creation, distribution, access, and storage. Publishers who understand
this are well positioned to continue serving the needs of scholars and
librarians, while making a fair and equitable profit for their efforts.

Notes

1. Michael Strangelove and Diane Kovacs, comps., *Directory of Electronic Journals, Newsletters and Academic Discussion Lists.* (Washington, D.C.: Association of Research Libraries, 1991).

2. Elizabeth Parang and Laverna Saunders, comps., *Electronic Journals in ARL Libraries: Issues and Trends,* (Washington, D.C.: Association of Research Libraries, 1994).

3. Michael Jensen, "Digital Structure, Digital Design: Issues in Designing Electronic Publications," *Journal of Scholarly Publishing* 28 (October 1996), 13–22.

4. Carol Tenopir, "The Complexities of Electronic Journals," *Library Journal* 122 (1 February 1997), 37–38.

Shift or Drift?

Decision Making in the Movement from Paper to Digital Collections

■ ■ ■ ■ ■

LISA COVI and ROB KLING

Many people take for granted that we are making a transition from paper to digital libraries for research and education as part of an inevitable information technology revolution. Faculty, staff, and students examine national indicators showing exponential growth in the use of the Internet and find support for these assumptions. Furthermore, in virtually every academic discipline, they find numerous experiments with electronic media: World Wide Web home pages for classes, journals, conferences and scholarly societies, repositories of experimental data, collections of personal bibliographies and literary materials. Given these assumptions, we might expect that academic administrators who are charged with planning information technology support for faculty, staff, and students would be working to make a "digital shift" from supporting paper to supporting electronic materials. However, a closer

LISA COVI is a postdoctoral researcher at the Collaboratory for Research on Electronic Work (CREW) at the University of Michigan. She holds degrees in mathematics, higher education, and information and computer science. Her main research interests are in work practices surrounding the use of information and collaborative systems in organizations. Her e-mail address is covi@umich.edu.

ROB KLING is a professor of information science and information systems in the School of Library and Information Science at Indiana University, Bloomington, where he also directs the Center for Social Informatics. He is also editor-in-chief of *The Information Society* and author of *Computerization and Controversy: Value Conflicts and Social Choices*. His e-mail address is kling@indiana.edu.

look at decision patterns about resource planning also revealed a pattern of "drift" toward increasing investments in digital libraries while sustaining support for paper libraries.

We conducted a study in 1995 to investigate some key issues surrounding the transition from use of paper to electronic materials in university libraries and campus computing infrastructure (Covi 1996; Kling and Covi 1995). In this chapter, we will describe how academic administrators, facing budgeting and policy issues about information technology access for research and education, were making decisions concerning these transitions. In particular, are resource decisions signifying a shift in support from paper to digital libraries or a more incremental drift towards increasing support for digital libraries?

A Shift Away from Paper . . .

Paper libraries are rarely the glamour centers of university life: they often store books in musty stacks, attempt to maintain tight control over the collections, and are well posted with signs warning visitors to remain quiet and leave food and drink outside. They sometimes offer quiet places for reflective reading, but are often used as warehouses in which faculty and students seek specific kinds of books or articles but read them elsewhere. Libraries bear a greater resemblance to the stoic halls of ancient museums or the cramped quarters of small used bookstores than to the more popular social settings of commercial book superstores of the nineties. These brightly lit venues offer the comfort of overstuffed chairs in which to sample a wide variety of merchandise surrounded by the smell of piping hot coffee and an opportunity to munch on a sticky roll. Although a small number of research universities have recently built new "library buildings" (some offering hot beverages nearby), these new facilities often highlight electronic resources and services over print repositories, which are limited or relegated to the margins of the activities therein.

In addition to the unappealing burden of maintaining and circulating paper collections, university libraries pose major expenditures for educational institutions. In 1994–95, forty-five North American universities each spent between fourteen and sixty-eight million dollars a year on academic libraries. Twenty-three of these universities each spent over twenty million dollars a year (ARL 1996). These expenditures get relatively little attention from faculty and students, who view libraries as warehouses or study space. The size of the university library collection used to be a cherished status marker of the value of the institution.

66

Libraries bear a greater resemblance to the stoic halls of ancient museums or the cramped quarters of small used bookstores than to the more popular social settings of commerical book superstores of the nineties.

99

However, in our study, we listened as faculty and doctoral students complained about the lack of accessibility of books and journals they wanted to read (Covi 1997). In the last ten years libraries have been faced with rapidly rising prices for books and journals. As a result of rising costs and relatively flat (and sometimes declining) institutional budgets, university librarians have usually slowed the rate at which they buy books and have sometimes canceled large numbers of journals subscriptions.

. . . and the Movement Toward Digital

We interviewed academic administrators and faculty who relayed stories about the exciting elements of digital libraries for research and education. They defined digital libraries from two common approaches, one based on Internet services and the other based on library automation. Computer scientists have a loose definition of digital libraries including a variety of complex databases. They focus on collections of whole-text documents and images that are available via Internet services, such as FTP, gopher, and World Wide Web (WWW). These corpora are still growing at a relatively rapid rate and include a wide variety, but rarely comprehensive (or sometimes comprehensible) collection of diverse materials. Library and information scientists cast a different net and identified digital libraries with a variety of catalogs, bibliographic databases, and agglomerations that offered whole text (Arms 1990; Buckland 1992). Buckland originally defined an "automated library" as computerized bibliographic access to a paper collection. "Digital libraries" grew

out of this automation movement and have also been called electronic libraries or bionic libraries by this particular community. Digital libraries were offered independently of the Internet (although often available through it), and collections and services were usually purchased by university libraries.

Many direct costs of automated library services showed up in university library budgets, and their costs and usage were, in principle, controllable by academic administrators such as university librarians and chief academic administrators such as provosts and academic vice chancellors. The contracts for automated library services and parts of the human and technological infrastructure to support them can be traded off against other parts of academic library budgets. For example, one university librarian claimed to be investing in automated library support with a growth rate of 10 percent, while the rest of his much larger overall budget remained flat. This budgeting process resembles a problem-solving method called disjointed incrementalism (Lindblom 1979), which focuses on areas for remediation rather than specific broad ambitions. Despite optimistic plans for improving research and education with information technology campus-wide, academic administrators were careful to align their projects with other incremental goals, such as serving more students and lowering costs. Instead of advocating a desirable rate of investment for library automation, these data reveal that academic administrators made investment in digital libraries relatively visible, controllable, and tradable against other inputs for library services (i.e., holdings, hours, and staffing).

The control over access to Internet-type digital library resources is relatively decentralized in North American universities. Universities support access to the Internet, but the nature of such access and the ways that academic schools, departments, and institutes pay for services varies from one university to another. During the time of our study, some "leading-edge" universities had provided two ethernet connections to every campus office and classroom, while other universities had wired only a fraction of offices (often in the sciences) with twisted pair and didn't offer SLIP or PPP. Universities relied upon academic units to find funding for relatively "up-to-date" high-performance PCs or Macs and printers if they wanted such equipment for all faculty and doctoral students. Universities varied in the extent to which they centralized or decentralized the purchase of file servers or in support for computer training, network consulting, and other "human infrastructure." A local collection of computers, networks, software, and technical staff did not constitute a digital library. It provided a basis for faculty, staff, and students in that locale to search for, try to read, possibly print, and use documents that are stored in digital form elsewhere.

Step by Step on the Digital Path

A few (often elite) universities have created Internet-type digital library resources of their own. Projects to create campus-wide information systems, e-mail directories, or online catalogs for each academic department are examples of "big-step" computing policies (Lindblom 1979). In contrast, most universities have grown their networks and digital library resources over longer periods of time through incremental extensions. But the use of campus computer networks for research and education depends upon numerous decentralized decision processes (such as how to decide whether research or curricular materials should be available online) that fragment centralized efforts to use both paper and digital resources. For example, we found one project to catalog a special collection of rare prints that was clearly a mutual process between a faculty member (who had a cadre of students who would find it easier to work with this material) and a librarian who needed a constituency to justify budgeting for a previously little-used resource.

The costs of acquiring and storing materials from the Internet-types of digital libraries were also hidden from institutional accounting. For instance, faculty had different standards for what costs they could bear for electronic materials. Many humanities scholars continued to use computers with 80 megabyte disk drives while a few computer scientists had 40 gigabyte disk farms. We had difficulty finding academic administrators who had institutional budgetary control over the diverse resources necessary for effective access to both digital libraries and paper libraries. While most research universities were incrementally increasing their support for Internet access by faculty, staff, and students, it did not seem to be managed in some visible way as a direct trade-off with paper library investments. Moreover, to ensure reliable and convenient access to materials necessary for their research, faculty and doctoral students created their own paper and electronic collections, thus reducing their repeat use of shared central resources (Covi 1996). In contrast with the journals, books, and bibliographic resources that libraries make available to all, the paper and electronic materials in faculty offices were not widely shared or even visible to others.

Academic administrators base their primary information technology investment decisions on modest incremental extensions of their preexisting information technology infrastructure rather than on trying to match the national level growth in signs of demand for digital media in academia. They track local measures of actual computer use as a basis for planning—the number of people who seem to depend upon World Wide Web for their work, the demand for electronic mail accounts, and the number of information retrieval requests from bibliographic data-

bases. To be sure, many research universities have some kind of digital media supported somewhere on their campuses. As an example of a digital shift, almost every major university and many minor universities created institutional Web pages for their campuses in 1994 and 1995. (Many of these Web pages were built rapidly by using preexisting materials from campus gopher files that had been developed between 1992 and 1994. Even so, the depth and variety of materials on these collections of pages is uneven). And it was easy to find universities that supported a particular electronic journal, or electronic course reserves for a few courses, and so on. A few universities, such as the University of Southern California with its fifteen million dollar Leavey Library, have developed major centers for electronic media in support of teaching and research. But such examples of the scale of the Leavey Library are expensive and rare. The spotty and idiosyncratic patterns of "pockets of interest in electronic collections" seems to be more common today.

These findings about disjointed incrementalism in North American research universities are not immediately generalizable to national industries making decisions about major information technology investments. Characterizing investment as "digital drift" is, in fact, contrary to literature promoting information systems as purposive strategic investments (Morton 1991). Even those who cast a critical eye on the ways that organizations computerize tend to assume information technology managers make purposeful, rational decisions—albeit around values that they criticize (see, for example, Zuboff's studies [1988] on automating versus informating). However, academic administrators would do well to take note of an interesting set of studies of the ways that decisions based on managerial rationality in industry may backfire, and findings about unintended outcomes (e.g., Zuboff 1988; Kling and Iacono 1989; Orlikowski 1993).

Shift, Drift, and Organizational Behavior

How can we best describe these increasing investments in digital libraries? Overall, universities are making steady increases in their investments in digital library resources. While there are occasional large investments in digital resources, the bulk of investments seem to be driven by local disjointed incrementalism within departments. There might seem to be a big digital shift from paper to electronic materials taking place in universities. There certainly is technological momentum behind this move. However, in research production, paper materials remain the preferred mode for scholarly publication.

"

North American universities appear to be steadily drifting into more intensive digital investments with little managerial oversight about the extent to which their investments are effective or efficient, adequate or frugal.

"

Faculty outside the humanities preferred to publish in paper journals and often personally subscribe to four to eight journals. Aside from computer science, most faculty exchanged preprints in paper by mail. Moreover, even computer scientists preferred to print electronically stored preprints and technical reports for reading. There are today perhaps one hundred refereed electronic journals, but few seem to be widely read by top faculty researchers and scholars (Covi 1997; Kling and Covi 1995). Furthermore, when faculty, staff, or students do read electronic journals, they usually print the articles for sustained reading. Paper does not disappear when people use digital materials.

North American universities appear to be steadily drifting into more intensive digital investments with little managerial oversight about the extent to which their investments are effective or efficient, adequate or frugal. Few academic administrators seem to see this situation as a problem. Brown University's mid-1990's President Vartan Gregorian commented:

> The role of the president, of course, is not to lead the development of new information technologies, nor even to herald their arrival, argue their importance, or warn of their dangers. If presidents are successful at their leadership and managerial tasks, then there will be plenty of others who will be doing those things within the university community. The role of the president is to establish a process that will promote the integration of these new technologies, with each other and with the mission and the core values of the university (Gregorian 1996).

Presidents delegate the oversight to provosts and other senior administrators. In turn, oversight is delegated down and across the

administrative hierarchies. In the end, faculty, their curricula, and their disciplines drive the demand for digital media.

Quantifiable indicators such as the number of Web sites, electronic mail addresses, or even bits carried across research networks impress academic administrators to consider large shifts in resource allocation. After all, how can they attract research funding and capable students and support the best research without access to digital libraries? Nevertheless, in our study we observed how drift toward increasing investment in digital libraries and disjointed incremental decision making figure prominently in campus information technology policy. The necessity of basing decisions on decentralized use in a period of strong fiscal limits for universities makes drift rather than shift dominate the information technology decision making concerning the transition from paper to digital libraries in North American universities in the next decade.

Acknowledgments

Phil Agre, Michael Buckland, Mitzi Lewison, and Mike Zack provided helpful comments on this manuscript. An earlier version of this paper was presented at the Association for Information Systems 1995 conference. Funding was provided, in part, by U.S. Department of Education Grant #R197D40030.

References

Arms, Carolyn, ed. 1990. *Campus strategies for libraries and electronic information.* Bedford, Mass.: Digital Press.

Association of Research Libraries. 1996. *ARL Statistics 1994–1995.* Washington, D.C.: ARL.

Buckland, Michael. 1992. *Redesigning Library Services: A Manifesto.* Chicago: American Library Association.

Covi, Lisa M. 1997, in press. "The Future of Electronic Journals: Unpuzzling researchers' attitudes about electronic journals." *Revista Española de Bibliologia.* Asociacion Española de Bibliologia, Spain.

Covi, Lisa M. 1996. Material Mastery: How University Researchers Use Digital Libraries for Scholarly Communication. Unpublished Ph.D. Thesis, University of California, Irvine, Calif.

Gregorian, Vartan. 1996. "Technology, Scholarship, and the Humanities: The Implications of Electronic Information" in Kling (1996).

Kling, Rob, ed. 1996. *Computerization and Controversy: Value Conflicts and Social Choices.* 2nd ed. San Diego, Academic Press.

Kling, Rob, and Lisa Covi. 1997, in press. Digital Shift or Digital Drift?: Theorizing Institutional Transitions to Electronic Media in Scholarly Work. *The Information Society.* 13, no. 3.

Kling, Rob, and Lisa Covi. 1995. "Electronic Journals and Legitimate Media in the Systems of Scholarly Communication." *The Information Society.* 11 (4):261–71.

Kling, Rob, and Suzanne Iacono. 1984. "The Control of Information Systems Development After Implementation" *Communications of the ACM*, 27, no. 12 (December).

Lindblom, Charles E. 1979. "Still Muddling, Not Yet Through" Public Administration Review 39, no. 6 (November/December):517–26.

Orlikowski, Wanda J. 1993. "Learning from Notes: Organizational Issues in Groupware Implementation." *The Information Society* 9, no. 3 (July–September):237–50. Also reprinted in Kling (1996).

Scott Morton, Michael, ed. 1991. *The Corporation of the 1990's: Information Technology & Organizational Transformation.* New York: Oxford University Press.

Zuboff, Shoshana. 1988. *In the Age of the Smart Machine: The Future of Work and Power.* New York: Basic Books.

Basic Principles for Managing Intellectual Property in the Digital Environment

March 24, 1997

■ ■ ■ ■ ■

NATIONAL HUMANITIES ALLIANCE

The National Humanities Alliance (NHA) statement of Basic Principles for Managing Intellectual Property in the Digital Environment was drafted by the NHA Committee on Libraries and Intellectual Property and is intended to help build consensus within the educational community on mutual expectations for publisher and user behavior regarding the use of intellectual property in the digital environment.

The statement grew out of the NHA Board's concern with the limited progress being made by the Conference on Fair Use (CONFU) discussions. The Board believed that if agreement could not be reached by the various groups represented at CONFU, it was important for the educational community itself to come to consensus on these issues. Not only would such a consensus allow creators, publishers, and users to move forward in the digital environment, but it would also provide individual institutions and coalitions a common set of broad principles against which to evaluate legislative proposals. Moreover, the educational community would strengthen its position in the ongoing legislative debates on intellectual property if it could speak with one voice.

THE NATIONAL HUMANITIES ALLIANCE was created in 1981 to unify public interest in support of federal programs in the humanities. The Alliance is made up of scholarly and professional associations; organizations of museums, libraries, historical societies, higher education, and state humanities councils; university and independent centers for scholarship; and other organizations concerned with national humanities policies.

Reprinted with permission of the National Humanities Alliance.

The NHA is seeking broad endorsement of these principles by universities, scholarly societies, and other research and educational organizations. Individual institutions are encouraged to use the document to foster discussion of copyright-related issues on their campuses; to seek institutional endorsement of the statement; and to develop institutional policies consonant with these principles. Formal endorsements can be sent to John Hammer, Executive Director of the National Humanities Alliance, 21 Dupont Circle, NW, Washington, DC 20036, or <john@cni.org>.

Preface

The following document was prepared by the Committee on Libraries and Intellectual Property of the National Humanities Alliance (NHA) in an effort to build consensus within the educational community on the uses of copyrighted works in the digital environment. While the Committee members represent primarily institutions within higher education, the Committee believes that the principles presented here apply to a broadly defined educational community encompassing many other institutions and individuals, including primary and secondary schools, independent research laboratories, faculty and students, and independent scholars. Participants in the NHA Committee's discussions are listed at the end of the document.

The Committee would like to thank the University of California System for giving us permission to use as the foundation of our work their excellent document, "University of California Copyright Legislation and Scholarly Communication Basic Principles."

Context

Introduction

The educational community encompasses a broad range of public and private institutions whose primary missions include research, education, and the preservation of our scientific and cultural heritage. In the process of carrying out their missions, these institutions, which include research universities, colleges, university presses, libraries, scholarly societies, museums, and archives, among many others, are both creators and consumers of scholarly communication. As such, these institutions

participate in the full spectrum of activities regulated by the laws governing copyright and must be sensitive to the balance of interests embodied in them. While a degree of consensus has been reached concerning the rights of creators, copyright holders, and users of information in the print environment, new proposals for the copyrights of digital works are threatening to disrupt the balance between the rights of owners and public access in the electronic world.

❝

Unlimited technological capacity to disseminate by transmission in ways that can violate the rights of copyright holders confronts equally unlimited technological capacity to prevent works from being used in ways contemplated by law.

❞

As they revolutionize the means by which information is recorded, disseminated, accessed, and stored, digital technologies are eliminating the technical limits that have supplemented the legal framework of balance between ownership and public dissemination: Unlimited technological capacity to disseminate by transmission in ways that can violate the rights of copyright holders confronts equally unlimited technological capacity to prevent works from being used in ways contemplated by law. Carried to its logical extreme, either trend would destroy the balance, with results that would likely undermine core educational functions as well as radically transform the information marketplace.

Scholarly Communication

The educational community is heavily invested in scholarly communication. This process includes such functions as: exchange of cutting-edge discoveries and works-in-progress among scholars, scientists, curators; publication of new and synthetic works for the broad scholarly community; dissemination of new and existing knowledge to students through

teaching; establishment of repositories to enable handing knowledge down from generation to generation; and transmission of knowledge beyond the educational community to the public. It requires the ability to cite and quote the work of others, regardless of format. Whereas quotations from text can be manually transcribed, quotations from digital objects may require machine mediation. Scholarly communication involves individuals, academic departments and research units, libraries, archives, university presses, museums, commercial publishers, external research sponsors, academic and industrial software developers, and others.

Because it carries information that ranges from complex graphical and sound data to plain text, and must reach an audience that ranges from Nobel scientists to freshmen in remedial courses to citizens visiting a local museum, scholarly communication must include the full range of content and take place in all media. It must flow back and forth between all of its participants and be capable of moving rapidly enough to contribute to the evolution of understanding and knowledge. It must be disseminated through an economically viable system, and it must not be overwhelmed by a permissions system so burdensome that it makes rapid movement impossible.

Scholarly communication is based on an ethic of authorship that both compels publication and condemns plagiarism. It demands accurate attribution and respect for the integrity of works while asserting the importance of evaluating and interrogating sources for cumulative advance of knowledge. By promoting trust between authors, owners, and users, adherence to this ethic facilitates the rapid and broad dissemination of information. Educational institutions have developed organizational structures that insulate faculty, curators, and students—the core, but not the only, participants in scholarly communication—from direct dependence on economic returns from specific intellectual properties. Instead, they rely first on institutional rewards for their cumulative success in creation and dissemination. The institutions, however, function as both owners and consumers of the intellectual properties that circulate in the process of scholarly communication. As such, some of these institutions, such as museums, university presses, and scholarly societies, depend on the revenue from copyright ownership to support their educational, dissemination, and preservation missions.

The Documentary Record

New knowledge cannot be created without extensive reference to work already done by others and to the accumulated records of human and natural phenomena. Nor can the accumulated collective knowledge of

a society be transmitted intact to succeeding generations without its preservation and organization. Libraries, museums, and archives play crucial roles as custodians of knowledge and must continue to do so in order to carry out core educational missions. Faced with an exponential increase in the rate at which documentation is growing, libraries, museums, and archives increasingly seek to exploit the unprecedented storage capacities and facility for more effective access strategies of digital media. Moreover, the increased data creation and storage capacities generate new pressures on systems for preservation, organization, and access.

Although the functionalities of digital technologies will continue to give rise to practices and relationships that bear little resemblance to those surrounding print, neither novel arrangements nor enhanced capabilities should obscure the fundamental continuity of purpose underlying preservation and organization. The requirements of the academic mission and the accumulation of a cultural heritage do not cease when information and documentation cease to have commercial value and pass out of the marketplace. Hence, relations among copyright holders, educational institutions, and the law must reflect the needs of the future as well as the present and should acknowledge the added value to society of preservation and of well-ordered systems for navigating information.

Approaches to Change

During 1995 and 1996, the U.S. Congress and the World Intellectual Property Organization (WIPO) have attempted to revise intellectual property law to address issues raised by the still evolving digital environment. Domestic legislation died in subcommittee during the second session of the 104th Congress amidst contentious debate. Internationally, the WIPO treaties proved more supportive of the principle of balance between the rights of owners and the need for public use. But the treaties must now return to the U.S. for ratification and the possible development of implementing and related legislation.

The educational community urges that changes in the law be carefully crafted to enhance rather than impede the rich and timely circulation of information as well as its preservation and organization. The educational community recognizes the difficulty of prescribing a priori practices for a digital environment in which:

- commercial, academic, and public practice is still experimental and fluid;
- works as different as software, research reports, textbooks, primary text sources, visual art, and sound recordings are included;

- a volatile set of technologies for protection, dissemination, and tracking is being developed, whose implications are often not clear; and

- a wide variety of formats and media is involved.

Working on the frontiers of technological, economic, and legal knowledge, the educational community seeks opportunities for experimentation with new institutional arrangements for managing the dissemination and preservation of knowledge contained in copyrighted and public-domain works. It also seeks a legislative and economic environment that fosters collaboration and a search for consensus rather than confrontation and litigation.

In preparation for the ongoing legislative debates on intellectual property in the digital environment, the educational community believes it necessary to develop its own consensus on a common set of broad principles which would provide standards against which coalitions and individual institutions can evaluate legislative proposals. Faced with the strong interests of the infotainment industry to maintain tight control of intellectual property in a global marketplace, the educational community may strengthen its more balanced position by speaking as one voice guided by the principles. The following principles are based on the "University of California Copyright Legislation and Scholarly Communication Basic Principles," Working Draft, December 2, 1996.

Principles

The educational community approaches pending changes in copyright and neighboring intellectual property law (e.g., *Sui Generis* Database Protection Act) with the overriding conviction that it is in the interest of the evolving U.S. information society that the legal environment foster rather than disrupt the balance between intellectual property owners and the public good that is embodied in current law.

1. *Copyright law provisions for digital works should maintain a balance between the interests of creators and copyright owners and the public that is equivalent to that embodied in current statute. The existing legal balance is consonant with the educational ethic of responsible use of intellectual properties, promotes the free exchange of ideas, and protects the economic interests of copyright holders.*

Intellectual property is a significant form of social capital, whose growth depends on its circulation, exploitation, and use. As a major arena

in which intellectual property is created and disseminated, educational institutions have nurtured an ethic of intellectual property based on:

- respect for the rights of creators and copyright owners;
- accurate attribution and respect for integrity;
- guarantees of preservation;
- promotion of dissemination and access; and
- economic viability of the scholarly communication system.

This ethic complements the provisions of copyright law, which provide one form of protection for certain kinds of intellectual properties and a framework for their dissemination that encompasses all sectors of society, including both market and non-market transactions.

Existing copyright law recognizes the tension between the needs of society and the rights of creators by permitting a defense against charges of infringement for certain uses of copyrighted works as specified in sections 107–110 of the U.S. Copyright Act of 1976. Among these uses are: the fair use of copyrighted works for teaching, scholarship, or research, among other activities; the reproduction of copyrighted works by libraries and archives under certain conditions for specific purposes; and the performance or display of a work by instructors or pupils in the course of face-to-face instruction. Equivalent qualification of owners' rights should be extended into the digital environment with appropriate safeguards against abuse.

- These principles should be independent of particular technologies. Current statutory language embodies some of them in detailed prescriptions for specific practices in the print, tape, and broadcast environment. These are based on the print context in which the same object—a copy—is used to store, distribute, and use a work, and the simultaneous performance of more than one function (e.g., storage and distribution) requires the creation of more than one copy. In the digital environment, storage, distribution, and use are accomplished by algorithms instead of copies, and practices sanctioned by law in the paper environment may have significant unintended consequences. Accordingly, legislative efforts to extend print practices into the digital environment should focus on objectives rather than on strictly analogous practices.

2. Copyright law should foster the maintenance of a viable economic framework of relations between owners and users of copyrighted works.

The rich and timely circulation of information—regardless of whether it is contained in physical or electronic media—underlies the educa-

tional mission. It depends upon a viable publishing industry to promote communication across institutional and disciplinary boundaries and upon a sustainable library system to store, preserve, organize, and provide access to information. Other institutions, such as museums and historical societies, depend on a reliable source of revenue from their copyrighted collections to support their equally important stewardship responsibilities.

- To this end, the educational community supports the use of copyright ownership to enable publishers, creators, and owners to secure reasonable returns on investments in intellectual products and sustain their enterprise.

- Management of rights should encourage a reasonable balance between the cost of permission seeking and the use for which permission is sought.

- The educational community opposes extensions of copyright protection that would suppress fair competition or allow monopolies to prevent users from accessing and using information in an economical and convenient form. (For example, the proposed *Sui Generis* Database Protection Act, with its perpetually renewing rights, could suppress fair competition. In addition, excessive extension of copyright term could have the same effect.)

- Debate over whether and how the first sale doctrine should be applied to digital works is ongoing. Its resolution is likely to involve a complex combination of technical, legal, and business measures. Under existing law, the doctrine of first sale permits the legal purchaser of a copy of a work to dispose of it in any way the purchaser wishes, including reselling, lending, or giving it to others. The ability of libraries to lend is based on this doctrine. Because digital works can be instantly reproduced and transmitted—e.g., by posting on a Web site for browsing—while an "original copy" is retained, many copyright owners fear that extension of first sale rights into the digital environment will destroy their markets. Some have sought to protect their products by asserting that they are licensed rather than sold and that these works can be used only as the license prescribes. Concerned that license restrictions will prohibit the digital equivalent of examining the contents of or borrowing a book or journal without purchase, some libraries argue that a digital first sale equivalent is essential to the teaching and research enterprise. Emerging technologies not yet in the commercial marketplace may provide a means of simulating first sale conditions with "envelope" or "lockbox" software, but it is not yet possible to predict whether they can be applied in desirable ways that are acceptable to consumers.

3. *Copyright laws should encourage enhanced ease of compliance rather than increasingly punitive enforcement measures.*

The law should create an environment that provides incentives for simplified rights clearance and payment while preserving the principle of fair use contained in current law. Burdensome and inconclusive permissions systems may stifle dissemination of copyrighted works or encourage widespread violation of the law, as may undue constriction of fair use exemptions. In extending copyright law and practice to the digital environment, care should be taken that the creation of new rights does not become a disincentive to the circulation of information.

- Copyright law should provide a framework for voluntary contractual agreements that both provide fair returns to copyright owners and create incentives for broad dissemination of information. The law should not permit such contracts to abrogate fundamental legal guarantees, however.

- The law should permit the fair use defense in a contractual environment. At the same time, the law should encourage the application of fair use principles to digital works in a manner that maintains respect for the rights of copyright owners consistent with the provisions of current statute.

- The development and use of automated rights tracking, security technologies, and licensing mechanisms may reduce incentives for many kinds of infringement while simultaneously facilitating enhanced access to copyrighted works of others. Copyright law should encourage such innovations.

- Careful consideration should be given to the advantages and disadvantages of compulsory licensing schemes which require copyright owners to permit certain kinds of uses of their properties and automatically collect fees to pay for such use. Compulsory licensing provisions are already in effect for the broadcast of audio recordings of music. Broader application of this concept has not been thoroughly discussed, and it is premature to advocate for or against such a system for digital works.

4. *Copyright law should promote the maintenance of a robust public domain for intellectual properties as a necessary condition for maintaining our intellectual and cultural heritage.*

The public domain is an intellectual commons that is the essential foundation for an informed and participatory society. It is critical for education, research, and the creation of new knowledge. With copyright terms extending for periods that can exceed 100 years (life of the

66

*The digital format in which a work is first fixed
is likely to become obsolete long before the copy-
right expires.*

99

author plus 50 years), the digital format in which a work is first fixed is
likely to become obsolete long before the copyright expires. Security
technologies used to protect copyrighted works from unauthorized use
will exacerbate this danger if provision is not made for "unlocking" the
work at the appropriate time.

- Information created by governments and public agencies, includ-
 ing under contract, should reside in the public domain as they
 do under current law.

- Privately created works that have passed a certain age should
 reside in the public domain as they do under current law.

- Copyright terms should expire on dates that are certain and easy
 to determine.

- Copyright law should assure that new technologies do not
 impede the passage of works into the public domain as contem-
 plated by current law.

- Copyright law should facilitate preservation and migration to
 new media as technologies change. The educational community
 encourages a distinction between activities necessary for preser-
 vation and storage and activities to provide access to copyrighted
 works. Because technology evolves rapidly, the statutes and reg-
 ulations governing preservation and storage should be flexible
 enough to apply to successive generations of technology.

 5. *Facts should be treated as belonging to the public domain as they are
under current law.*

The educational mission requires that all who are engaged in it be
able to examine and analyze facts without restriction. Compilations of
facts that are creative or add value may be protected by copyright, but
the facts themselves are and should remain in the public domain.

6. *Copyright law should assure that respect for personal privacy is incorporated into access and rights management systems.*

Academic freedom and the Constitutional guarantees of freedom of thought, association, and speech require that individual privacy be respected. In the print environment, individuals may examine works in libraries and examine and purchase them in sales outlets without leaving records of their identities. The educational community urges that legislation be crafted to assure that the rights of individuals to access copyrighted works without recording personal identities are comparably protected in the digital environment.

7. *Copyright law should uphold the principle that liability for infringing activity rests with the infringing party rather than with third parties. Institutions should accept responsibility for acts undertaken at their behest by individuals but should not be held liable for the acts of individuals—whether or not associated with the institution—acting independently. This principle is an essential underpinning for academic freedom.*

The creation and dissemination of knowledge depends on a community of individuals who develop their own scholarly investigations and syntheses. Such a community can only be sustained if the tenets of academic freedom, including freedom of speech and rejection of prior restraint, are upheld. The educational community opposes copyright legislation that would make institutions liable for the acts of individuals acting on their own initiative, or that would impose prior censorship. Copyright enforcement provisions should uphold principles of due process in determining whether specific allegations of infringement are valid. Educational institutions accept responsibility for establishing policies, carrying out due process when appropriate, and creating climates in which all those who use their facilities and resources use copyrighted materials appropriately.

8. *Educational institutions should foster a climate of institutional respect for intellectual property rights by providing appropriate information to all members of the community and assuring that appropriate resources are available for clearing rights attached to materials to be used by the institution, e.g., in support of distance learning.*

As creators and repositories of vast amounts of intellectual property, educational institutions have both a responsibility and a need to assure that their own institutional practices conform to the requirements of intellectual property law and that their constituencies are well informed about their responsibilities. Institutional practices should set high standards for compliance and can serve as an educational tool for

heightening the consciousness of individuals within the educational community of what the law demands. Assurance that institutional practices are fully aligned with legal requirements will strengthen the position of educational entities in negotiating legislative and contractual conditions.

9. *New rights and protections should be created cautiously and only so far as experience proves necessary to meet the Constitutional provision for a limited monopoly to promote the "Progress of Science and useful Arts."*

Sui generis protections should be considered with extreme care and only after an adequate body of case law has accumulated to define the dimensions of what is at stake. Extension of copyright to new classes of works should be regarded with skepticism until it is demonstrated that the extension affirms the traditional balance between owners and users, and care should be taken to consider whether other bodies of law might be more appropriate vehicles for the protection sought and what the consequences of such applications might be.

10. *Copyright enforcement provisions should not hinder research simply because the products of a line of inquiry might be used in support of infringing activity.*

While the law should provide penalties for acts of infringement, attempts to criminalize the possession or acquisition of technologies or devices that might be used for illegal purposes will sweep with too broad a broom. Both applied and basic research related to encryption technologies and computer science may require that researchers be able to obtain state-of-the-art devices in order to participate in the creation of new knowledge. Moreover, decryption technologies may be necessary to place works in the public domain at the expiration of copyrights or to engage in legitimate activities, i.e., preservation. Legal sanctions should be reserved for those activities that violate or directly support violation of the law.

Participants

Participants in the discussions of the National Humanities Alliance, Committee on Libraries and Intellectual Property:

American Association of Museums
 Patricia Williams

American Council of Learned Societies
 Doug Bennett

American Historical Association
 Sandria Freitag

American Political Science Association
 Catherine Rudder

Association of American Universities
 John Vaughn

Association of American University Presses
 Peter Grenquist

Association of Art Museum Directors
 Anita Difanis

Association of Research Libraries
 Prudence Adler
 Mary Case
 Mary Jackson
 Duane Webster, Chair

College Art Association
 Susan Ball

Council on Library Resources/Commission on Preservation
and Access
 Deanna Marcum

Modern Language Association
 Phyllis Franklin

National Association of State Universities and Land-Grant
Colleges
 Laila Van Eyck

National Coordinating Committee for the Promotion of History
 Page Miller

National Humanities Alliance
 John Hammer

National Initiative for a Networked Cultural Heritage
 David Green

Redefining Our Information Institutions

The Shape of the
Twenty-First-Century Library

■ ■ ■ ■ ■

HOWARD BESSER

Social institutions today look vastly different than they did twenty years ago. A variety of forces, most specifically economic changes and technological developments, have reshaped and redefined our notions of what constitutes a bank, a service station, or a bookstore.

Libraries are not immune to the societal forces reshaping other institutions. We can expect the library of the early twenty-first century to bear as much resemblance to a 1970s library as a 1990s service station resembles a 1970s service station.

As the library rapidly evolves into something that looks quite different than it did just a few decades ago, it is critical that librarians not only become aware of this evolution, but that they actively intervene to help reshape the institution in ways that are consistent with the core mission of libraries. Changes to libraries are inevitable, and if librarians do not get actively involved in shaping those changes, it is likely that the twenty-first-century library will carry very few of the core missions and values that have historically been associated with libraries.

This chapter is an attempt to help librarians understand some of the changes that will affect libraries in the coming years, and to prompt librarians to think seriously about how to deal with these changes. The

HOWARD BESSER is an adjunct associate professor in the School of Information Management & Systems at UC Berkeley, where he teaches courses on the social and cultural effects of new information technology. His Web page is at http://www.sims.berkeley.edu/~howard/.

chapter begins by outlining the sweeping changes affecting other types of institutions. It then reviews how technological trends have been affecting library services, and focuses in on the implications of an increasing reliance on resources not controlled by the local library. The chapter then lays out a set of key areas that will challenge libraries in an online age, before discussing a number of the hazards that libraries will face, particularly if library services move out of local libraries into more centralized external sites. It then recommends that libraries examine their core missions, and using public libraries as an example, shows how one might focus in on the vital functions we need to preserve in a changing environment. The chapter concludes with some recommendations about areas of public discourse that librarians can get involved in to help preserve the key missions of libraries.

The Rise of the Megastore

Technology and economics are changing all our institutions, particularly those that shape our towns and cities. The replacement of "mom-and-pop" grocery stores by chain supermarkets over the past several decades has been supplanted by a movement to ever larger superstore markets (such as Safeway's Pak & Save) and warehouses (such as Price Club and Costco). These mega-discount stores now account for 35 percent of grocery sales by volume (Saekel 1991).

The average supermarket today is 7,000 square feet larger than in the beginning of the decade, and supermarket chains are closing stores that are not large enough (Saekel 1991).

Local pharmacies are being replaced by chain "drugstores." Hardware stores are being replaced by "superstores." Many of what we used to call "service stations" have become automatic-feed gas pumps, often accompanied by "convenience stores" that have replaced the service bays.

Thirty-four percent of grocery stores now have coffee bars and 27 percent of markets have banks inside their stores (Saekel 1991; Sinton 1996b). Drug stores are moving into banks (Sinton 1996a), and banks are moving into copy shops ("Glendale" 1996).

This recontextualization, consolidation, and movement to larger, less personal institutions is also affecting the institutions we rely upon for culture. The single-screen movie theater has given way to the mall-based multiplex. Repertory cinemas have almost disappeared, and access to older films is now primarily through video stores (Video Software Dealers Association 1996). Even the relatively new (1980s) institution

of the neighborhood video store is rapidly being replaced by the chain video superstore. And Blockbuster, the largest such chain, has laid out its vision of "a store in every neighborhood" (Blockbuster 1997).

Local independent bookstores are disappearing (Miller 1997, Sarasohn 1997). The proliferation of chain bookstores (such as Waldenbooks) in the 1980s has been replaced by the movement toward superstores such as Barnes and Noble and Borders in the mid-1990s (Mutter 1997).

Institutions that were a consistent part of our social landscape for decades are becoming unrecognizable, and services are becoming like commodities—divorced from any particular domain and shifted from one institution to another. Libraries are not immune to these kinds of changes. We will first examine changes in library service emanating from technological developments; then we will turn to changes in the library's broader role as a public institution.

Technology Transforms

Since the 1980s each new step in library automation has changed library services. In hindsight we can see a number of trends, among them access from multiple locations, making more resources available, making information available in rawer forms, and a diminishment in the role of intermediaries. These trends have been enabled by technological developments in the areas of networking, file storage, and more graphic user interfaces (Besser 1997). They have also been enabled by agreements on standards and protocols (such as Z39.50) that permit the linking together of resources from disparate sources.

Access from Multiple Locations

A key result of automation efforts was to make access more convenient to library users. In the days of card catalogs, library systems often forced users to travel to a central catalog or multiple branches just to discover holdings. Today those users can consult all holdings from workstations throughout the system (and often from home).

This notion of access from multiple locations has also affected the use of indexing and abstracting services. In the 1970s a user who was not willing to incur a significant pay-per-use fee from a private online service had to travel to the site in his or her library system that had the published volume containing the sought-after index. In the 1980s that user had to go to the location that had the CD-ROM of that particular

index mounted. Today those indexing and abstracting services are mounted as online databases or on CD-ROM servers, and are usually accessible throughout the system. Divorcing library services from a physical location provokes a profound difference in what a library is.

Making More Resources Available

For many years library automation systems were thought of as merely ways of delivering only bibliographic records (essentially online card catalogs). But over time these systems have been augmented with more services. Many library automation systems currently deliver indexing and abstracting services. And on a number of college campuses other nonlibrary information services (such as phone listings, course descriptions, class schedules, pre-enrollment capabilities) are being delivered through the same system that delivers library automation.

Making Information Available in Rawer Forms

The types of information available to users in digital form has continued to grow. If we consider a bibliographic record to be a "representation" of an original book or article, then over the past decade we have been providing users with progressively truer representations (i.e., representations that are closer and closer to the original raw material).

In indexing and abstracting services, we have moved from providing searchable index terms or descriptors to searchable abstracts, to (more recently) full text of articles and books. In online library catalogs, we have moved from bibliographic descriptions and subject headings to providing tables of contents information, to full-text and page images.

This movement toward rawer information or more detailed representations is often called "enhanced records" and has been a key element for those studying information retrieval. But if one considers that catalogers and indexers have always been in the business of "abstracting" from original materials to create searchable records, another way to look at these "enhanced records" is as abstracts that are a little closer to the material from which they are abstracted.

Diminishing Roles for Intermediaries

The success of library automation has meant that users increasingly interact with online systems and have less reliance upon library staff.

Many of today's systems allow users to check circulation information without ever contacting the circulation department. Many ILL experiments let the user request a work without ever interacting with a library staff member. And we're seeing an increase in experiments using strategies from the artificial intelligence community to aid user searching.

From Just in Case to Just in Time

We are already seeing a transformation in the world of libraries. Libraries are becoming less important for the materials they collect or house and more important for the kind of material they can obtain in response to user requests. This movement from collecting material "just in case" someone will need it, to delivering material from elsewhere "just in time" to answer a user's needs, is a profound shift for the library as an institution. This shift is a direct result of the recent proliferation of digital networking in an environment where standards for description were already well established.

Along with the changes in libraries as institutions have come changes in the roles of librarians. With the proliferation of networked digital information, the librarian's role is shifting from caretaker of a physical collection to someone who identifies resources in collections housed elsewhere.

This is currently evident in major research libraries where librarians spend much of their time creating (World Wide Web–based) electronic pointers to resources on the Internet. Efforts like this are likely to increase greatly in the foreseeable future. These trends imply less in-person mediation by library staff (as patrons access information directly) but more of a behind-the-scenes mediator role in selection and creating evaluative guides to external resources. This also means a greater role for library staff as instructors, troubleshooters, and guides.

Divorcing libraries and their services from physical collections raises serious issues. Libraries that need to provide access to materials they don't themselves own and control should worry about assurances that they will be able to access that material far into the future. This problem is particularly acute with World Wide Web resources.

At this point in time libraries need to be careful about becoming too dependent upon World Wide Web resources. Web resources often change location, and until location-independent naming schemes replace URLs, updating a library's links to external resources is likely to be a serious problem. Few information providers have the kind of commitment to long-term information maintenance that libraries have;

libraries need to be concerned that the creators of the key resources they link to today may soon tire of updating these resources. Finally, libraries need to avoid relying too heavily upon external information resources that are free today but may become expensive some time in the future; some information providers have learned the same business principle as drug dealers—give out free services until the user is hooked, then start charging.

"

Some information providers have learned the same business principle as drug dealers—give out free services until the user is hooked, then start charging.

"

Libraries that shift their focus from acquisition to access need to realize the implications for other parts of their operation. This often requires a significant investment in equipment and training. It requires the development of an infrastructure to support document delivery. And the process of selection can become even more time-consuming for a library that is pointing users to remote materials than for a library that is buying its own materials. (This is particularly true on the World Wide Web, where pointers have to be constantly maintained, and where there are fewer clues as to the reliability of information sources.)

Bottom Lines and Common Denominators

A number of societal trends have the potential to affect libraries deeply, particularly as these move into the online information delivery environment. Key among these trends are the movement from flat-fee to pay-per-use models, the best-seller phenomenon, the consolidation of electronic information distributors, erosion of privacy, and issues of access and cultural diversity.

Flat Fee vs. Pay-per-Use

The movement toward pay-per-use models is likely to affect users' habits, particularly as this begins to penetrate Web-based delivery systems. Pay-per-use models tend to discourage exploration and encourage a viewer/reader to examine items that others have already deemed popular (favoring best-sellers over more esoteric works). Libraries' 1980s experiences with pay-per-use online indexing and abstracting services led many librarians to embrace newer flat-fee models that have arisen (such as CD-ROMs).

Best-Seller Phenomenon

Economies of scale make mass-distributed information cheap and available, and can lead to an environment where smaller-audience information is more expensive and harder to find (Besser 1995). Over time this may well lead to the favoring of electronic delivery of entertainment over delivery of information (Besser 1994b).

Consolidation of Electronic Information Distributors

As corporate mergers, buy-outs, and consolidations leave us with fewer and fewer independent information providers, how will that change what information people get? Will large conglomerates with interests in many different types of industries begin to treat their information distribution divisions the same way they treat all their other commodity distribution divisions?

Privacy

As people begin to pay for the information they receive electronically, what kind of privacy issues does this raise? Will reading and buying habits be traced and sold as demographic data? Can libraries continue to take their strong traditional privacy stand when providing pay-per-view information?

Access

Who will guarantee access in an era when someone must pay for each byte of information that is accessed? Can libraries continue to provide free (or flat-fee) access to all their constituents in a pay-per-view era? Will society become divided between information *haves* and *have-nots?*

Cultural and Economic Diversity

Will the world of online digital information lead to more or less diversity in that information? Will the best-seller phenomenon take hold

and make available only *least-common-denominator* information (as in broadcast television)? Will the information needs of the less affluent be met in ways that they can afford?

Serving the Masses with Mass Delivery

A key trend affecting all types of commercial enterprises is the movement toward spreading costs over a broad area. Large chain stores have realized economies of scale and have put local stores out of business. In the future there is bound to be pressure on libraries not to duplicate the services of other libraries, but instead for all libraries to rely upon a core set of central services. While experiments like the Internet Public Library (IPL) are exciting and useful, they may prompt a movement toward elimination of local services that some taxpayers think can be best provided centrally.

The 1990s has been an era of shrinking funds for social services. We have seen the decoupling of all types of bundled services along with pressure to make each portion "prove" itself and pay its own way or be eliminated. This kind of pure capitalism is beginning to dominate all forms of public activity and cause restructuring everywhere. Bookstores that previously used the high revenue from best-sellers to subsidize more esoteric works can no longer do so in the face of competition from best-seller discounters. Even universities have adopted the philosophy of having everything pay its own way. For example, the University of Michigan's "value-centered management" system will require each academic department to pay for its own custodial services and electricity and will allow the departments to spend their savings on other activities. Over time it is expected that certain activities that prove costly will be eliminated.

Libraries heavily cross-subsidize their activities. If the cross-subsidy model were ended, one can imagine a scenario where a library would institute a surcharge for checking out expensive books but still allow users to check out cheap books free. Best-sellers might be more freely available because of the economies of scale realized in cataloging multiple identical copies, while rare books might be eliminated because of the heavily subsidized cost of cataloging relatively unique items.

While such a scenario may appear far-fetched, it's not very hard to see pressure developing to contract out services. With advertisements already claiming that "the entire Library of Congress is on the Internet," and the popular discourse about the World Wide Web as a library,

it won't be long before taxpayer groups and parent organizations ask libraries why they can't replace many of their services with some generic library like the IPL. The kinds of economic arguments that have been used with many other types of institutions will be directed at libraries— why are there thousands of similar institutions delivering almost the same set of services? Couldn't you realize great economies of scale by having only a very few institutions deliver these services to the entire country?

Elsewhere this author has discussed the implications of this kind of mass delivery in more detail (Besser 1995, pages 65–67). Services taking the mass-delivery approach tend to steer clear of controversy for fear of alienating part of their clientele, as Apple did when it dropped Voyager's *Making of America* CD from its bundled services (Meyer 1995). And these services often engage in self-censorship to avoid ever getting to the point of controversy. Mass-delivery services usually try to focus on the least common denominator, ending up with the blandness of network television. And they focus on mass-appeal ideas over narrow-appeal ones, partly because of economies of scale and partly because these are less controversial.

Here again, the chain video, music, or bookstore's relation to independent stores has implications for local libraries. In general, chain stores have less diversity. They carry a large number of mass-appeal items and fewer low-volume sellers. Chain stores are more prone to censorship. (Most chains refused to carry Salman Rushdie's works when threatened, while many independents prominently featured them. Wal-Mart has refused to carry recordings that satirize the store (Bates & Philips 1996).) Chain stores focus on national rather than community or regional tastes and standards, and frequently impose these on every local community. (For example, Blockbuster shies away from sexual or politically controversial material even in communities that do not find this offensive.) The market clout of chain stores can affect an entire industry, creating a situation where independent stores cannot obtain certain works even if they want to. (Because they control such a high percentage of the audio CD market, Wal-Mart's insistence on the elimination of certain themes within the music they sell is making the recording industry reluctant to produce music that Wal-Mart won't carry [Strauss 1996].) Over time, chain stores tend to put independent stores out of business and alter both consumer choices and the social landscape (Zoll 1997, Greenwald 1994). And chain stores tend to relate more to advertising and popular culture, while often being divorced from the history of their field. (For example, a recent Crown Books advertisement touted the book based on *Disney's Hunchback of Notre Dame* (Crown Books 1996).

Serendipity Costs; Who Pays?

If libraries *do* rely increasingly upon large-scale external information providers like IPL, these providers themselves will eventually face financial pressures that may lead them to institute new cost-recovery models such as pay-per-item. Pay-per-item models will likely force libraries into multitiered services, giving more extensive services to those who pay more. We've already begun to see multitiered services that have responded to budget cuts, such as information desks staffed by nonprofessionals (to alleviate the load on the real reference desk), experiments in "reference by appointment," and online searches for some key clients.

But the pay-per-item model can have some substantial negative results over the long term. Where flat-fee models encourage exploration, pay-per-use gives people the incentive to focus on information, books, etc., already highly recommended by others. People don't look for new things, but focus on already well-known paths. Pay-per-use discourages browsing. (Imagine how people's reading habits would change if they had to pay for each article they looked at in a newspaper or magazine!) And pay-per-use models lead to a focus on best-sellers, which are cheaper to deliver because of economies of scale (Besser 1994a, 1994b).

As libraries move to redefine their sets of services, they must be careful to avoid being caught in a squeeze play between other institutions that are essentially competing for the library's traditional "customer base." Commercial information services (ranging from Ovid to Lexis to Britannica to Microsoft Network) may skim off many of a library's users. Losing its more affluent customers may cause a cyclical decline in the library's financial support: As people with less clout begin to make up a higher proportion of the library's users, the library will lose stature with more powerful groups who, particularly in an era of deep cutbacks of public services, will be less interested in fighting for library funding.

At the same time libraries are facing increasing inroads from the larger bookstore chains that are currently trying to make their customers feel comfortable browsing, sitting, and reading. The migration of users from libraries to another physical place to sit and read will both undercut the specialness of libraries and further erode the library's support based on the justification that it is the only entity providing certain services.

What Are Public Libraries About?

In an era of changing institutions, libraries need to examine what their missions have been in the past and how they can concentrate on the part

of their core mission that is not repetitive of what other institutions do. Librarians need to find the parts of their core mission that will be sustainable in a changed environment. This section will focus on public libraries as an example.

We need to look at what public libraries are about besides just books, and focus on extending these important parts of the mission into the information age. As many of our tasks get usurped by other bodies and as we lose much of our clientele, we need to ask ourselves, "what are public libraries really about? And what would they be about in an age where checking out books was far less important?"

McClure has outlined a set of "public library roles" (McClure 1987) including: community activities center, community information center, formal education support center, independent learning center, popular materials library, preschoolers' door to learning, reference library, and research center. This set of roles needs to be rethought in an age when physical location and service can be separated from one another; some of these roles are more tied to the library's physical presence in the community, while others may function very well if delivered from remote sites. For example, it is very possible that public libraries will give up much of their local roles as reference libraries and research centers, having those services provided from central or external sites (perhaps supplemented with a set of locally maintained information or pointers).

This author believes that the four core missions of a public library are: that it is a physical place, that it is a focus spot for continuous educational development, that it has a mission to serve the underserved, and that it is a guarantor of public access to information.

Public libraries are, first of all, a physical place. They serve the role of a gathering place and a community information center. Even in a virtual world, the library must maintain this kind of role.

Second, a public library is a focus spot for continuous educational development. With popular discourse stressing the importance of "lifelong learning," this is a set of traditional library activities likely to command public attention and funding in the coming years.

The third key function of the public library is to serve the underserved. This means serving as an on-ramp to the information superhighway for those without the resources or skills to access it elsewhere. It also means transforming digital information into alternative formats for people who can't see, understand, or control the printed word. It means helping serve the poor and the technologically illiterate. And it means giving people a voice, through the establishment of electronic discussions, bulletin boards, etc.

The library also needs to promote diversity. According to Leonard, "the great majority of public library patrons continue to be white,

middle class, and fairly well-educated" (Leonard 1993). But early in the twenty-first century racial and ethnic groups are expected to outnumber whites in many areas of the country.

How do we reflect this kind of diversity? Ideally, not by following the "one size fits all" model of broadcast television, which gave us a very white-bread environment during its first thirty years. Instead, we need to rely upon local communities to develop the diversity in personnel, in services, and in materials. This includes diversity efforts in staffing and recruiting. It includes provision of services important to a more diverse clientele (addressing survival needs, legal and political assimilation needs, heritage needs, and entertainment needs and providing education for life skills and multilingual services). Our collection development also needs to reflect diversity, providing materials that reflect different cultural viewpoints, gender equity, and a variety of historical perspectives, and to avoid clichés, stereotype, superficial portrayals, and demeaning differentiation.

The fourth key function of the public library is as guarantor of public access to information. This goes far beyond providing access to those who make use of the library's services. In an online world where an increasing number of people get their information from sources other than libraries, this means fighting for core library principles (such as equal access and fair use) in environments outside library walls. As technological developments and legislation threaten to erode these principles in an online environment, librarians need to join with other public interest groups such as the Digital Futures Coalition (www.dfc.org) to extend some of the principles of our field into the information age. Without a strong campaign, principles such as equal access and fair use will disappear in the online environment. These principles are critical even in environments where the information is not delivered by libraries, and librarians still have a vested interest in defending them.

Librarians should exert pressure to extend the "library bill of rights" into cyberspace. They should push for "equal access to information," which implies subsidies for the have-nots and for public institutions such as schools and libraries. They need to fight against censorship. They also need to fight against the commodification of information, pay-per-use schemes, intrusions into users' privacy, and the increased concentration of information content providers into a few corporate hands.

The library is an integral part of the society that surrounds it. It is shaped and changed by many of the same forces that shape other types of institutions. Librarians need to recognize the changes that have already taken place in libraries and to be aware of the ways in which broader societal changes are affecting other institutions. Then (rather than sitting idly by and passively observing the evolution of the library

as an institution) they need to use this knowledge actively to reshape the library. If librarians do not become involved in this reshaping, key principles from librarianship may disappear in the library of the future.

Acknowledgments

This chapter was given as a talk entitled "Threats to Public Access in the Digital Age: What Will Happen to Libraries?" at San Francisco Public Library on August 7, 1996, and reformulated into a talk title "Impact of Information Commercialism: The Downside" for the LITA/ LAMA National Conference on October 15, 1996. Small portions of this chapter previously appeared in the author's chapter in *Resisting the Virtual Life* (Besser 1995) and in the *ASIS Bulletin* (Besser 1994b). Discussions with Paul Peters inspired a number of these ideas. The persistence of Milton Wolf and GladysAnn Wells brought this chapter into print. Sharon Seidenstein provided editorial assistance.

References

Bates, James, and Chuck Philips. (1996). "Wal-Mart Won't Sell New Record that Criticizes It," *San Francisco Chronicle*, September 10.

Besser, Howard. (1997 in press). "The Transformation of the Museum and the Way It's Perceived," in *The Wired Museum*, ed. Katherine Jones-Garmil (Washington, D.C.: American Association of Museums).

Besser, Howard. (1995). "From Internet to Information SuperHighway," in *Resisting the Virtual Life: The Culture and Politics of Information*, ed. James Brook and Iain A. Boal, San Francisco: City Lights, 59–70.

Besser, Howard. (1994a). "Fast Forward: The Future of Moving Image Collections," in *Video Collection Management and Development: A Multi-type Library Perspective*, ed. Gary Handman. Westport, Conn.: Greenwood, 411–26.

Besser, Howard. (1994b). "Movies-on-Demand May Significantly Change the Internet," *ASIS Bulletin 20* no. 7 (October/November), 15–17.

Blockbuster. *One World, One Word* [public relations booklet], The Blockbuster Infoset, February 24, 1997.

Crown Books. 1996. [Advertisement], Book Review Section, *San Francisco Sunday Chronicle & Examiner*, June 16, 12.

"Glendale Offices in Kinko Copy Shops," 1996. *San Francisco Chronicle*, November 20.

Greenwald, John. 1994. "Up Against the Wal-Mart," *Time*, August 22, 58.

Leonard, Gillian D. 1993. *Multiculturalism and Library Services*, New York: Haworth Press.

McClure, Charles et al. 1997. *Planning and Role Setting for Public Libraries,* Chicago: American Library Association. (figure 11).

Meyer, Michael. 1995. "Putting the 'PC' in PCs—Software: A flap over censorship spooks Apple," *Newsweek,* February 20, 46.

Miller, Mark Crispin. 1997. "The Crushing Power of Big Publishing," *Nation,* March 17, 11–18.

Mutter, John. 1997. "Analysis 96: One Size Doesn't Fit All," *Publishers Weekly,* January 6, 40–42.

Saekel, Karola. 1997. "Big Changes for Supermarkets: To survive in the '90s, one has hired a 4-star chef," *San Francisco Chronicle,* April 2, 1.

Sarasohn, David. 1997. "Independent's Day," *Nation,* March 17, 31.

Sinton, Peter. 1996a. "Wells Fargo to Put Drugstores in Banks," *San Francisco Chronicle,* July 3, A1.

Sinton, Peter. 1996b. "Wells Plans Big Expansion in Safeways," *San Francisco Chronicle,* August 2, C1.

Strauss, Neil. 1996. "Wal-Mart's CD Standards Are Changing Pop Music," *New York Times,* November 12, A1.

Video Software Dealers Association. 1996. *The Home Video Industry: A White Paper on the Future of Home Video Entertainment,* Encino, Calif.: Video Software Dealers Association.

Zoll, Daniel. 1997. "Home Despot: While America's neighborhoods fight Home Depot domination, our mayor sells out the city's mom-and-pop stores," *San Francisco Bay Guardian,* February 26, 19–20.

The Object in Question

Museums Caught in the Net

■ ■ ■ ■ ■

ROBERT SULLIVAN

Every society is held together by certain modes and patterns of communication which control what kind of society it is . . . Just as the physical environment determines what the source of food and exertions of labor shall be the information environment gives specific direction to the kinds of ideas, social attitudes, definitions of knowledge, and intellectual capacities that will emerge.

—Neil Postman[1]

The Internet represents a wholly new mode and pattern for communication, not only for this society, but soon for the world. Its scale and pervasiveness will require every educational institution to respond and consider its mission in the context of this emerging virtual world. The Internet is as powerful a development for the diffusing and shaping of information and knowledge as the printing press. Like any communications technology, it is not merely a passive, efficient delivery system, it is a value-laden meeting place with a distinctive electronic ecology. It is rapidly becoming an alternative community with its own residents, rituals, economy, values, morality, and language. In the same way that the printed word as a medium of diffusion encouraged linear, sequential, and vertical ways of thinking, the Internet encourages nonlinear, nonsequential, horizontal ways of thinking and connecting knowledge. The instantaneous horizontal connectivity of the Internet collapses time and space and evaporates or challenges all efforts by information and

ROBERT SULLIVAN is the Associate Director for Public Programs at the Smithsonian Institution's National Museum of Natural History.

knowledge rich institutions to remain isolated, fragmented, walled chambers. All of these technical and ideological characteristics of the Internet have direct implications and impact on institutions that are in the knowledge business. Museums have been traditionally seen as repositories for objects and destinations for learners. Their community and national reputation was built upon the perceived value of the collections they possessed. With the advent of the Internet, they are no longer necessarily isolated destinations; they can become active hubs within widespread learning networks. Their walls have become electronically permeable and access to collections in the twenty-first century may become as important as possession of collections was in the twentieth century. Museums as walled repositories of knowledge and

"

Perhaps the level of comfort and grace museums exhibit in navigating the permeable boundary between the virtual and actual museum, and between the virtual and actual object, will be a hallmark of the mature twenty-first-century museum.

"

information now have the opportunity to tear down those walls and join in an unimpeded flow of knowledge. But at what experiential, intellectual, and social cost? How do we establish some distance from our technologies, acknowledge their limitations, and keep from becoming them? How do museums as social institutions keep the quiet conversations that happen between people and things alive and seductive? How do we continue to be advocates for the direct experience of sensuous reality? In a media-saturated landscape, how do we remain contact points, touchstones, for the tangible, mysterious experience of the actual landscape? There is a livable and valuable balance point between virtual and actual experiences of things, people, and knowledge and that is the fulcrum to be sought. Perhaps the level of comfort and grace museums

exhibit in navigating the permeable boundary between the virtual and actual museum, and between the virtual and actual object, will be the hallmark of the mature twenty-first-century museum.

The Real Thing

It is very appropriate, at certain times of the day or night, to look deeply into objects at rest . . . Worn surfaces, the mark hands have left on things, the aura, sometimes tragic and always wistful, of these objects, lend to reality a fascination not to be taken lightly.
—Pablo Neruda[2]

One metaphoric way to think of a museum's public role is that of a thermostat. As a thermostatic, educational institution, one of the functions of the museum is to offer a set of learning experiences that provide a counterargument to the patterns dominating the mainstream culture. Broadly speaking, for example, this means that if the mainstream culture values disposability and consumption, the museum visibly embodies the values of preservation and conservation; if the mainstream culture values ephemeral, disembodied, virtual experiences, the museum should counter with concrete, tangible, actual experiences of things. In this positioning of the museum as a distinctly worthwhile alternative to the virtual experience, the museum can be radically conservative, which is both an oxymoron and a strategy. One initial response the presence of the Internet provides is an external motive for the museum to rededicate itself to the presentation of the solitary object at rest.

Direct, sensual interaction with the three-dimensional object, not merely as a source of information, but as a bodily, reflective, and imaginative experience, is fundamental to the museum's identity. For museums, the object is a source of inspiration as much as information. It is an iconic, intimate, mnemonic, often metaphoric way of remembering and experiencing reality. The meanings and values of objects are dynamic and routinely transformed by time, context, and the complex transactions that occur between them and active, value-laden perceivers. The object's position and reality is never finally fixed or unilaterally decodable as a passive source of data. The experience of the object as object is open-ended, multisensory, somatic, indeterminate, interactive, personal, sometimes even transcendent. The centrality of the experience of the object for museums creates a comfortable counterpoint with electronic media. As people's leisure time, entertainment, and learning experiences become increasingly saturated by media, the experience of the minimally mediated object in social settings will become a desirable

alternative experience. If museums remain radically conservative in their tradition of the object, they can generate an alternative niche market for themselves directly related to their one indispensable resource, the tangible object.

As digital communications media increasingly isolate learners in private learning space, the opportunity to learn in social groups outside the home will become increasingly desirable. As the presentation media of dioramas, exhibitions, etc., are superseded by electronic, virtual presentation media, these traditional museum exhibition techniques will be increasingly perceived as closer to reality, more authentic, "the real thing." The novel environment of the physical museum, unlike its virtual counterpart, requires the presence of fully sensing bodies. Sound, smell, touch, voice, ache, all are essential ingredients in the somatic experience of the museum and will seem to the digitally overexposed, a valuable relief from the disembodied experience of the Net. Ironically, the natural history life group, or the recreated historic room, or the great urban expositions, were the virtual reality of the turn of the last century. At the turn of this century, superseded by digital media, these same presentations are seen as experiencing the real thing. As such they will be seen as a more worthwhile experience, closer to reality, than their electronic alternative. One unexpected advantage of the existence of the virtual, online experience and digital simulations of museums and museum objects is to clarify and delineate the alternative that the actual museum offers. As novel, multisensory, three-dimensional environments that place a premium on presence and materiality, museums clearly offer a welcome harbor to escape the immateriality of cyberspace. In some ways, the emergence of the Internet may strengthen our hold on this experiential niche and increase both its visibility and value to visitors. A first, easy museum response to the Net, then, is to not respond at all and hold tight to our commitment to objects as experiential media. We can let the Net itself establish and redefine the value of the distinctive experience museums offer. Tired of getting the busy signal? Let your feet do the walking and log on to your local museum. The connection is immediate and sensually satisfying.

A Virtual Museum

While the direct sensory experience of objects is central to the mission and meaning of museums, it in no way exhausts their educational purposes or potentials. It is in these other arenas that the Internet is an

explosive outreach tool for museums, not only extending the spread and impact of the museum experience, but creating wholly new categories of experiences for virtual visitors. The actual visitor experience in museums is more provocative than comprehensive as a learning experience, and tends to be ephemeral in nature. The amount and depth of data about any given object, and the number of connections that can be made between an exhibited object and other material is severely limited by both space and time. Often the length and quality of a museum experience is more determined by the state of the visitor's feet than the state of his or her minds. The Internet is physically easy and accessible and can collapse space and time. Hundreds of thousands of virtual visitors can attend an exhibition tirelessly and simultaneously. Depth of data available about an object and interconnections between objects are limited only by visitors' interest and the internal interconnectedness of the Net site. Virtual museum visits can be totally personalized and interactive. Creatively designed text and image data bases will allow visitors to create their own exhibitions. The existing combination of in-depth information and quality images makes the museum presence on the Net a natural and efficient extension of an already existing resource.

Creating a virtual museum online is not unlike creating an actual one, although the ultimate uses of the two might appear quite distinct. As with all new media, the content is often transferred from previous media until the unique capacities and capabilities of the new media are better understood. It seems safe to say, however, that in both the actual and virtual museum, the common element is access to objects, images, and knowledge about them. These collections represent the unique resource museums can bring to the educational, entertainment, and research markets. At the foundation of both the virtual and actual museum, then, is an diverse, well-documented, richly cross-referenced collection of objects that is meaningfully and readily accessible to learners of all sorts.

After a solid and accessible collection is established, the interpretive products that mine the multiple meanings and connections between and among objects can be generated. Discovering and presenting the engaging stories, relationships, and unexpected connections that objects reveal is at the heart of the museum as educator. Whether in exhibitions, publications, performances, or other public programs, museums are ultimately rich storytellers about the diverse objects in their collections and how they came to be the way they are. This role need not change on the Internet. However, the capabilities and possibilities of the Internet suggest practices and experiences that may bear no resemblance to the actual museum visit and experience.

Four characteristics of the Internet experience seem important to consider:

Connectivity

The ability of the Internet instantaneously to connect thousands of horizontally related resources and sites allows for customized and unexpected exhibit experiences. Instead of one exhibition that serves many people, Web exhibits can be multiply organized and customized. No two people need see the same exhibition. Unexpected connections and surprises can be programmed into the experience. Millions of visitors can be simultaneously navigating the same exhibition elements, each connecting them in a unique way. Such exhibitions are not confined by space, as visitors can visit research sites, pursue related library resources or images, access video and audio. Webness implies connectivity and suggests new forms of interinstitutional collaboration that ignores traditional boundaries and territories. Visitors should be able to leap comfortably from one museum site to another and easily find their way back again. Ocean Planet, the first Smithsonian exhibition online, allows visitors to leap to NASA, NOAA, Navy weather data, university sites with oceanographic data, etc. It is a fully permeable and interconnected exhibition allowing visitors to pursue subject matter until their interest is satisfied.

Interactivity

Real time and distance interactivity are hallmarks of the Internet, and it is the ability of users to make authentic and impactful choices that will distinguish the mature virtual museum. Real time peer-to-peer exchanges can happen as part of the virtual museum visit. A far-flung family, for instance, could choose to visit the virtual museum together and share responses and experiences. Bulletin boards and chat rooms can provide instantaneous or delayed interactions between virtual visitors and museum staff. Ongoing forums on cultural issues could be conducted online. The Exploratorium in San Francisco, for instance, mounted an exhibition of photographs of the devastation of Nagasaki as part of the fiftieth anniversary of the dropping of the atomic bomb. On two interactive sites, the pros and cons of the issues of dropping the bomb and the retelling of history were hotly debated in real time. Bulletin boards were also provided for those who wanted to leave their solitary comments for others to react to. An edited version, a "best-of" board, was online as a reference tool for new debaters. This interactive community forum became a vital and highly personal extension of the exhibition. Such activities effectively relocate authority from the singular institutional point of view of the actual exhibition to the multi-vocal points of view of multiple interacting scholars and visitors.

Gaming

Gaming is perhaps the most creative and dangerous capacity of the Internet and other digital media. Multi-user domains or MUD rooms are a seductive form of online experience involving users in complex real-time games, often controlled by a central master who determines the dynamics of the game. "Dungeons and Dragons" is perhaps the most famous of these types of games and it cast an insidious shadow of mind-control and obsession. However, the notion of an museum-based, object-centered, educationally worthwhile online game is an intriguing alternative to the passive, or minimally interactive, exhibition. For example, a mystery setting (the theft of the Hope Diamond, the search for the missing curator) could propel visitors into an engaging behind-the-scenes adventure designed both to educate and to entertain.

Simulation

Digital simulation is still another strength of the Internet relevant to the museum experience. Online collections built with open digital architecture and interoperable and inheritable softwares could be directly manipulated and enhanced by visitors. A digitized beetle, for instance, might be animated as a bio-technical school project working interactively with museum scientists. The next year's class might add the habitat for the beetle to interact with, discovering and visualizing the biological facts of the beetle's environment and adding the richness of the digital environment. The fragility and rarity of actual objects are constraints to their mobility and use. The virtual object can be in perpetual motion. Once digitized it can be sliced, measured, compared, taken apart, and recombined. A three-dimensional digitized object is infinitely flexible, transparent, available. Because the Internet is not space constrained, the resources developed there can accumulate and be systemic in their effect and availability. Unlike the actual museum where exhibitions are episodic and come and go, Internet resources remain stable and accessible to be integrated and interconnected for classroom and home use.

In the end, then, what does the existence of the Internet mean to museums? There are two related answers: nothing and everything. Radical traditionalism is one answer: holding close to the long-held commitment to the sensual, provocative, reflective experience of the object; providing a novel, three-dimensional environment for social, interactive, first-hand learning with minimal mediation. Or create a wholly new virtual museum that provides new types of experience based on the unique strengths and capacities of this new fluid medium. At the moment, the potential is limited only by our imaginations and our willingness to challenge all the old bounded paradigms of what makes a museum.

Notes

1. Neil Postman, *Teaching as a Conserving Activity* (New York: Dell Publishing, 1987) p. 33.

2. Pablo Neruda, quoted in Luis Poirot, *Pablo Neruda: Absence and Presence* (New York: Norton) p. 38.

Redefining the Library Meme

Memory and Imagination

■ ■ ■ ■ ■

MARTIN R. KALFATOVIC

In January 1984, at the unveiling of the Macintosh computer, Steve Jobs, a cofounder of Apple Computer, noted that the Mac was the third major milestone in the history of personal computing. The two previous landmarks were, as described by Jobs in the 1996 documentary film *Triumph of the Nerds*, the IBM Personal Computer (PC) in 1981 and the Apple computer in 1977.

In choosing these three developments as milestones, Jobs was operating under the assumption that the essential unit of the personal computing industry was a metal and plastic box that millions, even tens of millions, of people would welcome into their homes and offices. In making this assumption, Jobs and his corps of creative geniuses in Silicon Valley and IBM's button-down executives in Armonk, New York, made the same mistake.

Eyeing each other warily across the breadth of the continent, both Apple and IBM missed the rise of their real competitors in the metal and plastic box business: a company in Korea, Leading Edge; the three engineers who formed Compaq Computers; and most unlikely, Michael Dell, a University of Texas freshman who assembled computers in his spare time.

Small firms were able to build computers as good as those of the big companies. Planning to dominate the industry with the "better box"

MARTIN R. KALFATOVIC is the information access coordinator of the Smithsonian Institution Libraries, Washington, D.C. His e-mail address is mkalfato@sil.si.edu.

turned out to be a bad idea. The importance of personal computing did not lie in the box, the hardware; it was what was in the box, what the box could do, and what made the box work. Software was the key. By defining personal computing through software, Bill Gates, one of the founders of Microsoft, became the wealthiest person in the United States, with a personal fortune of over eighteen billion dollars.

66

What is the library? The box and the stuff inside, or the ideas that make the box work? Hardware or software?

99

Just as Jobs narrowly identified personal computing with the box, libraries are in danger of being too narrowly defined—the library as box; more specifically, a box full of "stuff." Discussions about the future of libraries often devolve to definitions lodged in opposite extremes of the "library as box" concept: the library as a simple physical box, a building that contains books, journals, and magazines; and as a "virtual box" with the zinging, bouncing electrons that make up the much-hyped digital library. As in the case of most questions that seem to generate contradictory answers, the problem is not in the answers, but in the question itself. Perhaps a better question when seeking a new definition for the library is: What is the library? The box and the stuff inside, or the ideas that make the box work? Hardware or software?

Defining the Paradigm

The term "paradigm shift" has become a cliche in a number of professions, including that of librarianship. Though by no means its only incarnation, the most common form of the library is still a defined space containing an organized collection of information in "hard copy"

(print, microform, audio, and visual materials) supplemented with digital information sources, and overseen and serviced by a body of trained workers.

Increasingly, however, digital information resources are becoming more prevalent. To note this fact is not to predict the end of the physical, print-based book (although many people do) or to envision telescreens in every person's hands before the turn of the millennium. When we extrapolate from the current offerings of digital media for an important portion of the information housed in our libraries, it is clear that many of the information services they offer will be accessible in ways that will necessitate a logical evolution of the current model of the library.

The Iceman and the Knowledge Worker

Craig A. Summerhill of the Coalition for Networked Information, one of the library profession's most innovative thinkers, commented in a message to the PACS-L (Public-Access Computer Systems List) discussion group on June 6, 1996 "I don't think the issue is really whether the book itself will become an anachronism. I fully expect it will survive. . . . The real issue is whether the book will become an anachronism within the context of libraries." In the same posting, Summerhill points out the harsh reality for libraries that "Our nation is building an economy which is increasingly about the management of information. There are going to be people who will try to build a business aimed at cutting the library out of the loop. Some may succeed." (More information about PACS-L can be found at http://info.lib.uh.edu/pacsl.html.)

The library profession must be careful to define itself not by a product, but by a service. To borrow an example quoted by Summerhill, in the middle years of this century the iceman, much to his chagrin, discovered that it was not ice that people wanted, but refrigeration. (Summerhill quoted a message from Thom Gillespie dated June 4, 1996, with the subject "Re: the four librarians of the Apocalypse.")

In *Future Libraries: Dreams, Madness and Reality* (ALA 1995), Walt Crawford and Michael Gorman have noted a number of "myths" that drive thinking about the information future. Crawford and Gorman are adamant that libraries "are not wholly or even primarily about information. They are about the preservation, dissemination, and use of recorded knowledge." (p. 5) Some of the myths are "everything is online" and "the industrial age is over." Any librarian who has been confronted by a patron demanding information now, because "everything's online" knows the power of the first of these two myths.

The second myth is even more prevalent in the popular mind. Former Labor Secretary Robert Reich's and Speaker of the House Newt Gingrich's advocacy of the "knowledge worker" is one incarnation of this myth. The information age, however, is highly dependent on the industrial world. As Harald Preissler and Burkhard Jaerisch describe in a June 1996 *Wired* magazine sidebar entitled "A Material World," "The production of a single PC requires 33,000 liters of water . . . we need to realize the wired world will always be deeply rooted in the material one." (p. 124)

Without succumbing to the latest trends, or perpetuating myths, how can the library profession define itself in the current and forthcoming information age?

"A Library Is a Growing Organism"

In 1929, S. R. Ranganthan defined the *Five Laws of Library Science*. These five laws are:

1. Books are for use.
2. Every person, his or her book.
3. Every book, its reader.
4. Save the time of the reader.
5. A library is a growing organism.

With only a slight redefinition of "book" (one that will accommodate not only the traditional print codex but also the scroll from antiquity and the digital objects now appearing), Ranganathan's laws still hold true today.

Focusing specifically on the fifth law, "A library is a growing organism," leads to the title of this essay. Though not yet found in *Webster's* or the *Oxford English Dictionary*, the term "meme" has achieved currency in various scientific fields, and in technopop culture in the form of the monthly "Hype List" feature in *Wired*. The term was coined by evolutionary biologist Richard Dawkins. In an interview, "Richard Dawkins: a Survival Machine" (appearing in Richard Brockman's *The Third Culture: Beyond the Scientific Revolution*, Simon and Schuster, 1995), Dawkins noted that a "meme may be roughly defined as a unit of cultural inheritance, analogous to the use of gene as the basic 'unit of biological inheritance.'" (p. 81)

Just as genes mutate and evolve in biological organisms, a collection of memes or a "meme complex" can mutate to change a belief sys-

> **❝**
>
> *Are librarians reasonable or unreasonable? And what are the consequences of this orientation?*
>
> **❞**

tem or a cultural construct, a construct such as "the library." The meme is also flexible; it "can be encoded and transmitted in German, English or Chinese; it can be described in words, or in algebraic equations, or in line drawings." (Peter J. Vajk, http://www.lucifer.com/virus/alt.memetics/ what.is.html) Additionally, "Memes, like genes, vary in their fitness to survive in the environment of human intellect. Some reproduce like bunnies, but are very short-lived (fashions), while others are slow to reproduce, but hang around for eons (religions, perhaps?)." (Lee Borkman, same Web site) The idea of the library, the "library meme," has so far proven quite resilient. In what ways can it be rethought so the library can continue to survive?

"All Progress Depends on the Unreasonable"

Some of librarianship's most basic units of definition are undergoing rapid evolution: what is a book? Whom do libraries serve? What is the essential nature of library service? These and more immediate concerns over such concrete issues as copyright in a digital environment and, more basically, funding for core services (however those may be defined), make a challenging environment for this often fragile, yet still resilient, organism, the library.

How is the next generation of libraries to be defined? What roles, rules, and laws will be used? What will be the building blocks? How will the library meme evolve?

George Bernard Shaw once noted, "The reasonable man adapts himself to the world; the unreasonable man persists in trying to adapt the world to himself. Therefore, all progress depends on the unreasonable man." (*Man and Superman*, "Maxims for Revolutionists," Maxim 23) This presents us with a two-part question: Are librarians reasonable or unreasonable? And what are the consequences of this orientation?

What choices must be made that will lead to an evolution of the library that will bring both complexity and progress? What changes must be made in the library meme that will allow it to thrive, that will prevent the supplanting of this important institution created over the course of thousands of years?

Keeping the Library in the Loop

The transformation of the library meme is a process that should be welcomed by librarians and the supporters of libraries. The key to a successful transformation will be a library that embraces the best and most useful of the new technologies while at the same time preserving the best of past traditions and services. Three key areas the evolving library meme must address are:

- the digitization of existing materials;
- the organization of digital products; and
- access to digital products and print products.

The Digitization of Existing Materials: Libraries as "First-Choice Culture"

The foundation for library service in the digital age will lie in maintaining what George Gilder has called "first-choice culture."[1] Gilder explains that, "You go into a bookstore or a library and you get your first choice, and you expect to get your first choice. Because you have a first-choice culture, you have a bias toward excellence rather than a bias towards trash. The difference between book culture and TV culture is choice." (p. 10)

Digital libraries, or more specifically, the digital collections that libraries are building and will continue to build into the twenty-first century, must adhere to the high standards that are applied to traditional print collections. Currently, a large proportion of the World Wide Web's content is more reminiscent of TV culture than of book culture.

Walt Crawford and Michael Gorman have vigorously proclaimed that "Print is not dead. Print is not dying. Print is not even vaguely ill." (p. 14) As all but the most diehard of print-oriented advocates will admit, much information can and should be digitized. Libraries must take an active role in selecting print collections for digitization and validate this role through the careful articulation of digitizing plans. This articulation is being carried out in many libraries now, and some of the cri-

teria being applied to the selection of collections for digitization include intellectual coherence of the collection, the strength of the library's holdings in this area, and usage.[2]

Early on, the problem of selection for a "digital library" was outlined by the Internet pioneer J. C. R. Licklider in his important study, *Libraries of the Future*, published by MIT Press in 1965. The digital collection outlined by Licklider would not include fiction or most narrative nonfiction. Instead, it would be composed of "transformable information." Licklider went on to note, "We delimited the scope of the study . . . to functions, classes of information, and domains of knowledge in which the items of basic interest are not the print or paper, and not the words and sentences themselves—but the facts, concepts, principles, and ideas that lie behind the visible and tangible aspects of documents." (p. 2)

Today, a more expansive view of digital collections should include those "print or paper" items not readily available. Manuscripts, interview transcripts, photographic collections, special collections, and other similar material can all be enhanced by digital collections. Using digital surrogates for these collections will provide access to items inaccessible (or difficult to access) due to fragility or distance.

Work, Don't Surf:
The Organization of Digital Products

Digital products, such as those described above, as well as a small portion of the information found on today's Internet, need to be easily locatable. Looking at just the content of the World Wide Web, many tens of millions of Web "pages" are available. Searching for content that would meet the selection criteria of a collection development librarian in this sea of data is a formidable task. The promise of Web search engines has proven empty as searchers retrieve result sets with tens of thousands of "hits."

Commenting in 1990 (well before the explosion of Web content), New York University professor A. Richard Turner noted, "Let's not lose sight of what it's all about, knowledge and its structures, not mindless safaris into galaxies of informational garbage."[3]

What, if anything, can librarians do to ameliorate the difficulties of locating information on the Web? Without entering into the debate about "cataloging the Internet," it is clear that there is significant room for librarians to apply their knowledge of organization and skills in structuring data to the chaos of the Internet.

Taking advantage of the flexibility of the MARC (Machine-Readable Cataloging) format, librarians are able to catalog useful (and stable)

Internet resources. Using the enhanced capabilities of the new graphical online public catalogs (OPACs), researchers are able to move directly from an OPAC record to the digital resource. In combination with such programs as OCLC's Persistent Uniform Resource Locator (PURL) project, libraries are able to share data on the intellectual control of digital resources.[4]

For the more ephemeral resources on the Net, or those that might not warrant "full cataloging," librarians can exercise their discriminating selection skills through the use of "meta-lists." Creation of meta-lists may be seen as putting an apt and librarian-friendly spin on the concept of "expert systems." Librarians can act as "human agents" to locate subject-specific Internet resources and mount these lists (perhaps with brief, evaluative annotations) on library Web servers to provide researchers with access to relevant information.

Many libraries are already performing this service. Examples include Maryland's Department of Library Development Service's SAILOR project. In a presentation given at the American Library Association's annual conference in 1996, Rivka Sass, then of Maryland's Department of Library Development Services, has described how SAILOR uses "human spiders" to explore the Web to locate resources, select them in a manner analogous to traditional library collections development, and categorize the resources appropriately. Sass accentuated the point that the essential nature of SAILOR and search engines (in a library environment) in general, is to "enhance library use."[5]

Similar Internet resource collection projects are taking place at many libraries, including the Smithsonian Institution Libraries. Through the Smithsonian Branch Library Home Pages, subject-specific Internet resources are selected, categorized, and annotated by subject specialists in areas ranging from aeronautics, to museum studies, to zoology, and many others.[6]

By teasing out of the tangled World Wide Web such valuable Internet resources as weather reports, currency converters, measurement calculators, census data, and other such time-sensitive or frequently updated information, librarians can provide access to the type of up-to-date information that could never be obtained from print resources.

"A Wise Cicerone": Access to Digital Products and Print Products

In addition to the roles described above, libraries and librarians must continue to build upon the legacy the profession has made to the world's store of knowledge through digital means. When discussing

tomorrow's libraries, futurists—and too often librarians—forget the tens of millions of digital bibliographic records accessible worldwide through OCLC's Online Union Catalog, the Research Libraries Information Network (RLIN) bibliographic database, other bibliographic utilities, and hundreds of OPACs made available via the Internet.

The ease with which a researcher can now locate materials anywhere in the world through the use of these services is too often taken for granted. Similarly, when the migration of digital data or the obsolescence of storage media is discussed, that MARC bibliographic data created during 1966–68 is still available today—a longevity unmatched by MARC data's digital coevals—is a fact that is rarely noted.

Digital indexes, whether provided via CD-ROM (Compact Disc–Read Only Memory), through the Internet or by other means, have been part of library services since the introduction of the first online systems in the 1960s. Increasingly, these indexes are being directed to the end user. Such services as OCLC's FirstSearch, the Research Libraries Group's (RLG) CitaDel, and various CD-ROM products are quickly eliminating the librarian's task of mediated online searching. But who, if not the librarian, can best direct researchers to the most useful database or provide instruction for these "user-friendly" services?

As James Billington, the Librarian of Congress, has said, "The very flood of unsorted information makes the librarians' role of sorting, dispensing, and serving as objective, informed navigators even more important.[7] (p. 39) In more colorful language, Karl Weintraub (in 1980 during the Webless adolescence of the Internet) described the future librarian as "a knowledgeable sluicekeeper, a most sensitive filter, a wise cicerone who knows where what knowledge is available, how to get its essential parts, someone who does not block access but also someone who does not drown us in an unsorted morass of information."[8] (p. 38) This role, important in all eras of librarianship, will become even more important in the future.

The Continuity of Infoculture

In *InfoCulture: The Smithsonian Book of Information Age Inventions* (1993), historian Steven Lubar has named the rise of what he calls our "information culture" by the catchy neologism "infoculture." As Lubar clearly points out, infoculture is not the product of the postwar years or even the twentieth century. Today's "information appliance" can be traced back to the telephone, telegraph, and other information transmission and processing tools. In the library, the OPAC of today is a logical outgrowth

of the card catalog. But it must be remembered that the card catalog was itself a transformation of the earlier information technology of the book catalog.

Appropriate Technology versus Techno-lust

Librarians are no more—and perhaps, less—subject to techno-lust (the desire to have the latest, fastest, most bleeding edge technology) than members of other professions. Still, much of the incautiously enthusiastic literature on library technology ignores commentary such as that by Norman Balabanian, a professor of electrical engineering, who notes, "Technology is not a neutral, passive tool devoid of values; it takes the shape of and, in turn, helps to shape, its embedding social system." [9] (p. 37)

Blind faith in the benefits of technology will only harm the evolution of the library meme. The use of appropriate technology, whether it be the card catalog or the World Wide Web, will create the strongest future for libraries.

At a conference held at Harvard University in 1949, Donald Coney of the University of California at Berkeley noted that for libraries, "our futures are shaped by two magnitudes, those classic ingredients of librarianship: people and books." [10] (p. 53) Nearly half a century and many technology cycles later, these basic principles of people and books remain unchanged. "Books" (or more precisely, much of the information contained in some books) will become increasingly digital. The definition of "people" may change (patrons, users, clients, students, the public), but their essential needs will not.

In their long history, libraries have accumulated a reserve of goodwill and support from their constituents, as noted in the recent Benton Foundation publication, *Buildings, Books, and Bytes: Libraries and Communities in the Digital Age* (1996). This capital must not be squandered in pursuing an unattainable digital nirvana.

Imagination for the Future and Memory of the Past

The outline of the library of the future is with us today. The redefinition of the library meme is occurring daily in public, academic, special, and research libraries.

Vladimir Nabokov listed imagination and memory among the necessary qualities of the good reader. To shape and not to be merely carried along with the tide of natural and inevitable change, librarians will

need these same qualities: imagination, to see the potential of emerging technologies; and memory, to recognize the value of librarianship's past history and its current relevance.

Acknowledgments

This essay grew out of a talk delivered at the Beta Phi Mu Iota Chapter annual meeting in Washington, D.C., November 6, 1996.

Notes

1. George Gilder, "The Telecosmic Library," in *Tomorrow's Access—Today's Decisions: Ensuring Access to Today's Electronic Resources Tomorrow* (Dublin, Ohio: OCLC, Inc., 1996), 6–12. Also available from http://www.oclc.org/oclc/man/9680rldc/9680.htm.

2. Natalia Smith and Helen R. Tibbo, "Libraries and the Creation of Electronic Texts for the Humanities," *College & Research Libraries* 57 (November 1996): 535–53.

3. A. Richard Turner, "Lights Are On, Will Anybody Be Home?" in *Scholars and Research Libraries in the 21st Century* (New York: American Council of Learned Societies, 1990), 27–30.

4. See http://purl.oclc.org/ for a further discussion of OCLC's PURL project.

5. SAILOR can be accessed at http://www.sailor.lib.md.us.

6. Smithsonian Institution Libraries Branch Library Home Pages can be accessed through http://www.sil.si.edu.

7. James Billington, "Libraries, the Library of Congress and the Information Age," *Daedalus* 125 (Fall 1996): 35–54.

8. Karl A. Weintraub, "The Humanistic Scholar and the Library," *Library Quarterly* 50 (January 1980): 22–39.

9. Norman Balabanian, "The Neutrality of Technology: A Critique of Assumptions," in *Critical Approaches to Information Technology in Librarianship: Foundations and Applications*, ed. John Buschman (Westport, Conn.: Greenwood Press, 1993), 15–40.

10. Donald Coney, Newton F. McKeon, Jr., and Harvie Branscomb, "The Future of Libraries in Academic Institutions," in *The Place of the Library in a University* (Cambridge, Mass.: The Harvard University Library, 1950), 53–72.

Perils at Home
Changing Constituencies in Cyberspace

■ ■ ■ ■ ■

MURRAY S. MARTIN

The advent of the Internet has caused dramatic changes in any library's constituency. Instead of a clearly defined local population, any library that is online is accessible to anyone in the world with the appropriate hardware and software. Similarly, the providers of information have undergone massive changes. While there may not yet be a virtual library, most libraries now include electronic publications and access as routinely as they do books and periodicals. Nor is it any longer essential that library users should actually enter the library, since information can readily be transferred electronically. There is a downside to this change. The numbers of players may presently be great, but there is always the potential that the provision of electronic access will be subject to the whims of an oligopoly. There is also the difficulty of ensuring privacy, particularly in business transactions. A final problem is the lack of a clear referral point. Whereas the library exists in actual space, the Web has no physical existence. In cyberspace all publications are equal. There is no classification system, no sets of reference works, no

MURRAY S. MARTIN—Born and educated in New Zealand, Murray Martin has worked in libraries in New Zealand, Canada, and the United States, finally as University Librarian of Tufts University. In retirement, he maintains his library connections by writing and consulting on library topics, and also manages to find time for his life-long interest in Commonwealth literature.

guidance for surfers, no librarian to provide assistance. These are not insuperable problems, but they must be addressed if the millions of potential users are to be served as well as they possibly can be.

Perhaps the most important point is that the Internet, or more correctly worldwide electronic communication, has changed everyone's constituency. Whereas formerly each public, academic, or special library could define its own service constituency with some accuracy, and yet allow for spillovers via such traditional services as interlibrary loan, now they may find that they have a much larger service area, namely the world, or at least that part of it that is online, with a wide range of interests, often far beyond the capacity of the library to respond.

Library-User Relationships

This expansion alters greatly the ways in which libraries can handle their services. In particular, decisions must be made about whether to charge individual users for services rendered, since these are now truly individual rather than shared by many members of the community. If it is decided that there should be no charges, then the library has to determine how to meet the costs from its budget. It may be necessary for libraries to impose differential charges for local and distant users (always remembering that some distant users may, in the case of academic institutions, also be local students) in order to support the resulting costs. Public libraries are having to rethink their budgets in the light of electronic costs.[1]

The problems of providing total access to information, both printed and electronic, are much greater than simply buying books for a presumed audience. The ways of approaching the information differ just as much as the information itself differs. The result is that the relationships between information users and providers will change dramatically. There is a subtle but real difference between a local and a distant user of a library. The former has a direct relationship and will feel some sense of responsibility for the library. The latter will not have such a sense of bonding. This element of separation is an important concept and one which will be returned to later. An interesting experiment at the University of Michigan brought up a virtual library on the Internet but it is not yet the model for the future.[2] It sought to overcome the sense of alienation inherent in solely electronic access by providing the virtual equivalent of walking into a library.

Changes, Insiders, and Outsiders

Information providers are changing in nature, rapidly. While the readily functioning virtual library may still be decades away, digital information is already a reality, and the digital library already exists, in part, in most reference service areas—for example, in the many CD-ROMs available. The information accessible in this manner is also likely to be much more current than any printed medium could ever be. Since it may take six months to a year to collect the information for a book and write it, then another six months or a year to get it published, any information it contains will be, if not out of date, at least dated. Think for a moment about the role of a news column in a quarterly journal. When it finally reaches the public any news will be at least six months old. That means that it can contain only information likely to be of more than passing interest and certainly not information that is likely to have been superseded in the interim.

The many listservs and the like on the Internet are a much more efficient way of keeping up with current information. Many scientists have long been aware of this. A physicist friend of mine once remarked that printed information is only for the outsiders, and that, while grants for research appear to be soundly based on past experience, they are really intended to obtain money to support future research into totally new areas; i.e., the money is not actually used for the stated research, which is probably finding its slow way through the print chain. This suggests that there are many in-groups who share information, a possibility heightened by the fact that scientists disheartened by the slowness of the Internet have developed a much, much faster alternative for the transfer of data. This is another indication of there being two societies. Indeed, the number of societies may be somewhat larger since the advent of electronic information.

Care has to be taken to ensure that the information any carrier provides is accurate, but it is easier to update electronic than printed information. There are dangers in that the original provider may have moved on to other areas and may not care whether the past information is correct. To keep up-to-date requires that the individual user (or library) continue membership in the consortium and provide current information. Because there is no simple mechanism for removing outdated information, Internet users must act as their own filters, a process formerly the province of libraries, publishers, and other information providers, a further example of the individualization of participation in the sharing of information. There is here the issue of insiders and outsiders. The insider "knows" what is current; the outsider can only guess.

Print and electronic information complement each other. Each can supplement the other, but they are nevertheless not the same. In the same way as printed information, electronic information can easily become outdated and may need additional sources to keep it current. The ways of doing so are somewhat different in manner but not in intention. The point here is to remind the users of electronic information that many of the same rules apply in either situation. The responsibilities of authors, publishers, and libraries do not change substantially within the print and electronic universes. So far little attention has been given to the ways in which electronic information is generated, and even less to how it is maintained. This may well change if the focus shifts to author/publisher rights and revenues, but, so far, the traditional publishing community has not moved very far into the electronic world, mostly because the definitions of rights and ownership are much less certain and the resulting profits undeterminable.

Is Faster Better?

Many would say that instantaneous information is not the only need. Almost nothing intellectual is accomplished overnight. It requires longer term thinking and the consolidation of ideas. It is still difficult to imagine the process of reading a massive book online since it would require the dedication of many more hours (and the resultant costs) than most people would consider reasonable. Nevertheless, the process of intellectualization can be immeasurably improved by the use of electronic media. In the past, most thinkers have used personal meetings, letters, and even the telephone to follow through on their insights. E-mail and similar strategies are simply an extension of this process.

In its own way the fax machine, which combines manual labor (typing) with electronic transmission, illuminates this process, which is why it so quickly replaced regular postal services in such countries as Australia and New Zealand, which are so far from their markets. E-mail is a variation on this theme, with the added advantage that it can be instantly accessible to many receivers. The problem is that no one can be sure that the message is exactly what the originator intended.

There is always the problem of confusing the medium with the message, *pace* McLuhan.[3] The ways in which information is retrieved are as variable as the human operating space. Information can be received aurally, visually, through digital communication, or by the mental digestion of displayed facts. Meshing these different messages may

often require great acuity. One of the deficiencies of most digital networks is that they downplay the role of human perception, which is often much more acute than any programmed access protocol. For instance, even now, most spell-checks are unable to differentiate between homophones, or, for that matter, between the correct and incorrect uses of synonyms. Certainly such mechanisms can reduce greatly the laborious process of checking a manuscript (When will we get a better word?) but they cannot substitute for the human supervision of a text. The whole issue of editorial responsibility has become a major problem for electronic publishing. In the academic arena this translates as peer judgment and review.

Babel Tower: Multiple Tongues

This difficulty is increased greatly when it becomes a matter of bringing together human texts in several languages. Multilingual access has not advanced very far, in fact it has not advanced much since thirty years ago when the dean of the Engineering School at the University of Saskatchewan (who was also a faculty member of the School of Information Science at the then Case Institute of Technology) told me that he and his wife had been working on this problem for many years without results. It depends, for the most part, on a long series of equations, some of which may not fit very well into such settings as literature or sociology, where exact relationships are rare, as they are in most human situations. The nature of electronic communication requires exact translations or equivalents, but these are seldom available in human discourse. The translation of such discourse requires not one- or two-dimensional equivalencies but tri- or more equivalencies. To achieve this kind of relationship will involve much higher levels of interpretation than are currently available. Because most advances in electronic communication research have taken place in Western countries, there has been a tendency to underplay the need for access to other languages, a tendency that underestimates the need to understand other ways of expounding information. At the moment this is being underlined by the French government's push to require translation into French of all communications originating with or being used by French participants.

Although there is a tendency to see English as the global language, other peoples will continue to think in their own languages. This bilingual approach will require much more sensitivity from electronic services. This also relates to the very curious question of Postculturalism,

whose proponents see the Internet as having superseded local cultures,[4] but without producing any equivalent standards for the international culture. The fear is that rampant individualism, represented by the aloneness of the Net surfer, will destroy the links that have bound us together. Isolation is not the most satisfactory setting for intellectual achievement, or even for success in business. The "loneliness of the long distance runner" has its equivalent in the loneliness of the home office worker or the Internet surfer. This situation has become one of great concern to all managers. Human beings, no matter how much individuals may differ, are dependent on social sharing, whether of information or of experience. Indeed, the practical application of information depends on its being placed in a social setting.

❝

The fear is that rampant individualism, represented by the aloneness of the Net surfer, will destroy the links that have bound us together.

❞

Because we have so far concentrated on individual benefits we have tended to overlook community benefits. For this reason we have also tended to overlook the need for community support for information access. Unless all members of the community can have the same level of access to electronic information they had to printed information, some will be shortchanged.

Most library budgets can no longer support individual access to information online, nor can they support free access to any and all information that may be wanted. The issue here is how the library and the individual user determine the ways in which information access will be shared and paid for. The recent turmoil in San Francisco over the ways in which the San Francisco Public Library should support local information access simply underlines this issue.[5] This kind of situation can only be expected to multiply unless libraries and their financiers come to grips with the changed information setting.

The cutoff point for free information access in an electronic world is far more complicated than in a print world where information can be

obtained simply by opening a book. In the electronic age, communications costs, subscriptions, downloading and printing costs are involved. While it is inappropriate to charge the individual user with more than a proportion of the costs involved, arriving at this proportion is not exactly easy. Libraries may approach this problem by setting up individual accounts, but have also to look at the general expenditures that are supporting this endeavor.

In academic and special libraries this issue may be resolved by looking at their primary mission, to see whether such services are included in their charge. This approach suggests the possibility of passing on at least some costs to the user. For academic and special libraries this may be the ultimate solution. Public libraries may have a somewhat more difficult issue. The defining statutes may or may not define basic free services, and may leave open the whole issue of special services. There have been several judicial or administrative decisions about this issue, many of which leave open the role of public responsibility.[6]

Who Controls Access?

While the issues of public access and payment are vitally important to all libraries, there are other issues that may affect even more profoundly the ways in which individuals may use and profit from the electronic world. Among the most important are concerns as to who will control access to the Internet. To date, the Internet and allied electronic systems have grown in a rather chaotic fashion, with few rules and few directives. This kind of growth has made the determination of fiscal responsibility extremely difficult. Now that major corporations (Microsoft and America Online, for example) have taken an extremely large interest in access to the electronic universe, we may well find that its use will become increasingly subject to well-established financial patterns, with suppliers setting the terms for participation. The problems experienced by America Online simply underline the difficulties faced by all Internet providers. They may or may not be able to overcome these difficulties, but will remain captive to the nature of the information universe, where individual users are seldom controlled by financial considerations while their supporting institutions can continue to supply "free" service. At a meeting of program heads at the Association for Library and Information Science Education (ALISE) I asked how many would be willing to continue using e-mail and similar services if they had to pay individually. The answer was no one. When access becomes subject to

the usual laws of supply and demand, the world of cyberspace may change dramatically. Access is never "free," even though many institutions behave as if it is. If it becomes necessary to pay for the use of Internet then we can expect that library and other budgets will have to find the money, as they have had to do when institutions decided to pass on the general cost of telephone access.

These developments could be seen as parallel to the ways in which monopolies were established by print publishers, were it not for the fact that it is possible for an electronic access provider to control and limit the kinds of access that will be provided. There is less competition than with printed products. Even though the United States has moved to ensure wider competition between electronic service providers, there is little or no guarantee that there will be any recognition of public rights, as was the case with "fair use" under the copyright system. This issue is still subject to Congressional debate.

Economic Collusion

The second issue that must be faced is that of economic collusion. It is much easier, in the electronic universe, for groups of people (publishers, vendors, etc.) to set standards or to control software in order to promote their own interests. It is also possible for providers to set up programs in such a way as to ensure that they achieve a virtual monopoly over a given group of transactions. Even more disturbing is the possibility that an insider group can manipulate, for their own profit, general financial information. Whereas, in the print world, each author had ready access to each reader, in the electronic world, each provider has many advantages over the individual respondent, particularly in relation to the interpretation of rapidly changing information, such as the stock market reports. This issue has been raised in Canada, where concern about individual rights in financial settings has been subject to parliamentary review. The openness of the electronic world is a major plus, but can also become a serious problem when it comes to individual rights to privacy.

As has often been shown in the marketplace, groups with a higher level of sensibility to current trends have a higher success rate. The converse is that such groups may manipulate data to their own advantage. Although this kind of manipulation is less common in library circles, there is a constant likelihood that information providers may gerrymander the market in order to maximize their share of the information

❝

*There is a constant likelihood that informa-
tion providers may gerrymander the market in
order to maximize their share of the information
consumers.*

❞

consumers. Although libraries do not have a mandate to protect the eco-
nomic rights of their users, it would seem reasonable that they should
be able to guarantee the integrity of the information they provide.

Information Collusion

Electronic information is much easier to manipulate than printed infor-
mation. All users should be aware that it is possible to alter online in-
formation without leaving a trace, rather different from the attempt to
persuade libraries to substitute new pages for the Stalin article in the
Great Soviet Encyclopedia. There is no baseline to which to refer, nor are
there any editorial responsibilities to fall back on. Librarians have de-
veloped systems of classification, cataloging rules, and a wide range of
reference tools to assist the user of printed information. The equivalents
do not exist in cyberspace. There is no way to determine what kinds of
scrutiny an online publication underwent (e.g., peer review), there is no
certainty that the text is uncorrupted, there are no surfer librarians to
provide assistance. Without these helping hands the Internet user is on
his or her own and cannot be assured that the information discovered is
appropriate or even true.

One of the most alarming possibilities is that unscrupulous entre-
preneurs could set up major scams which might never be uncovered.
The subject need not be money, but could be any of a wide range of
social issues. Many Internet users have already pointed out that cyber-
space houses anti-Semitic propaganda as well as sexually and racially
biased information. Libraries that are providing Internet access may
well have problems over what information can be recovered, even

though they may follow the American Library Association's stand on freedom of information. The openness of cyberspace is one of its greatest strengths, but could well become one of its weaknesses.

Without guarantees of the integrity of the information online, users may be badly served. There are no obvious differences between good and bad information. The same is true of printed information, but there, at least, the user is able to refer to the source, whether author or publisher, and to make some determination as to whether it is a reliable source. Even though libraries have sought carefully not to discriminate between information providers, they have also sought to follow a path of selection that differentiates between good and bad information. This has not been an easy path, as libraries have sought to provide appropriate information to their users and at the same time fend off various bodies concerned with regulating what is provided to the general public.

In a recent interview on WBUR (Boston) Walter Cronkite, perhaps the preeminent example of the independent newscaster, and now the author of *A Reporter's Life* (New York: Knopf, 1996), expressed great concern that every human interest would be reduced to thirty-second soundbytes. He insisted that the only way to achieve the fullest possible information on any problem was by reading. He foresaw a society in which each individual could select what kinds of information he or she would look at and never take an interest in other information that might be different or require a rethinking of values. An example of this situation is the possibility of preselecting what parts of an online newspaper you want to read, thus rejecting everything else.

The screening of information through selection committees is no longer possible in the electronic world. What is there is there. The Supreme Court has declared the Communications Decency Act unconstitutional, thus protecting free speech, but also making the community task of librarians more difficult. It is true that the Internet is not controllable by legislative fiat; after all, there is no way that U.S. laws can be applied to information generated elsewhere, even though the copyright meetings in Geneva have sought ways of doing so. The community problem is in dealing with unrestricted access. A recent case in Connecticut (no names are used to ensure privacy) related to the novel *Kaffir Boy*, which was finally removed from class use in the school. Perhaps the most disturbing comment was from a parent who had chosen that location to protect his children from the harsh realities of the world. This clash of cultures has long been a problem for education and now it may become a major issue in the use of electronic information since there is even less ability to screen out "unwanted" information.

Supplier-User Links

One of the most intransigent difficulties is how to mesh independent users with a wide range of institutional suppliers. Without some accepted codes of conduct, libraries or similar organizations will have to improvise and develop their own ways of handling electronic librarianship. This could lead to a splitting of the information community, particularly because of the widening gap between the haves and the have-nots. It is unfashionable to emphasize the costs involved in going electronic, despite the public concerns of some highly regarded librarians,[7] but any school or library with outdated hardware and software is only too aware that it costs a great deal of money to update your equipment. In the past libraries have been funded as community activities. Will this attitude continue into the electronic future? We must hope so, or it is only too likely that we will lose much of our necessary information and much of our sense of community. These points demonstrate how important is the role of such organizations as the Coalition for Networked Information (CNI). Unless we are able to work together with a full understanding of the ways in which the different parts of the information world interact, we are likely to misinterpret our own roles in the world of information.

Notes

1. Evan St. Lifer, "Public Libraries Brace for Internet Costs," *Library Journal* 122, no. 1 (January 1997): 44–47.

2. A possible exemplar is the Internet Public Library, developed by the students of the University of Michigan School of Information. See "Internet Public Library: Same Metaphors, New Service," *American Libraries* 28, no. 2 (February 1997): 56–59.

3. Marshall McLuhan. "The Medium Is the Message," chapter one in *Understanding Media: The Extensions of Man*. Rev. ed. (New York: McGraw-Hill, 1964). 7–21. This metaphor has been characterised, even by Peter Drucker, as grossly exaggerated, but recent developments in television, cyberspace, and other similar media (for example, the infomercial and the factoid) lend it new credence.

4. Christopher Clausen, "Welcome to Postculturalism," *The Key Reporter* 62, no. 1 (autumn 1996): 1–6.

5. There are numerous running references to this controversy in *American Libraries*, *LJ Hotline*, and *Library Journal*, but few consider the ramifications of the problems of introducing electronic information on a broad scale. The same problem has arisen in Philadelphia in relation to the discarding of printed materials.

6. Although there are too many such decisions to record here, it may be reasonable to refer to the *Thor Tools* decision, which decided that inventories were taxable, hence the many publisher overruns readily available in chain bookstores; and the *Texaco* case, unfortunately settled out of court, where the issue was photocopying between branches of an institution. In Washington State the attorney general determined that telephone reference was covered by free public library service, and many more such decisions could doubtless be added. The current controversy about access to the Internet may well provide many more such decisions.

7. Clifford A. Lynch, "Pricing Electronic Reference Works: The Dilemma of the Mixed Library and Consumer Marketplace," in *Issues in Collection Management: Librarians, Booksellers, Publishers*, ed. Murray S. Martin. (Greenwich, Conn.: JAI Press, 1995). 19–34; and "Serials Management in the Age of Electronic Access," *Serials Review* 17, no. 1 (1991): 7–12.

Visioning
the New
Organization

The Library Transformed
Building a Shared Vision

■ ■ ■ ■ ■

JERILYN R. VELDOF, PATRICIA MORRIS, and LOUISE GREENFIELD

The environment is rich with opportunity. Technology is changing the ways information is published, stored, and accessed and our users are expecting more from us than ever before. These transformations challenging libraries today demand outstanding leaders and electrifying vision. We see this need all around us. If we are here to stay, we must have a vision for our libraries that motivates and inspires librarians to take leadership roles and provide direction at all levels of our institutions or communities.

One of the most tangible benefits of library-wide visioning is the sense of shared purpose and direction it offers. Many of us feel we are adrift in a lifeboat, revolving in circles as more and more new interfaces, products, Web sites, and demands on our time blow in with each tide. How can we keep up? How can we keep going? How can we stay ahead

JERILYN R. VELDOF is an assistant librarian at the University of Arizona where she works on the Social Science Team and on various occasions, as a member of other Library strategic projects including the Educational Vision Team. Her e-mail address is jveldof@bird.library.arizona.edu

PATRICIA MORRIS is an associate librarian at the University of Arizona on the Science-Engineering Team. Her e-mail address is pmorris@bird.library. arizona.edu

LOUISE GREENFIELD is a Fine Arts/Humanities Librarian with much experience and interest in promoting information literacy.

The Education Vision Team of the University of Arizona Library was made up of the following team members: Louise Greenfield, Patricia Morris, Jeff Rosen, and Jerilyn Veldof, plus Karen Warren of the computing center on campus.

"

Visioning must be done in the trenches, by those people who will translate the vision into daily action.

"

of our patrons without drowning? We are in dire need of a great compass and map to lead us through these challenges—something which inspires all of us and fills us with a sense of purpose and worth.

As Frigon and Jackson point out, the compass is a vision, and the map is the plan for achieving that vision. (1996, 37) Others have defined vision more academically as a compelling conceptual image of the desired future. (*Strategic Planning and Performance Measurement Handbook*, State of Arizona, p. 43) Or, put in another way, vision is what you want to accomplish; it is the target that you set.

Library administration is certainly no stranger to the vision retreat that business executives have been participating in for decades. A look at library Web sites shows that the vision, goals, and mission gamut is not uncommon. But how many of these planning efforts involved the staff on the front lines? How many were mandates to the library, instead of a reflection of it? How many of these library employees are taking the vision with them campus-wide or city-wide or county-wide or business-wide?

Many models of leadership describe the ability to create and communicate vision as one of the top characteristics of a leader (Kouzes and Posner 1987; Conger 1989). But to be effective, leadership should not be contained only at the administrative level. Leadership and therefore visioning is very much a shared process—not something that is done up in administration by the director and his or her associates. Visioning must be done in the trenches, by those people who will translate vision into daily action.

A Model for Visioning

The intention of this chapter is to present a model for the visioning process. The examples in this model are based in part on the experiences

of the Education Vision Team of the University of Arizona Library during the 1995–96 academic year. It was the intent of this team to articulate a vision to direct and focus the Library's educational initiatives.

The University of Arizona Library, like many institutions, recognizes that a major challenge facing librarians is to create a planning process which is dynamic enough to respond to change, yet thoughtful enough to provide vision and broad direction. Creating a vision worth working toward (Gilbert 1996, 8), which sets expectations for educational directions and activities and which serves as a model for continuous revisioning is recognized as being critical.

In order to initiate this process, a visioning team composed of a group of people responsible for and committed to exploring and coordinating such an effort is essential. This team should have representation from throughout the organization. Although we may all work in the same organization each person brings to the table different work experiences, skills, and perspectives. They may also consider issues, barriers, problems, and ideas from a variety of points of view. In addition, it is also helpful to include representative stakeholders from outside of the organization. A staff member from the computer center, a city council member, or a librarian from another system can all bring a different vantage point from which to both contribute ideas and to process the information. To ensure the success of such an approach, the administration must have confidence in staff's ability to take a leadership role in the vision's creation. Implicit in this confidence is the willingness to let go of ultimate control and support the outcomes of such a process.

This group's purpose is not only to produce a vision document, but to guide and encourage the library to constantly think about vision. Staff members have the responsibility to ensure that their own objectives, as well as the team or departmental objectives, align themselves with the library's direction. The vision of the library is not a stagnant document sitting somewhere in the administration office; it must live in the minds of the staff leading them through the work decisions they make.

Create the Vision

It is unusual in this era of quickened paces, and astronomical learning curves to have the time to think; that is exactly what is often missing in times of chaos. It is essential for this group to take time to scan and synthesize relevant information about their environment. Members should read articles, discuss issues, attend conferences and reflect on their current knowledge. Build these activities into the group's time frame.

Brainstorming, discussions, and reading constitute the foundation of the visioning process.

Visioning Guidelines

In addition, it is important for the team to develop and agree upon a list of guidelines underlying the visioning process. Some examples follow, drawn in part from Steven Gilbert, director of technology projects at the American Association for Higher Education.

- *Support the institutional vision and direction:* Understanding and having goals compatible with the goals of the larger institution ensures a direction that will be recognized and supported.

- *Respect one's own institutional and personal values:* Identify and build on the basic values of the organizational culture and respect the personal values of the people who make up that organization.

- *Encourage staff participation in creating a library-wide vision:* A library-wide vision is not created in a vacuum. Its strength emerges from creating and working toward it together. This promotes both a common understanding of the process as well as a shared investment in the outcomes.

- *Create a model for continuous visioning:* A vision today, which is shaped by such elements as new technology, changes in the political environment, rising expectations of users and unpredictable budgets, must be open to continuous rethinking and modification. Develop a model that can be used by individual teams or departments and modified to suit their own needs.

It is essential to make use of existing key documents and build on their strengths. The group needs to look at what is and was in order to see a clear transition to what will be. Research into what has been already written, said, and thought by members of the organization, the users, and the people in charge of the purse strings needs to be part of the process. Documents and reports developed within the library and the larger institution will increase understanding of the current environment and help create a relevant context from which to shape the future. Documents that examine relevant issues such as the economy, new technology, and demographics will set the stage for the vision, especially those that explore the implications of these issues for the library and the campus in general. Internal library assessments of services, functions, facilities, staffing, user responses, etc., help to provide an accurate snapshot of the library and larger institution. Such infor-

mation contributes to the foundation of knowledge upon which one can begin to build a vision.

Drafting the Vision

Creating a draft vision for others to respond to is the next important step which, if taken early, will help shape the visioning process. While a library's vision can be developed through a variety of formats, below is one example.

1. Identify the institutional, regional, and global driving forces or key issues effecting the future of the library.
2. Examine the impact these driving forces could have on the user, the library, and the larger institution or community.
3. Suggest the possible next steps the library might take, both proactively and in response to these implications. Do not take a prescriptive or dogmatic approach, but rather take a reasoned and exploratory approach. This team's work should be viewed as possible directions, not as directives.

Identifying Driving Forces and Implications

The first step—identifying driving forces—was discussed above and involves doing a scan of environmental factors which are, and potentially could be, driving the institution forward. Remember, the library and the team members themselves are experiencing these driving forces as well as studying them. Based on the myriad of articles, ideas, predictions, and concerns team members will encounter, a focusing process must be built in. Once a group really begins to share information, explore relevant themes, and examine the issues in depth, they may find that this material fits quite easily into categories. If this does not happen naturally, the use of a tool called the Affinity Diagram can be helpful (Brassard and Ritter 1994, 12–18). Next decide which of these forces are the most important. There are a variety of consensus building activities available to help groups identify priorities (Brassard and Ritter 1994).

While some driving forces will be unique to a particular institution and circumstances, others may have more commonality. Examples are:

- Rising expectations of customers;
- Adaptability of the organization;
- Managing access to excess;

- Changing nature of technology;
- Library staff's learning curves;
- Learner-driven education;
- Funding;
- Partnerships;
- Information policy (copyright and censorship);
- Online and distance education.

Once the key issues driving the vision are identified, team members can discuss these major issues again and the concerns around each. Capturing the essential points from these dialogues and integrating them with ideas from earlier learning and sharing sessions will help generate implications and next steps. Other helpful collaborative methods include putting working documents on a shared computer drive to see each other's syntheses and make suggestions online.

Encouraging Dialog

In building the vision the team must create numerous and constant opportunities to engage the library staff in a dialog about the environment and the desired outcomes. Because different people prefer different methods of input it is helpful to take a multipronged approach. The group must organize open forums, speaking events, initiate dialog at regularly scheduled departmental or team meetings, hold open houses, route articles, send out e-mails, talk to individuals one on one, and make comment/input forms available. Opening up the process encourages others to challenge assumptions, modify any of the issues, or offer new ideas. Each staff member's voice can be heard, considered, and in most cases incorporated into the final version. Such participation not only strengthens the content of the final document, but begins and nourishes the process of vision integration. It is important to develop and take advantage of already scheduled opportunities for staff education and dialog. One such activity the University of Arizona Library took advantage of was called, "Where Is the Information Superhighway Taking Us? A Dialogue and Action Session with Library Colleagues." This half-day forum brought together information professionals from throughout the Tucson area to hear Paul Evan Peters discuss the societal implications of the Information Highway. Following Peters' presentation, participants met in small groups to explore discussion questions based on his presentation. They shared their thoughts about what users' potential information needs and expectations

might be for the next one to three years. Peters synthesized comments and responses from these breakout discussions with suggested next steps. These next steps included the importance of looking at each other's users, as my library users are your library users, and continuing the conversations with one another we had begun that day. He also challenged us to think of global access not just in terms of what we can locate and reach, but to think about our local information and how we can produce and make it available to others. Paul Evan Peters provided a significant outside perspective to our educational vision and helped our library staff further reflect on issues that would be relevant to creating our own education vision.

Creating the Document

The final document should provide both a vision and a vehicle for continuous visioning. A vision can be quite concise, as long as the key points that have been developed as an organization are reflected. The following is the vision statement for education developed at University of Arizona Library:

> To be a leader on campus for providing excellent educational services that meet expressed and anticipated needs of the learner, and that aim to exceed expectations for our learners.
>
> By developing information literacy skills for our diverse learners.
>
> By developing partnerships on campus to strengthen information literacy skills.
>
> By effectively utilizing information technology.
>
> By encouraging, supporting and promoting continuous learning for Library staff so they can more effectively educate others.
>
> By developing an environment that promises adaptability to change.
>
> By creating a library that is focused on the learners and directed by their needs.

Create a user's guide to accompany the final vision statement which discusses the tangible reasons for working toward the vision. Teams, for example, should be encouraged to periodically incorporate the visioning process into their own team meetings, and to continually reassess and modify their vision. The guide can remind staff of the need to provide and take advantage of a variety of learning opportunities so that they continue to bring knowledge, understanding, perspective, and insight to the visioning process.

Plan for the Vision

As mentioned earlier, the vision document should not be viewed as a stagnant statement but a dynamic tool. It is a compass that provides guidance/perspective in a broad direction and therefore should be utilized in the planning process as well as the assessment/evaluative phase of activities. Some examples of how libraries could use their visions in the planning process are:

- *Team objectives planning.* As teams decide upon annual projects, the vision document guides them in selecting critical activities such as designing information literacy skill training and increasing librarian-faculty or librarian-community partnerships.

- *Strategic planning.* As the library plans its annual cross-functional team projects, the vision is used as a broad directional guide. Ask questions like: "What is the best way to provide services requested by customers?" "Which new technological developments on the horizon should we adopt?"

- *Individualized learning plans.* The vision helps an empowered staff (where individual initiative is valued) make informed decisions about how they balance their time, what training they emphasize, and what projects they initiate. The vision becomes a guide for making important professional choices.

Some examples of how the University of Arizona Library's vision has been used to guide our projects are:

- *Information Technology Learning Program.* The goal of this program is to institute a systematic training program that establishes a minimum technical skill level among all staff. This will serve as a foundation for supporting new customer services, improving staff productivity, and enhancing flexibility in staff work assignments.

- *Knowledge Management.* The purpose of this particular project is to create Web-based tools organized by disciplinary fields to promote ease of access to Internet resources from one single starting point.

These kinds of projects offer opportunities to look at an organization and assess how the visioning process has guided it. Did you come closer to achieving the library's vision for its future? How have you translated vision into action, performance or services? What measurable outcomes can you point to?

The Power of Vision

As we develop curriculum with faculty, create partnerships with business, and build community allies, every one of us has an obligation to carry our vision with us and direct these interactions toward our goals. There is no more powerful engine driving an organization toward excellence and long-range success than an attractive, worthwhile, and achievable vision of the future, widely shared. (Nanus 1992, 3)

Visions have the power to lift employees out of the monotony of the workaday world and to put them in a new world full of opportunity and challenge, say the authors of the book *Vision, Values, and Courage.* (Snyder, Dowd, and Houghton 1994, 75) We owe ourselves the opportunity to reconnect with our sense of purpose and direction in this new sea of information and changing landscapes. We owe ourselves the opportunity to build a vision not just for our profession but for our role in higher education, elementary and secondary education, and the public and corporate worlds. These opportunities must not be reserved for our elite core of directors and deans, but for each individual in our organizations. As Patricia Senn Breivik's 1996 American College & Research Libraries theme goes, Every Librarian a Leader. We would like to expand that message to read every library employee a leader and every library employee a visionary.

References

Brassard, Michael, and Diane Ritter. 1994. *The Memory Jogger II: A Pocket Guide of Tools for Continuous Improvement and Effective Planning.* Metheun, Mass.: GOAL/QPC.

Conger, Jay Alden. 1989. *The Charismatic Leader : Behind the Mystique of Exceptional Leadership.* San Francisco: Jossey-Bass.

Frigon, Normand L., Sr., and Harry K. Jackson, Jr. 1996. *The Leader: Developing the Skills and Personal Qualities You Need to Lead Effectively.* New York: AMACON.

Gilbert, Steven W. 1996. "Double Visions: Paradigms in Balance or Collision?" *Change Magazine* 28, no. 2 (March/April): 8–9.

Kouzes, James M., and Barry Z. Posner. 1987. *The Leadership Challenge: How to Get Extraordinary Things Done in Organizations.* San Francisco: Jossey-Bass.

Nanus, Burt. 1992. *Visionary Leadership: Creating a Compelling Sense of Direction for Your Organization.* San Francisco: Jossey-Bass.

Snyder, Neil H., James J. Dowd, Jr., and Dianne Morse Houghton. 1994. *Vision, Values, and Courage: Leadership for Quality Management.* New York: The Free Press.

The Five Disciplines

Learning Organizations and
Technological Change

■ ■ ■ ■ ■

SHELLEY PHIPPS and CATHY LARSON

Like it or not we find ourselves standing on the on-ramp to the new "superhighway." We can either back up and take a U-turn into our print collections, move forward and attempt to manage traffic, or redesign the highway. If we are going to move forward and survive the speed, the numbers, the changing needs of the highway environment, we must become learning organizations.

Each day new possibilities for increasing the amount, the color, the accessibility, and the format of information presents itself to us. Our students and faculty are beating down our doors for help, for answers, for access to the computers which they believe can answer all their questions. Why then, when technology can do so much for us, have many of us come to regard it more as burden than as savior? Why do we so often feel overwhelmed, uninspired, or even fearful when it comes to learning new technologies? Perhaps because everything about technology is changing fast and furiously—the navigating system of today is often history by tomorrow. Our view or perception of technology is often that of a shifting array of products—we see the parts but not the whole. Any quick review of *PC Computing, PC World,* or *Net Guide* is enough to send the computer neophyte right to the exit ramp. "42 Timesaving

SHELLEY PHIPPS is Assistant Dean for Team Facilitation at the University of Arizona.

CATHY LARSON is Fine Arts/Humanities team leader at the University of Arizona.

Tips" says one (probably if we could remember the forty-two tips we'd be writing the magazines, not reading them). "The Best 200 Products of the Year," proclaims another (who has time to even read about two hundred products, let alone choose and learn to use them?). And what are these products? How do we know if we need "streaming audio"? How can we discover what it is? What are the best design tools for creating our own Web page—do we need to know Java? Are others more important to our customers? Which are most important given that learning time is limited?

As librarians, we don't think of ourselves as "technologists." We even resist seeing ourselves that way, and by and large have received very little in our formal education to prepare us for understanding technological infrastructures. We have created a cadre of specialists and are now seeing that we all need to gain a knowledge of this specialty. Even informally, our access to learning opportunities may be limited. Training may be expensive, located some distance away, and come on top of whatever else we find ourselves doing at the moment. This situation has left us without the background to comprehend the current reality, let alone understand emerging technological trends.

Rearranging Educational Priorities

Technology is just one of many arenas of change in which we find ourselves. Also changing are our campus and higher education environments. Academic institutions across the country are rearranging their priorities, the way they budget, and the way they deliver instruction. What links these changes together are new technological capabilities and the changed expectations of faculty and students. Faculty are expected to be online and using new learning techniques. Students entering college may come equipped with computers and a basic knowledge of the Internet, or they may never have had such opportunities. People expect to get things faster and more conveniently than in the past. What they know about computers tells them it's possible. They expect—demand—that we will be responsive to their needs.

Formal education itself is undergoing radical change. Gone, in many aspects of our curricula, is the traditional notion of "discipline." Literature, for example, is rarely studied outside its social and cultural construct. Language courses include the study of music, even architecture. Art historians are factoring sociological theory into their discourse. This has major implications for information access and delivery, and, put into the larger context of technological change, it is no won-

der we cannot keep pace and experience fear, resistance, and frustration at having to become "continual learners."

In this environment focusing primarily on learning new technologies is *not* what will help us. Focusing on people will. Technology is not the key to our future—people are. People who are capable of and supported in continuous learning will be the benchmark of our future success.

Libraries will keep pace with upcoming developments in technology only by transforming into learning organizations. Presently our libraries are not learning organizations, and therein lies the basis for our present situation. There are significant barriers preventing our organizations from becoming true learning organizations—our systems, our structures, our processes, and most of all ourselves.

"

Technology is not the key to our future— people are.

"

Just as our universities need to take heed of the potential of losing market share as educators of future students, so libraries need to begin a transformation to becoming learning organizations if the values we represent are to continue to be part of the educational processes of the future. "My prediction is that . . . the mantle of responsibility for articulating and dominating the new way of learning is going to pass to yet another institution . . . Business. Because the old system is usually incapable of turning itself around, the new approach begins to gain market share" (Davis 1996).

Davis's remarks refer to state-run universities, but they are just as applicable to libraries. If we are to survive and lead in the developing information environment, to ensure equitable access, to stave off censorship, to assist in evaluation and educate lifelong learners we must develop our organizations around people's ability to learn; identify our core competencies; become purpose- and vision-driven; put learning systems, not training plans, into place; and discover the courage to lead in time of chaos, stress, and ambiguity.

To accomplish this, we must become learning organizations. A learning organization is "a group of people continually enhancing their

capacity to create what they want to create" (Senge 1990). In *The Fifth Discipline*, Senge talks of "growing" the capacity to learn and produce; questioning and testing what we think we "know"; the development of "core" knowledge throughout the organization; and the importance of commitment to core purpose—"what *we want* to create."

The Deep Learning Cycle

This endeavor requires entering the deep learning cycle. In this cycle we move from the development of skills and capabilities to new awareness and sensibilities, and then to changed attitudes and beliefs. It is these changed attitudes and beliefs that support a transformative evolution that will allow us to lead in the future, to join the designers of the superhighway.

Stan Davis (quoted above) believes that we in current educational institutions are not capable of developing the new attitudes and beliefs that will be necessary to make the leap into the next era of education. He believes we are too focused on how we did it in the past to see how it needs to be done in the future, we are not in sync with the paradigm shift in customer needs and do not have the flexibility to adapt technology to our core purpose in time to meet customer demands.

Full immersion in the deep learning cycle is what it will take. The skills and capabilities Senge refers to are not what you might think. They are: aspiration, reflection and conversation, and conceptualization. *Aspiration* is the capacity to orient ourselves toward what we truly care about, and to change because we want to, not just because we need to. Aspiration takes reflection, dialog, clarification, commitment, and action to align our work commitment to personal values.

The skill of *reflection and conversation* involves the capacity to reflect on deep assumptions and patterns of behavior, both individually and collectively. Questioning ourselves, seeking to understand where our behavior and our values are not in congruence, talking about what we assume but don't know, listening to ourselves, will be required. *Conceptualization* allows us to see larger systems and forces at play and to construct public, testable ways of expressing these views. This means constructing coherent descriptions of the whole, broadening our view of what a system is, focusing on the interdependent parts and how they relate.

Do we have this personal commitment to our professional values? Are we aligned with the changing goals of libraries? Are we questioning our "ingrained patterns of behavior"? Do we see the whole of the information/knowledge/education system of which we are a part?

Can we develop new attitudes and beliefs by becoming a learning community? Can we treat each other, all staff and librarians, with integrity, openness, and respect; develop our collective intelligence; and discover together where the future takes us?

Only by committing to the continual practice of the five disciplines can we develop new awarenesses, new attitudes and beliefs and, by so doing, discover the guiding ideas, innovations in infrastructure, new theories, methods, and tools that will support our continuous learning. Practicing the disciplines means changing ourselves. Changing ourselves includes letting go of ego needs, status, the pride of being an expert; discovering the limits of our present assumptions; valuing those we have chosen not to hear in the past; and unlearning the ways we have organized our present work and services.

The Five Disciplines
of the Learning Organization

Learning technology, "streaming audio," "fireflies," and "spiders" will be easy compared to learning and practicing these disciplines—personal mastery, shared vision, team learning, mental models, and systems thinking. It is critical for us to begin discussing what it means to practice the five disciplines and identify barriers.

Personal Mastery

Personal mastery is learning to expand our personal capacity to create the results we most desire and mastering the principles underlying the way we produce results. (Senge, et al. 1994, 194) Personal mastery requires knowing what we *care* about; when we articulate what we want to be and do, our purposefulness creates commitment—to discover whatever it is we need to learn and to find ways of learning it.

It is *not* performing for someone else's approval. It *is* self-reflecting and self-actualizing according to one's *own* purpose, desire, and capacity. By supporting personal mastery an organization helps staff eliminate barriers to growth and accept personal responsibility and accountability based on alignment of purpose—alignment of the individual's with the organization's goals. To do this we must be fluid and dynamic, not rigid and hierarchical. We must develop an environment of trust and personal satisfaction. Desire for personal growth shapes the organization, carries the organization, leads the organization.

What are the barriers?

Why is it so hard to practice personal mastery in our libraries?

Personal and professional low self-esteem—we are not convinced of our own importance and or individual capabilities. We view ourselves as followers, not leaders. Hierarchical structures in the universities and libraries have encouraged this self-image.

We are fearful of losing status if our present competency is not valued, so we cling to our image as unique expert while that expertise becomes less relevant.

Class privilege, status, position, and pay structures—we find it hard to accept that all can learn, contributions to progress can come from anyone, and we can't reward those who commit, perform, take risks, and develop themselves to learn what it takes.

Lack of strategic context—we don't stress enough what we need to become and we focus too intently on what we do today.

We distrust that our colleagues will make appropriate learning choices—we have not shared personal visions and discovered our co-commitment.

We see our work as jobs to be done, rather than purposes to pursue— we have job descriptions, classifications, detailed written expectations; there is little room for reshaping our present procedures to encompass the profound idea of personal mastery.

Focus on skill development rather than self-actualization—we miss the point that technology is a means to achieve what we are committed to.

No time to discover what our work means to us and what is meaningful about our work.

Loss of understanding about central professional purpose and personal commitment to it that will result in making the new technologies our own.

Not accepting and supporting learning as work—we separate work and learning, we see training sessions as add-ons to work, we don't see that when we are teaching we are learning.

"Personal mastery teaches us not to shrink back from seeing the world as it is, even if it makes us uncomfortable." (Senge, et al. 1994, 196) We *must* ask ourselves why we are uncomfortable, what is the reality of our situation—not seek comfort and denial of that reality. Embracing the reality of fast-paced change will allow us to take responsibility for creatively utilizing it for our ultimate goals.

Loyalty and truth are often in conflict. We have loyalty to the past (the comfortable libraries we used to work in), to colleagues who may resist change (whose personal vision may not encompass the new), to our faculty (who may not see the need to change and use new technologies, or feel threatened by them) to institutions (which may have lost touch with their "learning seeking" customers). We must abandon loyalty and seek truth.

Rather than maintaining our loyalty to our present mode of higher education delivery, to the teacher-centered classroom, to the book, to our collections, to our controllable, sheltered work life, if we are practicing personal mastery we *must* question ourselves. Davis refers to this as settling on finding our niche market—getting small, hunkering down, serving a specialized customer, rather than transforming to serve the changing mainstream. Others call it focusing on "legacy" work.

In a learning organization where personal mastery is practiced the world is not happening to people, people are interdependently creating their own future.

How do we practice personal mastery?

Hire not just experts, but those who want to learn in a technological environment.

Develop the learning capability of our staff by providing active support for time and opportunities to build their individual, competitive portfolios.

Empower ourselves to discover from customers and from current reality what we need to learn and not look to supervisors or administrators to define learning objectives.

Shared Vision

Shared vision is building a sense of commitment in a group, by developing shared images of the future we seek to create, and the principles and guiding practices by which we hope to get there. An understanding of the need for shared vision easily follows from an understanding of practicing personal mastery. In order to shape communities of learning, all must participate in vision developing. We must pay attention to the diverse, to the different, and even to the opposition. Those whose vision includes major focus on print, paper, books, and storage need to be in dialog with those whose vision is turned toward imaging, electronics, lasers, and servers. We are all interested in preserving, providing access, and supporting the creation of new knowledge. Shared vision emerges from our common reason for doing what we are doing and involves,

❝

Those whose vision includes major focus on print, paper, books, and storage need to be in dialog with those whose vision is turned toward imaging, electronics, lasers, and servers.

❞

explicitly, those who care deeply for that purpose. Shared vision is shaped by those who are encouraged and are willing to share from the heart about what really matters to them and how they see it as relevant to the organization that is developing.

> Catalyzing people's aspirations doesn't happen by accident; it requires time, care and strategy. Thus the discipline of building shared vision is centered around a never-ending process, whereby people in an organization articulate their common stories—around vision, purpose, values, why their work matters, and how it fits in the larger world (Senge, et al. 1994, 298).

Without shared vision, it will be difficult to practice the other disciplines, to create dialog and to question, to work together in teams, to support each other's personal mastery, and to learn together how to learn. We will become defensive, lack cohesiveness, energy, and synergy. We will confuse means with ends. We will participate in a technolust/technophobe debate. If we don't develop our vision together we will lose the creative tension necessary for learning. I need to know about your developing vision in order to question and refine my own. I need to have you question the work I have chosen to accomplish our vision. But, if we don't have a dialog about vision, and you question me, the result will be emotional tension, defensiveness, ambiguity. These are inhibitors of learning. When we can share and come to discover some alignment in our vision we will be open to developing our continuing vision together. I will learn from you, and you from me.

> When a shared vision effort starts with personal vision, the organization becomes a tool for the people's self-realization. . . . People begin to stop thinking of the organization as a thing to which they are subservient. Only then can they wholeheartedly participate in guiding its direction." (Senge et al. 1994, p. 323)

How can we do this in our libraries?

When creating our organizational vision:

> Start with personal vision—staff, librarians, administration, not the director's vision.
>
> Treat everyone as equal, include all in the process.
>
> Seek alignment, not agreement.
>
> Encourage interdependence and linkages across our organizations to allow for discovery of different realities and visions.
>
> Make visioning personal to teams and expect and nurture reverence for each other.
>
> Value people's diverse life purposes.
>
> Focus on the dialog about the vision statement, not the vision statement. (Senge, et al. 1994, p. 325–26)

Co-creating vision is also important to practicing the discipline of team learning. Visioning dialogs create a foundation for learning together, for achieving synergy, for tapping metacapabilities.

Team Learning

Team learning is the transformation of conversational and collective thinking skills so that groups of people can reliably develop intelligence and ability greater than the sum of individual members' talents. The overwhelming challenges of learning multiple new technologies demand the practice of this discipline.

In the literature of teams, great emphasis is placed on utilizing teams to increase productivity. How? The underlying premise is that teams can increase and accelerate learning. When groups work as teams, they exploit their commitment to a common purpose and a shared vision, use dialog and problem-solving tools to discover reality and create new responses. Teams don't ask someone in the hierarchy what to do—they discover what it is they need to do and share responsibility and expertise to do it or become responsible for learning how to do it.

Teams are groups of people acting together, people who need each other to accomplish a result. (Senge et al. 1994, p. 354) What we need to learn about technology can be learned more effectively by sharing our ever-increasing knowledge, discovering breakthroughs and analogous uses together, and testing and evaluating each other's applications. This will come from approaching learning as a team purpose—making learning a goal and learning to accomplish results.

Team learning is also the most challenging discipline—intellectually, emotionally, socially, and spiritually. The process of learning how to learn collectively is unfamiliar. . . . It starts with self-mastery and self-knowledge, but involves looking outward to develop knowledge of, and alignment with, others on your team. (Senge et al. 1994, p. 356)

The discipline of team learning utilizes the practice of dialog—conversation that questions our own assumptions—about what we think we know; about skills we think we have; about our beliefs, mental models, and conclusions we have come to hold and which are the bases of our current choices and actions. We hold dialog for the purpose of discovering our own limited views of the world—so we can change them. Team learning requires welcoming of diversity, willingness to honestly share our assumptions and open them up to question, in an attempt to discover a wider truth, a clearer picture of reality, a capacity to act in congruence with a vision. It requires a willing suspension of our own beliefs, a capacity for ambiguity and instability while we discover with colleagues and challengers, a new truth, a new understanding. It requires deeper listening, acceptance of feedback, a spirit of inquiry and a willingness to change one's mind—not a willingness to "share our knowledge" but to change our minds in a team discovery process, which will ultimately lead to the increased capability of everyone on the team.

Team learning goes against the mental model of the librarian as individual expert, working in isolation, giving answers, gaining status, but the application of team learning can jump-start the mastery of technology. When team learning is successful, the capacity to learn is transformed. The framework for continued learning is molded. The motivation for growth is stimulated. If we are to survive as a profession in the future, we must develop and practice this discipline. Without it our ability to keep up with, to understand clearly, and to tap into our own meaningful relationship with reality will be inadequate to the challenge.

What are the barriers?

What gets in the way of really practicing team learning?

> Creating "teams" but not charging them with learning their own work—telling them what the solutions are, not requiring them to find the problems and learn the solutions.

> Learning the very difficult skill of dialog—being open to questioning one's own assumptions first, before questioning others'.

> Lack of trust stemming from not creating a climate of respect and collegiality, coming from a place of respect based on understanding our shared vision.

Hierarchy—giving some the power to say what others will do, removing the challenge to teams to learn their responsibility.

Lack of good data and information gathering skills, evaluative skills and analytical skills—too much reliance on opinion, perception, and position as the source of what we can learn and not including our customers as the best sources of information.

What can we do to better practice team learning?

Empower teams to do what is strategically right for customers.

Flatten organizations; expand the knowledge base and the capacity.

Learn to dialog and discover.

Use problem solving tools that guide us to examine all information.

Base actions on quantitative, observable data.

Mental Models

What is the forth discipline of mental models? Reflecting upon, continually clarifying and improving our internal pictures and images of the world, and seeing how they shape our every action and decision.

> Mental models are the images, assumptions, and stories which we carry in our minds of ourselves, other people, institutions, and every aspect of the world. . . . (they) determine what we see. Human beings cannot navigate through the complex environments of our world without cognitive "mental maps"; and all of these mental maps, by definition, are flawed in some way. (Senge 1994, p. 235)

Why are they flawed? Because we inherently feel that:

Our beliefs are *the* truth;

The truth is obvious;

Our beliefs are based on real data;

The data we select are the real data.

The Ladder of Inference

A useful tool to question our mental models is the Ladder of Inference. The Ladder shows us how we move from observing data and experiences to construct individual meaning, develop assumptions, draw conclusions, adopt beliefs and take actions. (Senge et al. 1994, p. 242)

As we use this tool we discover that our own selves—our learned ability to attribute meaning, to develop generalizations, to rely on and

act out of individual beliefs—directly influence what data we select from our interactions with the world and how we act in that world. By practicing inquiry, going down the rungs of the ladder, exploring our own assumptions, gathering feedback, and testing our conclusions, we will develop the capacity to remain connected to reality and thus increase our ability to learn. All of our mental models are subject to inquiry.

By practicing this reflective communication we will also begin to recognize the gaps between what we say and what we do. We will recognize our ability to leap to abstractions that may not be true. Our egos are protectors of our ignorance. Our desire to protect who and what it is to be ourselves leaves us open to not becoming more than our present selves. Our defensiveness about what we "know" renders us powerless to learn. In order to learn we must let go, become part of a dialog, become practiced in collecting and analyzing data, and let both lead us to become learners.

What are some mental models we might hold?

Librarians know best how to organize information.

MARC records are the best way to provide access to information products.

Electronic publishing will not soon replace paper publishing.

To teach technology we need PCs in the classroom.

To teach technology we need a teacher in front of a classroom.

We should organize work for our convenience.

All students know less about technology than we do.

Most students know more about technology than we do.

All new technological innovations are better than old methods.

In order to shed inappropriate mental models we need to take responsibility for our thinking, to share our views openly, and to welcome questions. We need to discover more appropriate models for dealing with the ever changing reality.

We need to gather data and let the data guide us in designing learning. We need to find ways to involve others who have different models in the creation of our vision. We need to be open to taking wrong paths, receiving feedback, and learning. In our goal setting, we need to include those for whom we provide service as we seek to develop new models. Maybe we need to get out of the way—disintermediation. Maybe we should just design systems that support their exploration and discovery. Maybe customers need to show us the way.

As someone said a year and a half ago at an American Library Association session on teaching in the computerized environment, "It is impossible to stay ahead of students in what they know about computers." If we can't stay ahead of them and that is the reality, maybe we need to ask, "How can we support them from behind?" "How could we make the way they learn be more successful?"

What are the barriers?

Why is practicing the discipline of mental models so difficult?

We are our mental models—once again ego is a barrier.

We have learned to question others—and debate, or win—not to question ourselves and learn.

We are unaware of having mental models—we have not seen them as constructs but as the truth.

Yet shared mental models have been useful; they have allowed us to talk to one another, to build "our" profession, to speak a common language.

Systems Thinking

Systems thinking focuses on seeing the whole and understanding interrelationships. Practicing the discipline of systems thinking is the fifth and integrating discipline in a learning organization. From our positions, our "silos," our work departments in our organizations, we do not see the whole, the interrelationships, the processes that connect the whole. We too easily seek linear explanations of systemic phenomenon. We react to events, we fail to see them as parts of a process. We blame other people and outside circumstances, and, as such, we fail to see our own role in the chain of events and the creation of our own environment. This leads to a loss of empowerment. We focus on details and "immediate" causes, we fail to see the dynamic complexities of distant causes and effects embedded in the systems we have created. We apply short-run solutions rather than seeking well-focused actions that can leverage a long-term, lasting improvement. A need for immediate solution drives us. We rush in and treat symptoms, rather than support or encourage learning that will produce long-term health. We overlay new technology on existing processes. We buy this new software and that new hardware without stepping back and viewing the needs of customers in a systematic way.

66

Building learning organizations, becoming learn-
ers, practicing the learning disciplines; these are
the ways that we will not only manage techno-
logical change but develop the courage to lead
technological change.

99

How could we practice systems thinking?

Understand our organizations as whole; identify all the interrela-
tionships of our processes before applying technology.

Look at long-term consequences of all actions/decisions.

Increase our awareness of unintended consequences—pilot new
software—seek and pay attention to feedback.

Recognize limits to growth—see how we will need to change in
response to new demands; don't focus resources on the contin-
ued growth of what we do today—invest more in supporting the
future than in maintaining the present.

Develop our capacity to learn.

As systems thinkers we would ask:

How does our implementation of technology integrate with our
learning program? For example, are we taking the time to learn,
understand, and evaluate the resources available to our customers?

How do our human resources policies support continuous learn-
ing? For instance, are we rewarding learning? Are we providing
worktime for learning? Are we promoting people on the basis of
their willingness to continue to learn rather than what they knew
in the past?

How do our budgeting systems enable us to utilize new developing
technologies? Are we allocating money to prepare for our strate-
gic future and long-term values, even given limited funds, or are
our budgets demand-driven by today's priorities?

How do our organizational structures maximize our understanding of current reality and our ability to adapt to it? Are we nurturing dependence on directions from "above" or facilitating discovery, self-mastery, and team learning? Do our "job" descriptions, our departmental hierarchies, our "control" budgeting, or accounting procedures limit our system capabilities? Are they designed to confine staff or to let them experiment, take risks, and innovate?

If we are practicing systems thinking we will create the technology that supports our vision. We will learn the technology that supports our purpose. We will understand the relationship of technology to structure, to systems, and to learning.

Building learning organizations, becoming learners, practicing the learning disciplines; these are the ways that we will not only manage technological change, but develop the courage to lead technological change. Discovering and developing ourselves is the way we will discover our future role—whether it be shaping technological change, educational change, or global change.

References

Davis, Stan. 1996. "Slicing the Learning Pie," in *Educom Review*, September/ October, p. 32–38.

Senge, Peter M. 1990. *The Fifth Discipline: The Art and Practice of the Learning Organization*, New York: Doubleday.

Senge, Peter M., et al. 1994. *The Fifth Discipline Fieldbook: Strategies for Building a Learning Organization*, New York: Doubleday.

White Gloves and Digital Soup

Museums and the Challenge
of Information Technology

■ ■ ■ ■ ■

MARTIN SULLIVAN

Many museum workers agree that information technology is the single greatest transformation that has occurred in our workplaces for at least a generation, and perhaps in this century. It has begun to democratize access to information about museum collections in ways never previously imagined, and at the same time it has contributed to a decentralization of expertise that challenges core beliefs and practices in the museum industry.

The pace of this transformation has been astounding. Most large museums now use technology to manage collections, to shape the content and design of exhibits, and to reach off-site users through Web sites and CD-ROM products. In a few instances, they are joining with other institutions to create collaborative databases. Like libraries and other cultural institutions, museums are also struggling to make smart choices about hardware and software, to meet the cost of conversion to—and continual upgrading of—digital information systems, and to invest in retraining of staff to master the potential of changing technologies.

However, museum workers appear to be less prepared than library workers to embrace the unfolding potential of information technology, and possibly less comfortable in rearranging their organizational hierarchies to maximize that potential. Among the key reasons may be:

MARTIN SULLIVAN is director of the Heard Museum in Phoenix, Arizona, and chair of the United States Cultural Property Advisory Committee. He holds a Ph.D. in American history from the University of Notre Dame.

- a "white-gloves" standard of collection care, reflected in traditional practices that impose rigid control over the storage, handling, and display of art and artifacts;

- a related tradition, especially in older and larger museums, that has valued expertise in collecting and connoisseurship more highly than expertise in public education and outreach;

- limited experience in constructing, and limited motivation to participate in, multi-institutional networks to share documentation of museum collections;

- concerns related to the protection of intellectual property rights.

Each of these conditions bears on the future use of information technology by museums. The title metaphor of this essay, "white gloves and digital soup," is a starting point for analyzing the differences between traditional and evolving organizational styles.

White Gloves

In established museums of art, natural history, history, and anthropology, curators have long been regarded as ranking at the top of the staff pyramid, just under the director, who more often than not was first credentialed as a curator. A university analogy is applied: curators are a museum's "faculty." They are the holders of advanced degrees in collection-related academic disciplines who are expected to add to the collections, to research the collections, and to publish, whether in print or through organizing exhibitions. They tend to carry in their heads far more knowledge about an institution's collections than exists on paper.

To the public, curators are also the white-gloved guardians of the inner sanctum. Theirs is indeed a serious responsibility: to set and enforce standards of collection handling and care, including strict security and precise temperature and humidity ranges, in order to assure that collections are preserved as professionally as possible. To a large extent the internal work priorities of a museum tend to flow downward in this organizational model from curators to those other staff members thought to hold somewhat lower places on the table of organization: registrars and conservators, educators, designers and graphic artists, museum librarians and archivists, money raisers and money managers, marketing and public relations people, sales staff, security and maintenance workers, etc.

The curator-dominated organizational structure began to undergo change even before new information technologies took hold. Learning-

focused institutions such as science and technology centers and children's museums have become increasingly numerous and popular since the 1970s. Their effectiveness relates more to the quality of their ideas than to the quality of any collections they may hold. In such spaces, educators and exhibit designers have had more to do with creating a successful learning environment than have specialists in the care and study of objects.

The U.S. museum industry in general, influenced by a 1984 report of the Commission on Museums for a New Century and the 1991 Equity and Excellence task force of the American Association of Museums, affirmed that education ought to have a central role in the mission of all museums. High among the recommendations made in those reports were a heavier commitment to outreach services, more collaboration with schools and libraries, and greater attentiveness to economic and cultural diversity of audiences, especially young people.

To achieve such objectives, many within the museum industry began to advocate for more fluid staff arrangements, with project teams drawn from a mix of specialized skills including but not dominated by curators. The Kellogg Foundation invested a series of grants during the 1980s to encourage team-based exhibit development, putting designers and educators on equal footing with curators in making choices about content and format. Though widely applauded and emulated, the Kellogg projects did not reshape organizational behaviors as thoroughly as information technology was about to do.

Digital Soup

By the mid-1980s many museums were installing databases to manage their collections. Unlike their counterparts in the library community, museums did not gravitate to a limited selection of software choices, or to a vision of achieving widespread online access to collections by on-site and off-site users. Early efforts to embrace an information systems approach to collection management ran up against a number of obstacles: the staggering diversity of objects, specimens, and art forms found in museum collections, the difficulties of developing nomenclature sufficiently flexible to deal with that diversity, and the wide variations of museum governance and funding patterns. Another obstacle may well have been hesitancy to disclose information about holdings to unscreened outsiders.

It was not until ten years later, in the 1990s, that databases evolved by trial and error to the point that some standardization of collection-

management formats had begun to occur among different kinds of museums. For example, one such format called ARGUS had been adopted by 1997 at two hundred museums with collections ranging from fine art to natural history, anthropology, and history. Although no single collection-management software system dominates the United States museum industry, even an incomplete compatibility of formats holds some promise of eventual interface.

Concurrently, exhibit designers were abandoning their drafting tables in favor of powerful new CAD software, while graphics and publications staffs adopted other popular software products for desktop publishing. At startling speed, software developers improved these systems to enable ever increasing transparency of movement back and forth between all kinds of text and image databases, and easy transportability to online access through World Wide Web sites.

My own institution offers a case study of how the "digital soup" of information technology is modifying organizational structures and institutional priorities. A museum of Native American cultures and art in Phoenix, Arizona, the Heard had been among the first to adopt ARGUS software in the late 1980s. Thanks to the unusually strong computer knowledge and commitment of the museum's chief curator at the time, the Heard was a leader among ethnographic and fine art collections in converting its accessioning procedures, cataloging records, object loan forms, and other collection management tasks to a digitized data base. At that time ARGUS was not powerful enough to incorporate visual images, but the museum developed a surrogate means of bringing data and images together in the form of a laser video disc of thirty thousand still images of objects which was linked to the retrieval of text records about those objects.

As other technologies such as CAD design, desktop publishing, e-mail, and a Web site were implemented, it proved possible for the museum to integrate more and more digital text and images related to collections, exhibit design, education programs, publications, and their related marketing and promotional materials.

A Change in Climate

How has the organizational climate changed? A number of observations can be made.

Innovation tends to be led by ad hoc teams of people with strong computer proficiencies, who are constantly testing ways to ladle out new

products from the museum's "digital soup" of images and text. Although curators are core participants in these teams, they are not necessarily the lead people. At the moment, key innovators of technology within the organization are as diverse as the exhibit design and graphics staff, the photograph archivist, and a former teacher whose understanding of how curriculum materials are used in schools has been augmented by first-hand experience in learning how to create digitized products. At the Heard, information technology has evolved in tandem with a more decentralized, less hierarchical research and product development effort.

From my perspective as the institution's director, *change manifests itself in the form of concentric ripples of innovation that wash periodically over the entire organization*, rather than as top-down planning or procure-

66

Innovation tends to be led by ad hoc teams of people with strong computer proficiencies, who are constantly testing ways to ladle out new products from the museum's "digital soup" of images and text.

99

ment directives. In fact, our institutional strategic plan, crafted with grand presumptions of foresight in 1991, failed completely to anticipate how information technology would rapidly break down the old organizational boxes.

The physical museum space and its virtual presence on computer monitors are looking more and more alike. Web sites of many museums are being designed so that they can mirror the content and even the physical appearance of exhibit galleries. They can offer much the same educational resources, such as gallery guides, as are available to visitors who are physically present in the building. The Heard, for example, currently features at its home page two major virtual exhibits, *Inventing the Southwest: The Fred Harvey Company and Native American Art* and *Mayan Life:*

Source and Symbol, as well as substantial art history curriculum materials on the Native American fine arts movement. Many museums also provide access to their retail stores through the Web site, especially to market exhibit catalogs and other in-house publications. All of this capability comes from that rich soup of computer-based text and image files now available to be tapped by different internal users for different purposes.

Users of museum resources can be a much larger, and for some purposes more significant, audience than actual visitors. Distance learning through information technology puts any museum's resources in the hands of a far larger audience than that which comes through its doors. For museums like the Heard, which has an institutional commitment to provide services to Native American schools and communities throughout the United States, electronic outreach is efficient, relatively inexpensive, and not limited by geographical distance.

A series of more than twenty large grants made to museums by the Lila Wallace–Readers Digest Fund since 1992 under its Museum Collections Accessibility Initiative have enabled the grantees to test a variety of techniques for developing and serving new audiences. The generous grants ran as high as $1,500,000 over a five-year period. Although information technology was not specifically highlighted as a tool for such efforts in the Fund's application guidelines, it has turned out that many of the grantees have chosen to develop wider audiences by investing in digital imaging of their collections and in sophisticated on-site and off-site access. Among them are the University Art Museum/Pacific Film Archive at the University of California, Berkeley; the Minneapolis Institute of Arts; the Michael C. Carlos Museum at Emory University, Atlanta; and the Heard in Phoenix.

What can we expect next? What new products are likely to emerge? Is the museum industry prepared to invest in sophisticated networks of information technology, following the models established by public and research libraries? Or will it enter into information networks only as secondary priorities, and continue to place the highest value on direct encounters with real objects in real galleries?

There is no doubt that Web sites, visitor information stations, and CDs produced by individual museums will continue to grow in number and quality. Hundreds of museum-sponsored Web sites are now online in the United States, and countless more internationally. The best of them incorporate lively graphics, great ease of navigation, multibranched explorations of current exhibits and permanent collections, hot links to other institutions, and a high degree of interactivity. They also require a continuing investment of technology and time (often, at least one full-time staff position).

On-site installations, such as the National Gallery of Art's Micro Gallery in Washington and several interactive stations at the Minneapolis Institute of Arts, offer visitors a far deeper introduction to works of art, artist biographies, and main themes in art history than they can find on labels in the galleries.

Museums on Disc

Some recent art museum-based CD-ROMs are extraordinarily rich in content and technical brilliance, such as *A Passion for Art*, produced in 1995 by Microsoft's Corbis offshoot in cooperation with the Barnes Foundation of Pennsylvania. The user can view paintings as they are actually displayed, wall by wall, room by room, at the Barnes Foundation, and can also branch swiftly into many related areas, including not only the provenance of paintings and brief artist biographies, but even facsimiles of Dr. Albert Barnes' correspondence with artists and dealers, original bills of sale, and other archival items.

Writing in the March/April 1997 issue of *Museum News*, William J. Mitchell and Oliver B. R. Strimpel explored the implications of presence versus "telepresence" in museums. While applauding the benefits of telepresence, or wider electronic access to collections and exhibits, they note that even the best virtual museums cannot recreate fundamental sensory qualities of physical presence: the aura produced by direct contact with exotic, rare, or priceless art and objects; the better understanding of scale and proportion in relation to the size of objects and the environments in which they are exhibited; and the much higher level of detail at which the eye can process subtle shadings of color, texture, and light when viewing an original painting or sculpture. Another sensory dimension, often commented upon by those who study how learning happens in museums, is the complicated social interaction that takes place among visitors moving through a gallery setting.

Conversely, virtual museum experiences offer far greater convenience, economy, privacy, and flexibility for the user. A Web site or a CD-ROM is "open" seven days a week, twenty-four hours a day. After the initial purchase of hardware, Web browsers can visit thousands of the world's museums at no admission charge. They can snoop as long as they want, without fear of being stared at. They can download and rearrange text and images to meet individualized research or instructional interests, unlike gallery-goers who had better keep their hands off the works of art!

Mitchell, the dean of the School of Architecture and Planning at MIT, and Strimpel, the executive director of Boston's Computer Museum, offer a cautionary word on the subject of the "economy of presence," or the money and effort that visitors expend in order to have a first-hand experience:

> As the economy of presence matures, traditional museums (as well as live theaters, book-filled libraries, and university campuses) will only be able to maintain their prime real estate, and convince audiences and benefactors to cover their relatively high costs, if they vigorously emphasize the unique kinds of value that physical space and face-to-face presence can add to an experience.[1]

Put another way, unless a museum collection is really distinctive and well displayed in an attractive building and setting, that institution will find it increasingly hard to sustain an "economy of presence" that draws visitors and donors.

Museum professionals continue to grapple with the related concern of whether wider electronic access will prove to be a deterrent or a stimulant to actual visits. Where geographic distance is prohibitive, as in the example of Native American reservation communities located many hundreds of miles from the Heard Museum in Phoenix, there is no question that electronic access will probably be the only access for many people whom the museum desires to reach.

Similarly, classroom teachers in many parts of the United States find it increasingly difficult to schedule and to secure funding for class field trips to museums. Web sites and CD-ROMs bring museum resources into the school building on a scale never possible before, along with a tremendously enhanced capability to supply tools for individual student projects.

However, Maxwell Anderson, director of the Art Gallery of Ontario in Toronto, asserts that actual visitation need not suffer from wider technological access. He believes that wider online access may eventually stimulate not only more numerous museum visits, but better-prepared visitors. Prospective visitors can download a virtual preview of art works on exhibit, print out artists' biographies and historical context, and examine comparable art in other collections globally. "Like a long-lost relative whom we have never met, but knew so much about" he says, "the first in-gallery encounter will be all the sweeter as our fondness develops from afar."[2]

Digitized Images and Virtual Galleries

Despite widespread adoption of information technology by many American museums, relatively little has yet been done using networks to link the databases of individual museums on a scale comparable to that of the library community's OCLC and RLIN.

However, an important set of initiatives is underway thanks to the leadership of the Getty Information Institute. Launched in 1995, the Museum Educational Site Licensing Project (MESL) entails collaboration between seven collection-holding institutions and seven universities throughout the United States to develop methods and guidelines for the academic use of museum-owned digitized images. Participants are as diverse as the Library of Congress, the Harvard University Art Museums, the Fowler Museum of Cultural History at the University of California, Los Angeles, American University, Cornell University, and the University of Virginia. The institutions that own the more than seven thousand images currently available through the network have waived royalty fees and site licenses in order to better test and understand how the images are actually used.

The project's home page sets forth its working assumptions:

> Distribution of (digital) images over communications networks is changing the nature of teaching and research. For this transformation to be completed, however, a critical mass of digital information must exist, and it must be available in standard forms. Imaging systems also require a complex balance between the interests of rights holders and the desires of those who use images for study, research, or entertainment. Without a common framework of rights, permissions, and restrictions, the development of imaging systems is hampered.[3]

The last point, a common framework for protecting and exercising intellectual property rights, is unquestionably a major concern for museums seeking to maintain reasonable control over the use of images belonging to them, as well as for living artists who have retained copyright over their own work even after it has passed into museum collections. Many institutions contributed to the development of a working document entitled "Basic Principles for Managing Intellectual Property in the Digital Environment," the most recent version of which was released on March 24, 1997. (See Part 3 of this book.) It evolved under the auspices of the Committee on Libraries and Intellectual Property of the National Humanities Alliance and is based in part on a draft that came out of the University of California system.

Ten principles are articulated in the National Humanities Alliance document, beginning with the statement that "Copyright law provi-

sions for digital works should maintain a balance between the interests of creators and copyright owners and the public that is equivalent to that embodied in current statute." A further principle asserts that "Copyright laws should encourage enhanced ease of compliance rather than increasingly punitive enforcement measures."[4]

A viewpoint supporting less restrictive approaches to the use of digitized images, incorporating site licensing rather than item-by-item publication permissions, was advanced by Maxwell Anderson in an article for the International Council of Museums:

> There is no point in digitizing one's art collections if the next step is to hoard those images in the vain hope of striking it rich. The value of digital images will increase in proportion to the widening of the pool of available images. Museums' battleground in the realm of intellectual property will likely be not for the images themselves, but for the ever-expanding information attached to those images. . . . We will be in a position to earn less in cash value from digital dissemination, but earn more in our value to society at large. The result should be that more people will want to visit us more often.[5]

Another set of predictions was offered by Eleanor E. Fink, Director of the Getty Information Institute, in a keynote address to an international conference on Museums and the Web held in March 1997.[6] She anticipated what might be the scenario for a comparable meeting held in the year 2005, if the international museum community made a strong commitment to participation in networks of publicly accessible databases about their collections. Five crucial developments would have occurred:

1. A nearly universal willingness of museums to make their collection information available on the World Wide Web.

2. Evolution of more powerful information architecture to integrate cultural heritage resources.

3. Creation of international consortia to provide vocabularies and tools to help navigate the online universe more effectively.

4. Resolution of intellectual property rights issues through effective encryption standards, rights clearance boards, and site licensing.

5. Adherence to universal guidelines and practices for gathering, digitizing, storing and distributing images and text, at better quality and higher speeds.

Is it unrealistic to expect so much change in a tradition-bound industry within just eight years? I think not. It is clear from the trends noted above that information technology has already wrought tremendous transformations in the industry within less than a decade. Among the clear implications for museum workers are that:

- Regardless of job title or responsibilities, we must expect to acquire new kinds of information management skills, and we must be prepared to keep refining and updating those skills in a work environment that will be more fluid, decentralized, and team-centered.

- Although museums will always require resources and trained staff for the specialized business of collecting, preserving, and caring for objects, the general public will have more access to museum products through the medium of information technology than through actual visits.

- The material that museums will make accessible through information technology will include not only images and descriptions of items in their collections, but also archival holdings and other forms of documentation.

- Museum specialists are certain to find themselves collaborating more extensively and more imaginatively with colleagues in libraries, archives, film repositories, and other cultural resources.

These are all invigorating challenges. They should make museums much more vitally engaged in the educational tasks of the next century, and more deeply committed to serving larger and more diverse audiences.

Notes

1. William J. Mitchell and Oliver B. R. Strimpel, "To Be There or Not to Be There: Presence, Telepresence, and the Future of Museums." *Museum News*, March/April 1997, 59.

2. Maxwell Anderson, "Moving Museums Beyond Technology," *ICOM News*, special issue (spring 1997), 22.

3. The Imaging Initiative: Museum Educational Site Licensing Project. Available from http://www.gii.getty.edu/gii/muse.html.

4. National Humanities Alliance. "Basic Principles for Managing Intellectual Property in the Digital Environment." March 24, 1997. Available from http://www.ninch.cni.org.

5. Anderson, p. 23.

6. Eleanor E. Fink, "Sharing Cultural Entitlements in the Digital Age: Are We Building a Garden of Eden or a Patch of Weeds?" Museums and the Web: An International Conference, Los Angeles, California, March 16–19, 1997. Available from http://www.gii.getty.edu.

A Mirror Held Up to Tomorrow

Nanotechnology

The Library as Factory

■ ■ ■ ■ ■

STEPHEN L. GILLETT

"Knowledge is power."

Like most cliches, it contains an element of truth. If you *know* that light bulbs need to have an intact filament, then you know what to check when one goes out. If you *know* that boiling water prevents dysentery, then you can boil your water to avoid getting sick.

Or at least you can if you have fuel and a heatproof kettle—because the "power" depends on having the right materials available. Knowing how a light bulb works, or even knowing *how* to build one, doesn't help you when it burns out, unless you have a light-bulb factory handy. You've still got to go down to the store and buy a new one—which means you're depending on a vast infrastructure of manufacturing and distribution.

It can be grimmer. If you're infected with plague bacillus, just knowing that massive doses of tetracycline will cure you doesn't help if there's no tetracycline around. You get to understand why you're dying in agony—which isn't much help.

STEVE GILLETT is a research assistant professor at the University of Nevada's Mackay School of Mines in Reno. A geologist, he has recently shifted his research focus to the implications of nanotechnologies for conventional paradigms of resource extraction. He has also written science fiction and many popular science articles; his book *World Building*, a "how-to" manual for science-fiction writers on designing a believable planet, was published in 1996 by Writer's Digest Press.

Knowledge is effective only in the right physical context, which usually means that the right artifacts must be available. And artifacts, of course, cost time and money to make, and may not be available when you really need them.

Organizing Knowledge

So, like most cliches, "knowledge is power" also leaves a lot out. The library—the storehouse of knowledge—is not the seat of power in modern society, nor has it ever been in the past. Sheer knowledge—or "information," in modern jargon—has always taken a back seat to gritty physical reality.

This reflects a fundamental fact of our present technology (and all previous technology, for that matter): organizing matter is *hard*. At present, it involves:

- *Manufacturing.* We need machines to put those artifacts together. And *they* need to have been put together by *other* machines. Etc. And all this represents enormous "capital," an enormous investment of the time and labor of human beings. (At least we need machines if we're to put artifacts together fast enough to make them affordable, to achieve the economists' "economy of scale." Handcrafted tetracycline isn't very practical!)

- *Mining.* Not just any source of matter for organizing will do, either. Different artifacts require different kinds of atoms; that is, they require different chemical elements. And at present we must find a source enriched in the desired element by geologic happenstance—an "ore"—to be able to extract the element at reasonable cost. Furthermore, different elements require different sources. So, even though (for example) aluminum and iron are among the most abundant elements in the earth's crust, we don't get them from common rock; we extract them from specific ores in which they have been anomalously concentrated—in the case of aluminum, for example, most commonly a tropical soil called *bauxite*. Even rare elements like copper and zinc are dispersed in many common rocks at parts-per-million levels, but they're useless to us in that form.

- *Agriculture.* Alternatively, we can use biosystems to do lots of the matter-organizing for us—to grow food, fuel, and fiber. But those biosystems need lots of inconvenient tending, and their products are in inconvenient forms; they still need to be gathered and processed, just as with the products of mining.

"

Knowledge becomes power only when it can be cast into the form of real artifacts.

"

And all this, of course, leads into:

- *Transportation.* You have to move all those raw materials from their multifarious points of origin to the multifarious places where they're assembled. And then you have to move all those finished products back out again to the ultimate consumers. This costs enormous amounts of effort and energy, both to run the transport itself and to build and maintain the infrastructure it uses.

And all this comes about simply because matter is so hard to organize! Furthermore, this set of paradigms is internalized at such a low level—is so utterly taken for granted—that it's difficult to recognize. It pervades traditional economics, for example. Take the whole idea of the "relative efficiencies" that underlie the value of trade: the fact that people in some places can make things cheaper than people in other places, so it's to their mutual advantage to trade (implying a transport infrastructure again!), stems fundamentally from the difficulty of organizing matter. Similarly for the "economies of scale"; once you have a very expensive matter-organizer ("factory"), unit costs become cheaper if you use it a lot. This again implies centralization with attendant transportation costs: raw materials must be moved to the matter-organizer and finished products out.

So, with current technology, the library's function as a storehouse of knowledge is peripheral to the raw facts of capital, resources, and labor. Knowledge becomes power only when it can be cast into the form of real artifacts.

"Entropy" Is Not the Problem

Why is matter so hard to organize? All matter is made of atoms. That's a factoid internalized in grade school and then pushed below conscious

examination. And those atoms come in a limited number of different kinds, the chemical elements. So why can't we just take any old pile of atoms and arrange it into what we want?

Well, one obvious problem is that certain kinds of atoms are much rarer than others. There isn't much gold in the earth's crust, for example, less than a part per billion, on average. But that doesn't account for why even common elements such as aluminum aren't extracted from ordinary rock. (And even for rare elements, biological systems manage feats of element extraction that are far beyond current technology, as described below.)

So why is matter so hard to organize? You sometimes hear asserted that the Second Law of Thermodynamics is responsible; the fact that total entropy in a closed system must increase is supposed to make the costs of element extraction at low concentrations prohibitive. This is nonsense; simple back-of-the-envelope calculations show that the true thermodynamic constraints are miniscule (Gillett 1996).

Furthermore, biological systems compellingly demonstrate the irrelevance of the thermodynamic limits. Green plants use the diffuse energy of sunlight not only to extract CO_2 from the ambient air (where it constitutes only ~300 parts per million, or ppm), but to break it down for carbon, from which they construct the elaborate molecular organization that constitutes the living plant. Diatoms, a type of single-celled plankton, extract dissolved silica from seawater (in which it occurs at a concentration of about 2 ppm) to build intricately structured shells. And, for a less exalted example, vertebrate kidneys extract certain dissolved solutes out of the blood from a background of lots of other dissolved solutes.

So the answer, of course, is our cumbersome technology: Matter is hard to organize because our conventional methods of atom-arranging are so heartbreakingly clumsy, inefficient, and energy intensive. We shuffle trillions upon trillions of atoms around in vast herds, by boiling, melting, grinding, pounding, freezing.

We generally let these inchoate masses of atoms arrange themselves by the application and extraction of prodigious amounts of heat; that is, by the application of energy in its most disorganized and wasteful form. Since conventional extractive metallurgy—the extraction of metals from ores—exemplifies what I've come to call the "thermal paradigm," I'll use it as an example.

Take iron, for example. Iron ores are composed mostly of iron oxides, and the purer the oxide, the better the ore. The ore is "cooked" with carbon at high temperature to make molten iron metal and carbon monoxide:

$$\text{iron oxide} \quad \text{carbon} \quad\quad \text{iron} \quad \text{carbon monoxide}$$
$$Fe_2O_3 \quad + \quad 3\,C \quad ==> \quad 2\,Fe + \quad 3\,CO.$$

The CO, being gaseous, escapes, and in addition, impurities in the ore melt to form a separate, glassy melt, a *slag*, that can be decanted off and thrown away. Like oil and water, the slag and the iron don't mix. Thus, by virtue of changing what a thermodynamicist calls a "state variable"— in this case the temperature—you've caused the atoms to spontaneously rearrange themselves into forms you can physically separate. Again in the language of thermodynamics, you've caused "phase changes" and exploited the different partitioning of elements between the different phases.

Sure, it's simple. In fact, the essentials of metal smelting haven't changed since antiquity. But simplicity is its only virtue. The process is appallingly dirty and woefully inefficient; not only is a vast amount of heat required to drive the phase changes, but the partitioning is never complete, as some of the element always goes into the "wrong" phase. (You lose some iron into the slag, for example.) And also because of incomplete partitioning, you need to start with a feedstock—an "ore"— that's *already* anomalously enriched in the desired element. Again, ordinary rock is useless.

The whole procedure starkly contrasts with the biological mechanisms described above. They operate without phase changes; without freezing, melting, boiling; indeed, without any temperature change at all. They accomplish this not by treating atoms *en masse* but by manipulating individual atoms or molecules. A green plant, for example, absorbs CO_2 molecules with individual molecular receptors; the molecule is then split using solar energy stored by another set of molecular mechanisms, with the carbon then bound to water molecules to form simple sugars.

Hence, the capabilities of biological systems result from their being organized at molecular scales. In contrast, our technology does not manipulate atoms individually, and in fact the very notion seemed farfetched till recently. Recognition of such a capability as a goal of technological development has been lacking.

This is changing, as described in the next section. And it will have staggering significance for the library of the future.

Molecular Nanotechnology:
The "Last Technological Revolution"

Molecular nanotechnology (commonly called by the acronym MNT) is an embryonic field of study that proposes building things literally atom by atom. Because of the huge number of atoms in macroscopic objects,

objects will be built with molecular-scale machines, machines that in turn are capable of making copies of themselves.

No one has any idea currently how to build such molecular machines, though paper studies exist. Some overarching "proof of concept" technical issues are explored in Drexler (1992) and in a number of symposium volumes (e.g., Crandall and Lewis 1992; Krummenaker and Lewis 1995), as well as in a growing journal literature (e.g., the journal *Nanotechnology*), and informed opinion in the scientific community currently is that MNT does not violate any physical laws. Such a statement, of course, tells nothing about the developmental timescales.

The timescales are likely to be longer than some of the more enthusiastic literature suggests; a full MNT probably still lies a generation or two away. The key problem is the building of molecular "self-reproducing" assemblers, which is exceedingly difficult.

This may be a blessing, as it will give society time to get ready for it.

(The reason that molecular assemblers capable of self-replication seem necessary for a fully developed MNT is because the number of atoms in even a small macroscopic object is astronomical. For example, there are roughly 10^{24}, or a trillion trillion, H_2O molecules in a glass of water. Organizing this many "building blocks" in real time is a staggering challenge, and is only conceivable by vast numbers of assemblers acting in parallel. Placing atoms one by one would take a significant fraction of geologic time to build anything! In turn, this implies that the assemblers must be sophisticated enough to make copies of themselves, as only in that way can the huge number of assemblers be made in a reasonable time.)

Such a technology has staggering societal implications, many of which have been explored elsewhere (e.g., Drexler 1986; Drexler et al. 1992; Crandall 1996). Here I will concentrate on the idea of "artifacts as information," which is implicit in MNT.

The Library as Factory

So you have a nanotechnological assembler, a box that will fabricate anything you want given a source of atoms to build it with and a modest source of energy. (The box is plugged into the wall socket; but depending on the raw materials you give it, it may generate energy rather than consume it.) You can build most anything; but how do you find out how to build it?

Why, you go to the library. A nanotechnological assembler gives you the capability of copying any physical object, *if* you know where the atoms go! And the library will have a repository of templates ("plans")

that would specify anything material, down to the last atom. Physical objects are thus reduced to the level of software.

This is individual empowerment—to the max. The material wealth of a society with widespread MNT would beggar that of even the wealthiest First World nations now.

But, of course, there's a considerably darker side to this future, too. Already society is grappling with massive technological challenges to intellectual property rights. The technology of copying information is *cheap*, whether it be audiotapes, music, the printed word, video, software, or whatever. Copyright laws are colliding with reality because the technologies of copying are so cheap, and such things as massive (and probably fruitless) campaigns to induce guilt trips that "copying software is stealing" merely suggest a growing degree of desperation on the part of publishers.

Of course, libraries are becoming stuck in the middle in many of these issues. As journal subscription prices skyrocket, for example, their subscriptions are dropped. Then the library ends up in the position of directly administering the copyright laws, as librarians charge the per-copy fees for individual articles from journals the library no longer carries. Thus, as they are a visible target and are perceived as a "deep pocket," libraries become more vulnerable to legal action for alleged copyright infringement as well, and this vulnerability only increases with the legal uncertainties. (By contrast, individual users who make copies are shielded from legal action by their very amorphousness, and the utter impracticality of attempting to monitor every single copy machine.)

Patents and similar forms of intellectual property have so far largely avoided many of these developments because they are implicitly embodied in a physical object. The very difficulty of organizing matter has been a major shield against patent infringement, simply because it takes a significant capital investment to "tool up" to produce devices, and because the economies of scale dictate that making just *one* device is utterly uneconomic. When publishing the mere *plans* for a device become tantamount to giving it away, however, just as with a software program distributed over the Internet, what will be the library's position? Will librarians have to collect patent royalties as well, based on the "hits" for particular plans?

But compared to other implications, intellectual property issues become almost a sideshow. How will people cope with massive unemployment, or (what is perhaps the same thing) massive leisure? What would keep malcontents, or people who are simply bored, from using all that immediately realizable knowledge for destruction?

For one thing, the notion of a "controlled substance" will become moot. The DEA and the Medellin Cartel are likely to be equally dis-

turbed by a world in which anyone, with a commonplace molecular assembler, can put together a few grams of cocaine molecules from water and organic matter, at any time they wish. Drug bust? You don't need to keep a stash around; just make the drug in small quantities when you want it. And you don't have to deal with a large, illegal distribution system; no one need know about your habit—until, perhaps, the day you fall dead.

Terrorism is another frightening aspect. Suppose our citizen, bored with a technology that can provide whatever physical artifact she desires out of dirt and biowaste, decides to make a few kilograms of LSD instead? And release it as an aerosol, perhaps with some Semtex explosive also made in her home assembler unit? Or what about using botulin toxin instead of LSD? All these materials are made of the same stuff, carbon atoms, hydrogen atoms, nitrogen atoms, and oxygen atoms, just hooked together in different ways.

Will a psychopathic or simply asocial teenage hacker, working out of his home, loose a plague virus on humanity? (A virus, after all, is just an intricate collection of molecules that can reproduce itself, using the genetic machinery of particular living things.)

And we must remember that malice need not be involved. Our teenage hacker—or academic researcher—could simply be careless or incompetent. Perhaps that's even more frightening.

Already questions about the "dangers" of information that libraries dispense are becoming shrill. But shelving the *The Anarchist's Cookbook* is likely to be pretty small beer compared to the information that libraries will stock in a world of molecular nanotechnology—and the implications of its misuse.

And, of course, if you censor *some* information because it's too dangerous, where do you stop? Scientific information is value-neutral; the same information that lets you synthesize a pharmaceutical also lets you synthesize a toxin. And furthermore, lots of the basic knowledge that underlies weaponry is technically simple. Given a molecular assembler, for example, the author would not have difficulty building a serviceable chemical explosive, just with his general technical background.

Dangerous Power

A cliche from cartoons and B movies is the villain who steals the good-but-absent-minded inventor's plans—with the intent, of course, of using the wondrous devices for nefarious purposes. And in the real world, of course, the theft of plans is a staple of espionage, both military and

industrial. Still, plans don't help unless you have the sheer physical capability—the materials and equipment—to use them. In effect, MNT will give everyone that capability.

Knowledge *is* power. And somehow, we're going to have to learn to live with it.

References

Crandall, B. C., ed. 1996. *Nanotechnology: Molecular Speculations on Global Abundance*, (Cambridge, Mass.: MIT Press).

Crandall, B. C., and J. Lewis. 1992. *Nanotechnology: Research and Perspectives*, (Cambridge, Mass.: MIT Press).

Drexler, K. E. 1990. *Engines of creation* (New York: Anchor Books/Doubleday). Original edition c1986.

Drexler, K. E. 1992. *Nanosystems: molecular machinery, manufacturing, and computation*, Wiley Interscience, 1992.

Drexler, K. E., C. Peterson, and G. Pergamit. 1991. *Unbounding the Future: The Nanotechnology Revolution*, (New York: Morrow).

Gillett, S. L. 1996. Nanotechnology, resources, and pollution control, *Nanotechnology*, 7, 177–82.

Krummenacker, M., and J. Lewis, eds. 1995. *Prospects in Nanotechnology: Toward Molecular Manufacturing*, Wiley.

The Future Project
Twenty-Second-Century Wishes, Lies, and Dreams

■ ■ ■ ■ ■

JULIEN CLINTON SPROTT

By any standard, the Internet and its currently popular manifestation, the World Wide Web, are radically changing the way information is exchanged. Whereas the printing press gave widespread access to information produced by a few, the Internet will soon give nearly everyone the ability to produce information and to disseminate it freely throughout the world. We can thus anticipate an enormous increase in the already overwhelming amount of available information. Without appropriate selection and evaluation, the quality of this information will decline as its quantity grows.

I will report here preliminary results of a survey posted on the World Wide Web in which I asked people to predict what the world would be like at the dawn of the twenty-second century. This study is hardly scientific because the responses were limited in number and depth and because the respondents were not a representative sample of society or even of Internet users. Nevertheless, it makes interesting reading, and it serves to illustrate how one can extract information from people on a global scale.

JULIEN CLINTON SPROTT has been a professor of physics at the University of Wisconsin–Madison since 1973. His interests are in experimental plasma physics and nonlinear dynamics. He is author of several books including *Strange Attractors: Creating Patterns in Chaos* (New York: M & T Books, 1993). More biographical information can be found at http://sprott.physics.wisc.edu/sprott.htm.

Since most readers of this book will have Internet access, I have included in this chapter links to Internet resources where you can obtain more detailed information.

Genesis of an Idea

I owe the inspiration for this project to my imaginative colleague, Cliff Pickover, whose home page (http://sprott.physics.wisc.edu/pickover/home.htm) is on a World Wide Web server that I maintain in my office at the University of Wisconsin. Cliff is a research staff member at the IBM T. J. Watson Research Center in Yorktown Heights, New York. He is also a prolific author of books on science, computers, mathematics, art, and science fiction. In October of 1996 he had the idea of requesting wishes from visitors to his home page. I helped him set up a form (http://sprott.physics.wisc.edu/pickover/wish.htm) for collecting these wishes and storing them in a file on my hard disk that he could access. The responses poured in, and within a few months he was approaching publishers with an idea for a book based on the Wishing Project.

Seeing how easily he accomplished this project, I shamelessly asked his permission to adapt the idea to the collection of future predictions. Thus, the Future Project was born (http://sprott.physics.wisc.edu/future.htm). People were to imagine that, like Rip Van Winkle, they had just awoken to discover that a hundred years had passed. It's the dawn of the twenty-second century. As they begin to explore this brave new world, they see that many things have changed—technology, government, the environment, education, and the way people interact with one another and with their machines. I asked what they think will be the most interesting and surprising changes that will occur over the next hundred years. I provided a form for them to fill out, which, in addition to their predictions, asked for their name or initials, e-mail address, city, state or country, gender, age, and occupation. I assured them that they would remain anonymous, identified at most by first names and last initials, and that I would not give their e-mail addresses to anyone.

One problem with posting something like this on the World Wide Web is that you have to advertise it. I did this by putting links to it from my home page (http://sprott.physics.wisc.edu/sprott.htm), which gets about a hundred accesses per week, and from my Fractal Gallery (http://sprott.physics.wisc.edu/fractals.htm), which gets about a thousand accesses per week. I also cross-linked it to the Wishing Project, which was getting about ten responses per week. I posted short announcements soliciting responses in about a dozen USENET newsgroups and listserver mailing lists dealing with the future, science fiction, society,

technology, and culture. I also posted announcements in a few science and computer groups where I thought there would be people especially interested in the future. You can access online listings of newsgroups (http://www.liszt.com/news/) and publicly accessible mailing lists (http://www.NeoSoft.com/internet/paml/).

The idea of conducting a survey through the Internet is certainly not new. The Graphics, Visualization & Usability (GVU) Center at Georgia Tech's College of Computing has conducted extensive World Wide Web User Surveys (http://www.cc.gatech.edu/gvu/user_surveys/) twice a year since January of 1994. Anyone interested in information technology should read the Executive Summary of these surveys and the comments on the problems of conducting such surveys.

During the period October of 1996 to March of 1997, I received fifty-five responses. This was considerably fewer than the approximate 250 responses that Pickover received during the same period for the Wishing Project. Apparently people find it easier, or perhaps more fun, to make a wish than to make a prediction. Maybe he was more successful in advertising his project, although anyone who visited one project was also apprised of the other by the cross-linking.

The responses ranged in length from a few words to a few pages. Some were very thoughtful; others were flippant. One person wrote a poem, and one provided the words to a song. The quotes that follow are excerpted from generally much longer responses, with only minor corrections in grammar and punctuation. The respondents ranged in age from an eleven-year-old girl in Malaysia to a seventy-five-year-old man in California. Respondents were about 70 percent male, in contrast to the Wishing Project, where the genders were more evenly divided. The geographical distribution mirrors the global distribution of Internet users, with about half from the United States. The United Kingdom (15 percent) and Canada (10 percent) were next most popular, and there were responses from Singapore, Germany, Russia, Malaysia, Brazil, Mexico, India, Australia, Israel, Italy, and New Zealand.

Hope and Concern

Opinion is about equally divided on whether the future will be better than the present, or worse. The prevailing sentiment is one of concern but hope. Many respondents worried about the problems currently confronting society such as crime, pollution, depletion of resources, political turmoil, and the social isolation of individuals. For example, Alan M., a twenty-six-year-old unemployed M.B.A. from Montreal, writes:

While I'd like to believe that the advances in technology will solve more problems than they create, I'm not so certain this will be the case. While it may be possible to navigate through the future without disaster, I think that we're going to face the most difficult problems in human history. One misplaced footstep in the coming century could easily spell disaster for mankind. This sounds rather bleak, but I believe it is the case. In the past, advances and societal change could usually be planned for and dealt with (despite the occasional revolution when change appeared too slowly for someone's liking). However, today the process of technological change far outpaces the ability of human beings to adapt to it. Our antiquated notions of government, law, and economy are being changed around us. This process is not going to slow and can only continue to accelerate. We are no longer guiding the course of human progress but are adapting to it as it happens.

❝

We are no longer guiding the course of human progress but are adapting to it as it happens.

❞

Brad M., a fifty-year-old Ph.D. in interpersonal communication and communication media theory from New York, is even more pessimistic:

I am not optimistic for the twenty-first century, although resources (e.g., Habermas, Gregory Bateson, Husserlean Phenomenology, Gadamerean hermeneutics, Jacques Ellul, and many others) are available if those with the power to do something have any interest beyond capitalizing on junk bonds and cutting costs by cutting payrolls (and overworking those who aren't eliminated).

By contrast, Jeremy G., a thirty-eight-year-old writer, artist, and musician from the United Kingdom with a vital interest in spirituality and technology, was more optimistic:

I believe that we are on the cusp of remarkable transformations as a species. We will, in the near future, begin to access new dimensions on both the inner and outer planes, and have enhanced communication with other beings in the universe(s).

Dean H., a thirty-nine-year-old systems programmer from Detroit, put it bluntly:

> You have two choices—a wasteland (possibly no life bigger than bacteria), or a paradise that is peopled by wise immortals who tell terrifying stories of the chaos of the mid-twenty-first century.

Modest to Fanciful

People generally see continuing rapid technological development, although most did not attempt detailed predictions. Those who did either predicted relatively modest extrapolations of current technologies or somewhat fanciful new developments. Many respondents clearly had trouble thinking as far ahead as a hundred years, while others postulated developments that seem unlikely, given our present understanding of physical laws. Waldemar O., a nineteen-year-old astronomy student from Ontario said:

> I think computers will be huge in the future. Space travel will become common, and people will be working on transporters (*Star Trek*). Physics will be taken to new levels of understanding, and we will see how strange but simple the universe is. Nature will get better with better technology, and maybe these things will happen if we don't nuke ourselves.

Mauricio C., a twenty-five-year-old architecture student from Mexico, sees the century unfolding as follows:

> By the early 2040s the new generations of Superhumans were being born, raising questions about its ethical value, and after much discussion it was ruled that any modification on the human race should not modify the human emotion. Therefore there could only be physical and neural improvements which didn't affect the human appearance and psyche. In the decade of the 2050s the Earth became completely unwired; all energy resources were obtained from the cosmos and distributed via satellite on microwaves, as well as all communications. By the 60s contact with extraterrestrials (now an obsolete word since humans also inhabit Mars and the Moon) was finally achieved, and an efficient method of communication was developed. The first expedition of humans in a non-human spaceship was sent as a diplomatic mission to another galaxy. In the 70s and 80s further developments in biology increased crop productivity more than 15,000 percent. Humans started considering the "vitalization" of every nongaseous planet in the Solar System. By the mid 80s an alliance was established with the extraterrestrials, who became very interested in the agricultural technology in exchange for interstellar propulsion technology.

❝

Tomorrow's nonconformists will be those people who embrace the physical world and choose to live within it.

❞

Brad M., the fifty-year-old Ph.D. in interpersonal communication and communication media theory from New York, sees serious problems with the new technologies:

> The dependence on ultra-complex technologies will need to be reduced, so that the breakdown of a computer system nobody can understand does not result in inability to provide basic necessities of life (e.g., food) to large numbers of people. The most likely scenario is probably (to use a postmodernist word) bricolage: most things falling apart in a haphazard way and some things being recombined in a jerry-built way which keep falling apart and patched back together, with most people living in insecurity and probably at lower standards of living than the last forty years.

Radical Change

Not surprisingly, this sample of Internet users sees radical changes in information technology, with many societal implications. Alan M., the twenty-six-year-old unemployed M.B.A. from Montreal, predicts:

> Virtual worlds will captivate many. Entertainment will become a driving force in many people's lives. Physical discomfort will be exchanged for "windows into cyberspace." While this may seem far-fetched, this is already happening as many people choose to live in cramped quarters, yet spring for a twenty-four-inch television set with stereo sound and a hi-fi VCR. As virtual worlds become more appealing than the physical, many will be drawn to live, work, and entertain themselves from within the attractive confines of cyberspace. While today's city inhabitants hardly know their immediate neighbors (unthinkable years ago), tomorrow's city inhabitants will hardly know the people they share the same house or apartment with. Those who can afford it will have access to more worldly experience through the eyes of cyberspace than anyone today can imagine. Tomorrow's nonconformists will be those people who embrace the physical world and choose to live within it.

Alan L., a twenty-five-year-old senior computing officer from London, considers the way information and entertainment will be dispensed:

> The development of better display technology and forthcoming network computing, coupled with ever improving data communication into both the home and work place, will lead to the more-or-less inevitable integration of phone, voice mail, e-mail, Internet, WWW, TV, video, hi-fi, etc. This development will provide the necessary platform for true multimedia information systems. This mass integration of hardware into one consumer-friendly box will lead to the establishment, I hope, of concise standards for the required range of deliverable features. This will help ease the burden on the coming generation of multimedia engineers, because the standardization will enable them to concentrate on working with the information and not get caught up in the issues of binding the types of information onto the various types of proprietary dedicated hardware. This final abstraction of the information from the physical display and processing hardware will aid true portability of the information constructs and services that are created.

Patrish, a newspaper worker in Virginia, offers a jocular look at the future of newspapers:

> I have to believe they will be around in their present form for years to come. Here's why: You can't clip out a computer TV show you like and stick it to your refrigerator with little magnets. Watching the computer screen makes you fat and lazy (this has been scientifically demonstrated). However, if you subscribe to a newspaper, you must, at the very least, step outside and get it off your porch. You can swat flies with a rolled-up newspaper. Just try rolling up your computer. Your computer won't soak up spilled coffee nearly as well as the newspaper. You can take a few sheets of newsprint and fold it into a hat. Old-time printers knew how to do this, anyhow. To my regret, I never learned. You can buy one of those cute ads that say "Be kind to Bernice; she's 40 today." If there's a power failure you can't watch your computer by candlelight. Finally, when you get angry at something you read in the news, you can wad the paper in a ball and throw it. This will make you feel better.

S. Anand, a twenty-two-year-old male software engineer from India, nicely captured the recurring theme that our interactions will be more virtual:

> My aerial path is filled with advertisements of the 3-D kind—stuff that I feel and smell as I pass through it. I like this perfume so much I'd like my girlfriend to look at it. I call her (not too loudly, though). She pops up, not physically, of course—just an image. But I can't tell the difference. She smells it and approves of it. I nod at the ad, and the

perfume pops into her hand. That reminds me: I've got to credit some goodwill into the bank. Maybe I'll give away my next dream free. I compose dreams. You might call me a director, but dreams aren't movies. You can't feel a movie within yourself. You can change the course of a dream. Many of my dreams are about feelings. I live in a $4' \times 4'$ cubicle. That's OK, because I'm actually in virtual space.

Ben J., a nineteen-year-old music and art lover from Australia, sees continued growth of the Internet:

> Besides making faster computers, I hope they will start to experiment with brainwave-computer interactions—if not controlling them, then recording them and playing them back. In the immediate future the Internet will go through the roof (even more so than it has already). It will probably replace TV, phones, the post, banking, etc., most of life really. Links carrying hundreds of megabytes per second will be running into every household in the civilized(?) world, thus giving us no reason to leave the house anymore.

An anonymous twenty-one-year-old cyberculture hacker sees a more grim future of the Internet:

> The future is an information war. When the Internet takes over the world, only the computer freaks can control how much the system knows about them; but the normal people will be manipulated, tracked, and monitored by the system. Maybe we fall into a dark era when violence is common and nobody is safe. We are not far from such a thing.

Nancy P., a twenty-nine-year-old teacher and photographer from London, also sees dangers in the information revolution:

> In the western world, the separation of place of work from place of residence has fueled the dependency on gadgetry. But in order for technology to work in society it must be both necessary and socially acceptable. The danger of the Internet is that it's growing so quickly and it remains in the hands of those with economic power that society hasn't been able to test drive it to see if it works.

Since this survey coincided with the first successful cloning of a mammal, several respondents commented on the consequences. Scott G., a thirty-one-year-old software designer from Tennessee, writes:

> Cloning of human beings will take a frightening turn as the technology of cloning is now simple and foolproof. The secondary research into brain/thought duplication from one body to another becomes reality. The legal problems become nightmares as people constantly upgrade themselves to new or even different bodies. Individual rights and inheritance laws become moot as laws are constantly being rewritten. People can no longer distinguish between a brain-transferred

individual (full rights), a duplicate (questionable rights), or stolen material (goods or cattle). Black-market copies of brain patterns become the hot new slave-market trade. Clone rights of even those who are legitimate heirs are still a legal gray area. Therefore, within the twenty-second century legalized slavery (cloning) becomes almost impossible to control or regulate due to the ease with which clones can be recreated from limited equipment and expertise.

James J., a sixteen-year-old computer hobbyist from Italy, adds:

Human society will lose its hierarchical structure, courtesy of many-to-many information distribution, of which the Internet is only the start. Genetics and biology in general will be the "big science" of the twenty-first century, just as physics has been this century. I also expect some answers to the thorny question of conscience, courtesy of neuroscience, and the confirmation that, while brains are computers, computers are not brains!

Other Predictions

Respondents addressed a variety of other issues including the environment, government, business, the economy, education, and religion. Soo Ching L., a twenty-six-year-old male information-service analyst from Singapore, says:

The globalisation of identity will result in the fusion of cultures. This will cause individuals, towns, states, and countries to exert their own identity even more intensely. Huge nations with multiple cultures like China, India, and even the USA will break up (albeit very likely to be bloody) into smaller entities. For all you know there will no longer be the concept of "country," "nation," etc. Individuals may exert their own identities to that extent.

Bob M., a thirty-nine-year-old systems manager from the United Kingdom, sees changes in the environment and economy:

The countryside reverted to a greener model, with small villages, hamlets and isolated homesteads connected electronically, and serviced by large, mostly automated depots which deliver goods ordered "on line." As the infrastructure of cities is no longer required, so the overall work load decreases, enabling people to spend more time developing their own skills, as artists, or artisans, or by growing their own produce. A new economy based upon barter developed.

Matthias, a thirty-one-year-old chemical engineer from Berlin, sees growth but diversity in religion:

Different religious sects will become very attractive. There will be a large diversity of communities, individualistic beliefs, Christian sects, and others I cannot think of yet. Anyway, in the twenty-first century there will be a comeback of spirituality.

Alice K., a thirty-six-year-old Internet junkie from Ohio, paints a bleak picture:

The environment will be a mess. Everyone will have to wear hats and sunscreen in order to go outside because of damage to the ozone layer. Littering will be a felony, recycling mandatory. (We will finally have figured out the consequences of soiling our own nest.) The government will be pretty much the same as it is today. I don't think anything would happen in 100 years to change that. The economy will still be a disaster. Unless there is some threat to the planet that would unite the human race, I think there would still be fighting amongst groups of people. Basically I can't see anything short of alien invasion, the often-predicted end of the world, or nuclear war ending the strife that seems to be the hallmark of our race. It goes without saying that technology will be more advanced than can be imagined. I think there will be a whole subset of people who live in a virtual world. It will be a much more complete and total escape from reality than it is now. It will contribute to the isolation of individuals.

Karin G., a forty-nine-year-old journalist from Australia, sees great changes and problems:

Looking forward just one hundred years, we will find all present day trends taken to their extremes. Nations will fragment and reform along cultural and technological divides: some subsets will be pantheistic Luddites, while others will exist in hyperspace, insulated from raging violent hordes. Environmental and population excess will create "no-go" areas, which the wealthy won't even fly over. Other pockets, deep within jungles or hidden in mountains, will protect themselves with purifying rituals and chemical-free products. The oil crisis will have come and gone; cars will have evolved, and new, cleaner ways of using coal will be developed for those who can't access the technology for solar. Africa will be decimated, but Siberia will flourish as the peak of the greenhouse effect is reached. A new form of world governance will seek agreement on a few vital and strategic environmental or political issues. There will be no meetings, only video conferencing among this highly enlightened elite. At the other end of the spectrum, barbarian religious fanatics will ruthlessly oppress great masses.

Greg W., a forty-three-year-old system administrator from North Carolina, says:

The "one-world state" is in place, and no cash exists—nor are you limited by your "wages." Certain items are "luxuries" and can only be

obtained if you have excess credit, and you contribute one day a week to community service to earn the basic credit. Smart cards provide the identification and accounting functions. Education is a life-long process, after "high school" (they don't call it that anymore); education is done in two-year increments, with practical experience in the year(s) between.

Troy L., a twenty-three-year-old engineering student from Ohio, sees a violent future:

> I think that in the few years following the end of the millennium there will be unprecedented changes in the world. Small countries fighting to gain control of limited natural resources will be using nuclear devices and chemical warfare. Any moderately backed terrorist will be able to obtain devices and products to kill thousands or even millions at the touch of a switch. The Gulf War and the Oklahoma City bombing will pale in comparison to the future destruction we will see on our TV screens. There will be a rise in random and serial killings, possibly due to generation X's hopeless and hypersensitively negative outlook on life.

R., a thirty-five-year-old woman from Canada, sees the world at a juncture and says, with hope:

> In the future I see a world of computer-generated commerce, and hope this would get rid of all the wars, hate and poverty. I see either peace or total destruction and rebirth. And maybe in the future we will have actually learned to learn from the past, and not repeat some of the horrors we humans seem so good at repeating.

Closing Thoughts

While I cannot claim any special abilities to predict the future beyond a training in physics and a long interest in technology and its consequences, I agree with many of the sentiments expressed by those who responded to the survey. I believe that electronic entertainment and the flow of information will dominate life in the next century. Many people will live much of their lives in physical isolation, even while the world becomes increasingly crowded. We will routinely don headgear that will expose us to a wide spectrum of sensory experiences. Most of these experiences will be mindless and passive entertainment, much as television is today, although displayed with such realism that it will be hard to distinguish from reality. This assault of our senses will further deaden us to the consequences of our actions and make us even more accepting of violence and inhumanity.

On the other hand, improved worldwide communications will permit social and even sensual interactions uninhibited by physical separation. Easy availability of educational materials will enable the small minority who are so inclined to achieve unprecedented intellectual growth. This will further widen the gap between the educated and the uneducated, and as a consequence also the economic gap, since knowledge usually engenders wealth.

I am more skeptical about other technological advances. Progress in biotechnology and medicine will lead to the cure of many diseases, but there will be new strains to conquer, and immortality seems unlikely. Overpopulation will continue to deplete our resources and degrade the environment. Limited but vicious wars will continue to occur as people compete for the dwindling resources and struggle for survival.

After a lapse of thirty years since landing on the moon with no return mission in sight, I can easily imagine that another hundred years could lapse before humans venture to the planets. Although the technology will exist, the cost is huge, and governments seem increasingly reluctant to fund such exploratory projects. I think we will find evidence of extraterrestrial intelligence during the next century, but I doubt that a meeting or even a conversation with them will occur during that time because of the large distances involved. Time travel, teleportation, faster-than-light travel, and antigravity machines seem even less likely since they violate our current understanding of physical laws.

Human nature will not radically change, but new technologies, especially information delivery and electronic entertainment, will alter our lives and the lives of our descendants in astounding ways. Our challenge is to harness these technologies and use them wisely to make the world a happier and more interesting place in which to live.

The Internet
as a Commons

■ ■ ■ ■ ■

DAVID BRIN

Back in the European middle ages, before the enclosures of the six-teenth through eighteenth centuries, there existed in England and sev-eral other kingdoms vast tracts of territory called "common lands." These were fields and pastures which no one owned, left open by tradi-tion for use by all responsible citizens of the neighboring community. Over time, unwritten rules of courtesy and sharing evolved, sometimes enforced by a feudal lord, but more often mediated by consensus among the farmers and herdsmen themselves.

In an influential academic study, *The Tragedy of the Commons*, Gar-rett Hardin described what happened when the medieval order began breaking down. A combination of increasing population, improved farm-ing technology, and accelerating commerce put ever greater pressures on the communal land. It began occurring to some individuals and groups that they might gain substantial personal benefit by grazing their herds on the commons until every scrap of greenery was eaten. Water was diverted. Trees were felled and lumber taken without the earlier, cautious, forest-tending techniques of coppicing.

DAVID BRIN has a triple career as scientist, public speaker, and author. His novels, such as *The Postman* and *Startide Rising*, have made the *New York Times* best-seller list and have won multiple Hugo and Nebula awards. Brin has been a fellow at the California Space Institute and a research affiliate at the Jet Pro-pulsion Laboratory and has participated in interdisciplinary activities at UCLA's Center for the Study of Evolution and the Origin of Life.

David Brin expands on his thought of the Internet as a commons in his book *The Transparent Society*, to be published in 1998 by Addison-Wesley.

In other words, the logic of competition had arrived. Since it wasn't your land, you did not directly benefit from its wise management, so your short-term incentive was to use up the common-but-unprotected resource as quickly as possible, before anyone else could. Nor is this the only example out of history. Lessons learned from Asia and the Americas are not too dissimilar. A more recent case is the continuing giveaway of federal lands in the western U.S. under hundred-year-old mining laws. Companies are still known to pay pennies on the acre, plunder a region of its minerals, and then depart leaving only spoilage and detritus in their wake.

An Uncommon Commons

Although one should always be careful in using historical metaphors, the parallel with today's Internet is striking. In the strictest sense, all of the Net's parts and components belong to somebody—much of it to the federal government—but for all practical purposes nobody controls the present system.

Some official groups, such as the National Science Foundation (NSF) exercise partial sway over decisions having to do with major infrastructure—the fiber optic web and the switching yards called Network Access Points (NAP). In order to achieve standardization of technology, the Internet Engineering Task Force (IETF) mediates and exchanges ideas, seeking consensus among major users. Countless commercial and private bulletin boards restrict entry into their own sections of cyberspace to members only, just as some parts of the country have private or toll roads. Nevertheless, the macro entity of the Net itself has grown far too diverse, with too many alternate pathways, for anyone to justifiably claim any real dominion. As those Stanford feminists found out, today's Net operates as a collective virtual frontier through which anyone may roam doing pretty much as they please, so long as they have a port of entry.

To some far-seeing thinkers, an analogy with the medieval commons falls short of adequately describing the blithe chaos of today's burgeoning data networks. After all, information can be duplicated endlessly and for free, a trait not shared by pasture or farmland. According to futurist Bruce Sterling:

> The Internet's "anarchy" may seem strange or even unnatural, but it makes a certain deep and basic sense. It's rather like the "anarchy" of the English language. Nobody rents English, and nobody owns English. As an English-speaking person, it's up to you to learn how to speak

66

Today's Net operates as a collective virtual frontier through which anyone may roam doing pretty much as they please, so long as they have a port of entry.

99

English properly and make whatever use you please of it (though the government provides certain subsidies to help you learn to read and write a bit). Otherwise, everybody just sort of pitches in, and somehow the thing evolves on its own, and somehow turns out workable. And interesting. Fascinating even. Though a lot of people earn their living from using and exploiting and teaching English, "English" as an institution is public property, a public good. Much the same goes for the Internet. Would English be improved if the "The English Language, Inc." had a board of directors and a chief executive officer, or a President and a Congress? There'd probably be a lot fewer new words in English, and a lot fewer new ideas. (*Magazine of Fantasy and Science Fiction*, February 1993.)

Fields of Throbbing Electrons

While Sterling's allegory is enthralling, it may be too blithe in its basic premise—that our information networks consist only of information, the abstractions of words and data. Equally important, and binding this new realm to the pains of the real world, are the pieces of hardware, the fibers, cables, switching yards and nexus points of silicon memory. These are the equivalent of gates, fences, and flowing streams. Today, a kind of chaos does, indeed, reign across fields of throbbing electrons, allowing individuals to ramble across continents under only the loosest of regulation. But can chaos last long when vital pieces of the whole can be owned? Here the parallel with language breaks down.

Like the medieval commons, the electronic realm emerged not out of some grand scheme or design, but from step-by-step evolution of makeshift techniques and trade-offs arranged by a relatively small number of "neighbors" . . . the well-educated, highly motivated Brahmin

classes of academia, the military, and government research centers. One might even picture this miracle sprouting out of the new computer technology without anyone seeing the big picture—what was being born—but I suspect that image oversimplifies things quite a bit.

In fact, this burgeoning of a new world was aided and abetted by some of the smartest and most influential individuals on the North American continent—vice-presidents of research for major corporations, generals and admirals, heads of foundations and agencies, professors, deans, and Nobel laureates. Surely most of these people were aware, while authorizing funds for the creation of data nodes and capacious information pathways, that the routes they were laying down would be used for more than just the exchange of research data. From the start, scientists, engineers, and bearded UNIX-junkies used the embryonic Internet to exchange birthday greetings, gossip, cartoons, short stories, political opinions, social commentary, quirky ideas, and proposals for ways to make the network even more wild and free.

The big-wigs in charge faced a critical decision. On the surface, they were suffering a small but steady drain of resources toward "frivolous" pursuits and interests. They could have clamped down, as Germany and several other countries have indeed done, reigning in the disorderly mob, establishing firm rules and oversight procedures, enclosing most of the fields and pastures of cyberspace into tidy, fenced-off, accountable territories.

A Stipend for Chaos

Perhaps it's worth noting for the record that this is not what the network-backers of the 1970s and 80s did at all. Instead, they willingly let their institutions—their universities, companies, and agencies—"tithe" a steady subsidy for irrelevant, extracurricular, impractical, unprofitable, flippant, and even trivial excess uses. This hidden allowance, this stipend for chaos, was embraced by a cabal of individuals who collectively defied the prosaic image of mean-minded bureaucrats by looking beyond the short term, watering and tending a crop they could but dimly perceive.

Don't expect them to get any credit. The stereotype is too deeply entrenched for their kind ever to be perceived as far-sighted or generous. To their credit, I doubt many of these men and women even care about that. Many are making oodles of money, congratulating themselves over their earlier vision. Others are simply as enthralled as the rest of us by the new world they helped create.

Today the Net has become a truly international commons, one growing at phenomenal rates. The enthusiastic millions now signing up are no longer intellectual aristocrats. They include people from all walks of life—high school teachers, building contractors, journalists, even ambulance-chasing lawyers. From this perspective it is easy to see inevitability in many of the events people are getting so worked up about—flamers, impertinent "free" advertising, child-porn interest groups, FBI "clipper chips," overstrained data nodes—all symptoms of conflict among the countless centrifugal needs and desires of contemporary society at large.

Already there are widespread calls for order, for organization and structure, for legislation and a bureaucracy to enforce rules of the road for the coming Information Superhighway. The Taxpayer Assets Project (TAP), founded by Ralph Nader, is one of many on the Net calling out alarums over plans by the National Science Foundation to consider a change in pricing structures, so that users would pay for each second they dwell within the cybernet domain, and for each kilobyte of information they send or retrieve along the expressway. Those protesting raise valid points about the difficulty of enforcing such rules. They declaim a threat to privacy whenever some authority starts tracing user identities, keeping detailed logs of who accessed what. They point out that today many local net libraries and servers send out torrents of valuable data free to all who request it, but those sites might have to shut down if such benevolence turns into a fiscal hemorrhage in a system where the sender always pays.

Finally, the protesters denounce what they see as an approaching end to one of the great emancipatory events of modern life, the opening of an untamed, open range, a frontier with possibilities as fertile and hope-filled for its settlers as the Old West was to a prior generation.

Deep down, what they fear is a threat to liberty.

As Vital as Air

So what if this independence, this sovereignty they now enjoy, is newer than the youngest Net user, a surprise gift few dreamed of, as recently as ten years ago? It is a fact of life that any liberty, once enjoyed, swiftly becomes essential, a requisite as vital to happiness as food and air.

Are we about to see another "tragedy of the commons" on a vastly greater scale? Ask any of the dour pessimists who dwell in electronic discussion forums the way earlier generations of cynics used to mutter warily in smoky coffee houses, unsurprised by any depths society might

"

It strikes me as possible at this date to think, argue, innovate, compromise, and think some more . . . until a way emerges to make this dream something greater and more startling than ever.

"

plunge. To them, Garrett Hardin's scenario is already unfolding, only this time over a span of mere months, rather than the centuries it took in post-feudal England. Indeed popular cyberpunk books and films project tomorrows that have more in common with Dickensian nightmares of the nineteenth century than the supposed innocence of a Saxon village—bleak tales of stalwart individuals struggling for niches between gray, faceless mansions of unassailable power. Realms dominated by vast, corporate entities that have parceled out the territory of dataspace, erecting a maze of fences, walls, and for-profit channels that only a few brave, clever souls dare infiltrate, at great risk.

These are disturbing visions. Some of them may even come true, if history is our guide.

On the other hand, I see no reason why history should recapitulate. The analogy to long-ago events in feudal England may be apt as a thought-provoking warning. But the info-network has traits that go far beyond simple parables about medieval farming villages, and we are a more knowing, far mightier folk than our ancestors ever were.

It strikes me as possible at this date to think, argue, innovate, compromise, and think some more . . . until a way emerges to make this dream something greater and more startling than ever. Something diverse, free, and immune to the tragedies that ruined other "commons" in the past.

INDEX

ABOUT THE EDITORS

MILTON T. WOLF is Vice President for Collection Programs at The Center for Research Libraries. He is also a scholar/teacher of science fiction. He was founding editor of *Technicalities*, coeditor of *Thinking Robots, an Aware Internet, and Cyberpunk Librarians*, of a special issue on "The Information Future" in *Information Technology and Libraries*, of the 1996 science fiction anthology *Visions of Wonder*, and editor of a 1997 special issue of *Shaw: Shaw and Science Fiction*.

PAT ENSOR (PLEnsor@uh.edu) is the head of Information Services at the University of Houston Libraries; she has worked with electronic information since 1981 at California State University–Long Beach and Indiana State University. She is the editor of ALA Editions' *Cybrarian's Manual*, co-editor-in-chief of Public-Access Computer Systems Review, and book review editor of the Library and Information Technology Association's (LITA) *Telecommunications Electronic Reviews*.

MARY AUGUSTA THOMAS is Assistant Director for Management and Systems, Smithsonian Institution Libraries (SIL), managing SIL's administrative and automation efforts including the SIL digital library. Professional commitments include serving as vice-president/president-elect of the District of Columbia Library Association, member of the Federal Libraries and Information Centers Coordinating Committee (FLICC) and the Library Administration and Management Association (LAMA) Publications Committee. Thomas has been a contributor to *Magazines for Libraries* since 1979. She is 1985 Senior Fellow, Council on Library Resources/University of California, Los Angeles, Graduate School of Library and Information Sciences.